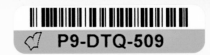

TREASURES FROM THE KREMLIN

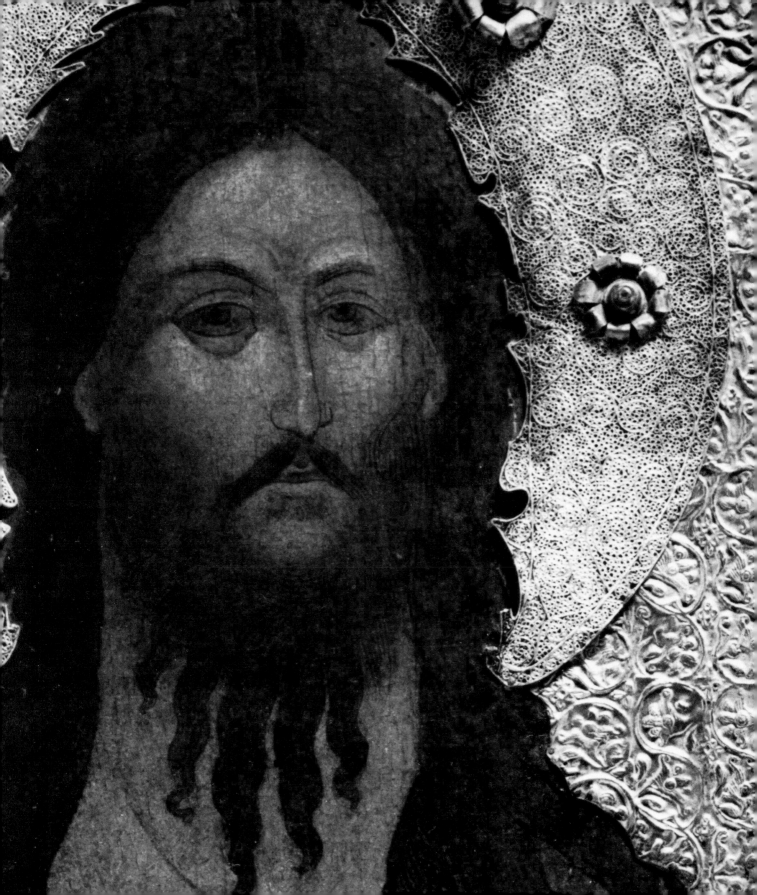

TREASURES FROM THE KREMLIN

An Exhibition from the State Museums of the Moscow Kremlin
at
The Metropolitan Museum of Art, New York
May 19-September 2, 1979
and the
Grand Palais, Paris
October 12, 1979-January 7, 1980

The Metropolitan Museum of Art, New York
Distributed by Harry N. Abrams, Inc., Publishers, New York

The exhibition is made possible through a grant from
the Robert Wood Johnson Jr. Charitable Trust.

The exhibition was organized by:
Emma P. Chernukha, Senior Researcher and Curator,
 State Museums of the Moscow Kremlin

Olga Raggio, Chairman, Department of European Sculpture and Decorative Arts,
 The Metropolitan Museum of Art, New York

Francis Salet, Membre de l'Institut de France, Inspecteur Général
 Honoraire des Musées

Library of Congress Cataloging in Publication Data

Gosudarstvennye muzei Moskovskogo Kremlia.
 Treasures from the Kremlin.

 Bibliography: p.
 Includes index.
 1. Icons, Russian—Exhibitions. 2. Art
industries and trade—Russian Republic—Exhibitions.
3. Silverwork—Europe—Exhibitions. I. Sizov,
E. S. II. Russia (1923- U.S.S.R.).
Ministerstvo kul'tury. III. New York (City).
Metropolitan Museum of Art. IV. Paris. Grand Palais.
V. Title.
N8189.R9G68 1979 704.948'2 79-1051
ISBN 0-87099-193-0 (MMA HC)
ISBN 0-87099-192-2 (MMA pb)
ISBN 0-8109-1656-8 (HNA HC)

Published by The Metropolitan Museum of Art, New York
Bradford D. Kelleher, Publisher
John P. O'Neill, Editor in Chief
Polly Cone, Editor
Gerald Pryor, Designer

Cover: 64. *Fabergé's stylized model of the Kremlin*, 1904. (p. 177)
Jacket: *Gold pectoral cross*, late 17th century (p. 168)
Frontispiece: Detail of 10. *John the Precursor*, painted icon, 1560s (p. 141)

CONTENTS

NOTE

The text was prepared by the chief curator, E. S. Sizov, and members of the senior research staff of the State Museums of the Moscow Kremlin: I. A. Bobrovnitskaia, E. P. Chernukha, L. M. Gavrilova, L. P. Kirillova, I. D. Kostina, S. Ya. Kovarskaia, M. N. Larchenko, G. A. Markova, M. V. Martynova, T. V. Martynova, A. S. Nasibova, I. S. Nenarokomova, A. V. Petukhova, I. F. Polynina, E. V. Shakurova, G. S. Sokolova, A. M. Terekhova, E. V. Tikhomirova, I. I. Vishnevskaia, and O. V. Zonova. The Russian text was edited by N. A. Maiasova, Deputy Director for Research.

The transliteration used is a modified version of the Library of Congress system, although the soft and hard signs of the Cyrillic have either been rendered by ''i'' or omitted.

FOREWORD

The exhibition *Treasures from the Kremlin* has been organized as part of the program of cultural exchange and cooperation between the Soviet Union and the United States and marks a significant step in the history of cultural relations between the two countries. Hitherto only individual works from the Kremlin State Museums have been displayed internationally, and these have always been merely part of larger, more general exhibitions. Now, for the first time, these museums have sent abroad an exhibition that fully represents their basic collections.

The cultural heritage of ancient Russia has excited much interest—and understandably so. The monuments of Russian art created many centuries ago still astonish us as evidence of great technical mastery and distinctive talent. Such works are inspired by great humanistic ideals and reflect a search for spiritual beauty. These enduring qualities make them relevant and particularly valuable to us today.

The Moscow Kremlin is the ancient and historic center of Russia. It was aptly called the heart of the country, since for centuries it was the axis of Russian culture. It was here that works of great historical and artistic significance were created and amassed over many centuries. After the great Socialist October Revolution of 1917 the Revolutionary Government decreed that the historic and artistic treasures of the Kremlin were to be nationalized and brought together in a single museum complex—the State Museums of the Moscow Kremlin. During the sixty years of the Soviet period, the number of Kremlin treasures has more than doubled.

The architectural monuments and examples of painting and the applied arts in the Kremlin Museums have great historic and artistic value and are an integral part of the universal cultural heritage. They embody the

great artistic gifts of the Russian people; they express the national pride of their creators and inspire and nurture future generations. That is why the task of preserving and restoring these works assumed such vital, immediate importance from the moment the Soviet state was established. In October 1917 the Moscow Soviet created the Commission for the Preservation of Art and Monuments of Antiquity, whereby all cultural monuments were recorded by the state; despite severe economic hardship during those early years, funds were appropriated to renovate and refurbish endangered works. In May 1918 Lenin decreed that major repairs and restoration begin in the Kremlin, and, as a result, the unique architectural monuments, the frescoes, painted icons, and many objects of applied art were restored to their original appearance.

In recent years a general restoration plan for the Kremlin has been implemented. It goes far beyond the previous schemes and affects both the architectural complex and individual works. Concern for the preservation and restoration of historic and artistic monuments has become an official policy of the Soviet government and has found its place in the Fundamental Code of the Soviet State, the constitution of the USSR. Questions of the preservation and propagation of our cultural heritage are especially relevant today, when problems of peace, security, and international cooperation are being discussed and resolved. The extensive cultural exchanges between our two nations doubtless serve the cause of universal peace and understanding.

M. P. Tsukanov
Director, State Museums
of the Moscow Kremlin

FOREWORD

Treasures from the Kremlin is the fourth exhibition in the program of ongoing cultural exchange initiated in 1974 between the Museums of the Soviet Union and The Metropolitan Museum of Art. The exhibition, to be seen first in New York and then in Paris, contains one hundred of the most magnificent works in the collections of the State Museums of the Moscow Kremlin. This group of seven museums within the Kremlin walls includes the State Armory Museum and the Bell Tower of Ivan the Great as well as the cathedrals of the Assumption, Annunciation, and the Archangel Michael and the churches of the Deposition of the Robe and the Twelve Apostles. Because of the nature of the Kremlin collections, the exhibition not only dazzles the viewer with resplendent and precious works of the twelfth to the twentieth century, but also conveys a historical dimension too seldom present in exhibitions of art.

The major figures of Russian history are poignantly evoked here by the very objects they owned. The twelfth-century silver-gilt chalice of Yurii Dolgorukii, the legendary founder of Moscow; a Gospel book and altar cross of Ivan the Terrible; the coat of mail worn in battle by Czar Boris Godunov; and the grand cap of state made in about 1682 for the coronation of Peter the Great are spectacular examples of Russian craftsmanship that bring the past stirringly alive.

The greatest number of objects in the exhibition are works of the sixteenth and seventeenth centuries—the period during which Moscow became the political, religious, and artistic center of Russia. The splendor of court life is illustrated with rich ceremonial horse trappings and the monumental treasures of gold and silver plate that so awed foreign envoys and merchants posted to Moscow. A famous fourteenth-century painted icon, *The Savior of the Fiery Eye,* represents the beginnings of the great artistic tradition associated with the Russian Church, but the exhibition is

especially rich in seventeenth-century works made for the cathedrals of the Kremlin and contains several paintings from the iconostases of the Cathedral of the Annunciation. Gold and silver liturgical vessels, opulent ecclesiastical vestments, and pearl-embroidered hangings in the exhibition attest the remarkable production of the Kremlin workshops before 1700.

The Kremlin continued to be associated with the decorative arts after the removal of the capital to St. Petersburg in 1707. The Armory remained a court repository and, after 1800, was organized as a museum for works from all parts of Russia. Several pieces in the exhibition demonstrate the brilliance of the craftsmen in such provincial centers as Velikii Ustiug, Tobolsk, and Tula after the beginning of the eighteenth century.

A splendid and apt closing note is provided by a masterwork of early twentieth-century goldsmithery—the stylized representation of the Kremlin in semiprecious stones and jewels created in 1904 by the St. Petersburg firm of Fabergé.

The entire exhibition is a tribute to the splendor of Russian design. Metalworkers, goldsmiths, armorers, painters, embroiderers—Russian craftsmen together with masters from Europe and the East—all worked to create one of the most sumptuous court and ecclesiastical complexes ever known and some of the most enchanting and masterly objects ever made.

The continued success of our exchange program is very much due to the support of Petr Demichev, Minister of Culture of the USSR, Yurii Yakovlevich Barabash, First Deputy Minister of Culture, and their agency, the Ministry of Culture. I wish especially to thank Vladimir Popov, Deputy Minister of Culture, Alexander Khalturin, former Head of the Arts Department, and Hendrick Popov, Head of the Arts Department, with whom I conducted negotiations when I visited Moscow.

Mme Alla Boutrova, Chief of the Western European and American Section of the Foreign Department, Ministry of Culture, was also most helpful in the planning. James Pilgrim, Deputy Director for Curatorial Affairs at the Metropolitan Museum, assisted at various stages of the preparation.

Anatoly M. Dyuzhev, Cultural Counselor at the Embassy of the USSR in Washington, and Ivan A. Kouznetsov, Consul-Designate of the Consulate General of the USSR in New York, have both been very helpful. Malcolm Toon, Ambassador of the United States in Moscow, as well as Marilyn Johnson, formerly of the Press and Cultural Affairs Division of the

American Embassy in Moscow, also gave much assistance, as did Peter Solmssen of the U.S. Department of State in Washington.

The exhibition benefited greatly from indemnification by the Federal Council on the Arts and Humanities. Special thanks are due Linda Bell, of the Museum Program, National Endowment for the Arts, for her help in processing our application.

I would like to mention in particular the generosity and cooperation of Mikhail P. Tsukanov, Director of the State Museums of the Moscow Kremlin, Natalja Andrejva Maiasova, Deputy Director for Research of the State Museums of the Moscow Kremlin, and Emma Petrovna Chernukha, Curator-in-Charge of the exhibition in the USSR.

The exhibition was shaped and organized by Olga Raggio, Chairman of the Department of European Sculpture and Decorative Arts at the Metropolitan. Her involvement in the show has been complete—from participating in negotiations in Russia to preparation of the catalogue and the mounting of the actual installation. Among the many others at the Museum whose hard work contributed to the success of the exhibition are John Buchanan, Registrar, Lucian J. Leone, Designer of the installation, and Sheldan Collins and J. Kenneth Moore, who made a special trip to Moscow for the photography of the objects in the catalogue.

I am grateful to John E. Bowlt, Associate Professor, Department of Slavic Languages, at the University of Texas at Austin, for his translation of the Russian text for the catalogue.

It has been a pleasure to cooperate in the organization of the exhibition in France with L'Association Française d'Action Artistique, presided over by Louis Joxe, Ambassador of France, and directed by André Burgaud, and with La Réunion des Musées Nationaux, administered by Hubert Landais, Directeur des Musées de France. Francis Salet, Membre de l'Institut, Inspecteur Général Honoraire des Musées, worked closely with Olga Raggio and me in every stage of the preparation of the exhibition.

Finally, I would like to express my deepest gratitude to the Robert Wood Johnson Jr. Charitable Trust for the generous grant that has made possible the presentation of *Treasures from the Kremlin* at The Metropolitan Museum of Art.

Philippe de Montebello
Director
The Metropolitan Museum of Art, New York

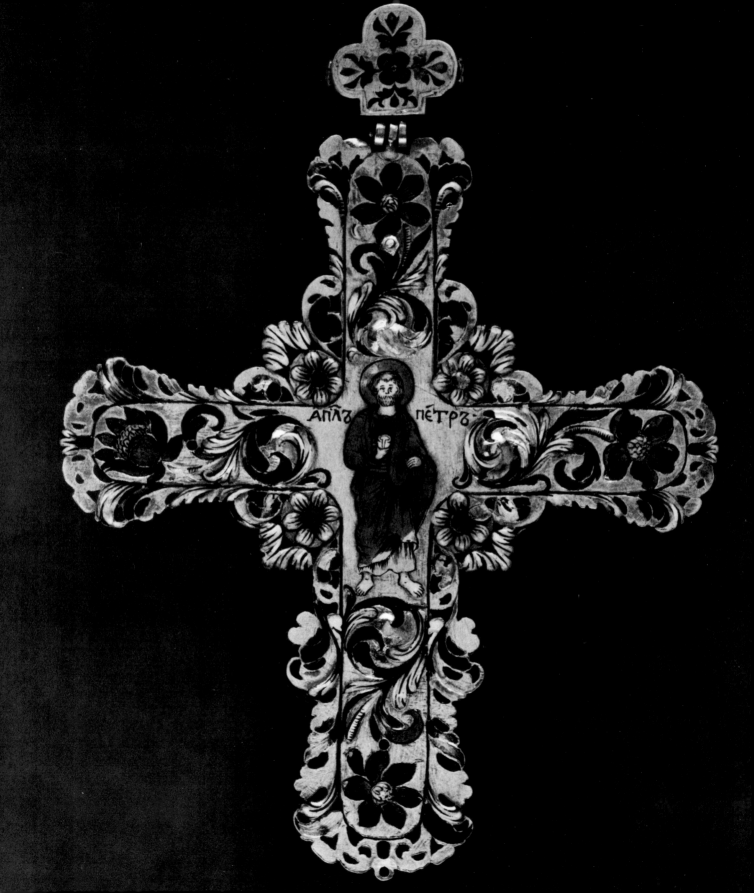

INTRODUCTION

The year 1147 is generally considered the date on which the real history of Moscow and the Kremlin began. The old chronicles tell of two allies, the princes Yurii Dolgorukii and Sviatoslav Olgovich, who met on the high, wooded bank of Borovitsky Hill in that year. Then, in 1156, "Prince Yurii Vladimirovich the Great founded the city of Moscow at the mouth of the River Neglinnaia, above the River Yauza." That is how an old chronicler began his story of ancient Muscovy more than eight centuries ago.

However, archaeological finds on the Kremlin site indicate that Borovitsky Hill was inhabited as early as the eleventh century. The Slavs who first lived there were potters, smiths, cobblers, and jewelers. The oldest objects discovered on the site—weapons, glass items, multicolored vessels, remnants of silk—bear witness to close commercial ties between ancient Moscow and the other Russian principalities as well as the countries of eastern and western Europe. The finds constitute the archaeological collection of the Kremlin Museums.

The thirteenth through fifteenth centuries were marked by the tragic domination of the Mongol Horde in Russia, which did much to impede the development of Moscow. This is not to say that the city did not evolve at all; after each devastating raid by the Mongols the Kremlin was repaired or rebuilt. Archaeological digs have yielded fragments of stone buildings dating from the late thirteenth century.

Examples of the material and artistic cultures of the twelfth and thirteenth centuries can now be collected only bit by bit, so what remains of that dark period in the history of the Russian people is of particular value to us. One such relic, for example, is a twelfth-century icon of St. George. This image of the handsome warrior, the defender and liberator of his country, was the embodiment of a popular patriotic ideal.

13

5. Gold pectoral cross.
nameled figure of the apostle Peter (see p. 168)

As time went by, the diplomatic and military successes of the Moscow princes helped to strengthen the authority of Moscow, and, in 1271, it became the capital of the then still tiny Moscow principality. Frequent attacks by enemies made the local princes ever concerned for the security of the inhabitants of Borovitsky Hill. We know, for example, that during the first half of the fourteenth century the Kremlin was surrounded by oak walls that followed the courses of the Neglinnaia and Moscow rivers; the town was protected from the east—where Red Square is now—by a wide moat. The first stone walls around the Kremlin were constructed under Dmitrii of the Don (Dmitrii Donskoi) during the second half of the fourteenth century, a time when the Russian people were struggling resolutely for their independence. The walls were built of large blocks of white stone reinforced with tall towers rising above gateways; blind round towers also stood at the corners and points of juncture of the walls. The total length of the white stone walls was about one and a quarter miles.

As the political prestige of the Moscow principality increased, the capital city expanded. The fourteenth century was particularly rich in important events for the Kremlin: the metropolitan Peter moved from Vladimir to the Moscow Kremlin in 1325, thereby establishing Moscow as the spiritual center of the Russian lands. In 1328 in Moscow Prince Ivan Kalita assumed the title of great prince, or grand duke, thus becoming head of the feudal union of the princes of the central principalities. These events were paralleled by an intense period of construction in the Kremlin, for monasteries and churches were erected, a wooden ''golden-roofed chamber'' for the grand duke was built, and many monastery enclaves and boyar residences were also constructed. In those days the Kremlin was like an entire city, the center of which was Cathedral Square, so named because of the surrounding stone cathedrals. These small, simple, classical buildings, distinguished by the characteristic features of Vladimir-Suzdal architecture, served as the prototypes for the grand constructions of the fifteenth century. Today these buildings constitute the most imposing and important part of the State Museums of the Moscow Kremlin. The Cathedral of the Assumption, the Cathedral of the Archangel Michael, the Cathedral of the Annunciation, the Church of the Deposition of the Robe, the Palace of Facets, and the Bell Tower of Ivan the Great, erected in the fifteenth and early sixteenth centuries, form a unique complex. The Moscow Kremlin, residence of Ivan III, grand duke of ''all Russia,'' became the advance post of the young and vigorous Russian state, which, after throwing off the

Tartar yoke, declared itself a mighty neighbor of Europe.

During the fifteenth and early sixteenth centuries the most intense building program in the history of the Moscow Kremlin took place, and it reflected the unifying tendencies peculiar to Russian history and culture of that time. Master craftsmen from many centers in Russia (Pskov, Novgorod, Rostov, Tver, and the Vladimir and Suzdal principalities) and architects from Italy (the most artistically progressive country of the time) took part in the grand-scale construction activity. The territory of the Kremlin was expanded to seventy acres and was enclosed by more than a mile of new brick walls, supporting eighteen towers. The result was the fortress we see today. The walls were built to take full advantage of the local elevation: along the top runs a defense corridor or platform protected on the outside by crenellations with tiny arrow slits. The Kremlin was an outstanding fortification, one that answered all the demands of defense technology of its time.

The main fifteenth-century structure in the Kremlin is the Metropolitan Cathedral of the Assumption, built by the Italian architect Aristotele Fioravanti in 1474–79. However, Italian innovations did not spoil the essential spirit of the medieval Russian architecture. The Renaissance style as practiced by the European artists manifested itself only in the decorative innovations and did not cause any drastic inherent changes in the development of Russian architecture. Working side by side with the Moscow and Pskov masters, the Italians were able to grasp the distinctive features of the indigenous artistic traditions. With the Russian architects they created masterpieces that formed an organic link with Russian art as a whole. The serene yet severe Cathedral of the Assumption, with its five majestic cupolas, is characteristic of Vladimir-Suzdal architecture of the twelfth century, and it astonishes us by its majesty and its harmony of component parts. Its laconic simplicity of forms and restrained ornament give the cathedral a monumentality and expressive force; the interior space is also distinguished by a unity and harmony of design. Fioravanti made the principal chamber spacious, allowing ample room for the slender, round columns supporting the tall and graceful sail vaults of the arches. The walls of the cathedral were first decorated with frescoes in 1481 by a group of artists led by the brilliant painter Dionysius, but only fragments of these murals survive. Most of the wall space is now occupied by paintings of the seventeenth century.

From earliest times the Cathedral of the Assumption was a gathering

point for ancient Russian paintings. Some icons were painted especially for the cathedral, while others were brought there—to the principal church in the land—from various Russian cities and from other orthodox centers. Among the works brought to the cathedral was the famous *Our Lady of Vladimir*, a matchless example of late eleventh- or early twelfth-century Byzantine painting much esteemed in ancient Russia; the work is now in the Tretiakov Gallery, Moscow. The early twelfth-century icon of St. George was brought from Novgorod, and the icons called *The Savior of the Fiery Eye* (**2**) and *The Trinity* were painted especially for the first Cathedral of the Assumption in the mid-fourteenth century. The original cathedral was distinguished by the unusual elegance of its design and ornamentation: the colors of the numerous icons and frescoes shimmered in the sun's rays as they fell from the highest windows and the drums of the cupolas. The radiance of the precious stones, of the gold and silver of the icon covers, of the church utensils, and of the rich, gold-embroidered vestments and the lights of the many candles and multicolored icon lamps all contributed to the great splendor and magnificence of the interior. The cathedral was the scene of many important ceremonies—coronations, royal weddings, elections of heads of the Russian Church. Here solemn prayers were delivered before military campaigns and thanks were given in honor of victories newly gained. It was also here that the Moscow metropolitans and patriarchs were laid to rest.

The Cathedral of the Annunciation was the family church of the great princes. It was built by Pskov craftsmen in 1484–89. The cathedral is an elegant building with three main cupolas and is surrounded on three sides by a gallery with steps leading down to Cathedral Square. It combines elements of the early Moscow and Pskov architectural styles, although the final version was finished in the sixteenth century, when alterations and additions were made that both complicate and enhance the architectural construction. The small, intimate interior of the cathedral was decorated in 1508 with frescoes that incorporated the political ideas of the early sixteenth century into the traditional code of mural painting. Social awareness and endeavors to resolve social and political problems were characteristic of this period in the flowering of Russian culture. The iconostasis of the cathedral is a jewel of ancient Russian painting and is the oldest surviving example of the multitiered, classical type. From a chronicle of the time we learn that it was actually painted in 1405 by the greatest artists of the

Russian Middle Ages—Theophanes the Greek, Andrei Rublev, and Prokhor of Gorodets. Their work marks the zenith of Russian icon painting.

The Russian icon is an artistic phenomenon of great distinctiveness. It embodies the conventions and abstract ideals of the medieval world as conveyed by nameless artists through the emotional language of spare and concise lines and pristine, glowing colors. A noble simplicity and classical precision of composition and a highly developed, very personal style are characteristic of the Russian icon. In contrast to the severe, contemplative style of Byzantine images and the exaggerated expressivity of Gothic works, the Russian icon evokes a mood of serenity and concentration. The artists of ancient Russia transmitted ideals of profound humanistic meaning through their creations and expressed in them their conception of permanent human values. These works require long and careful scrutiny. For the viewer the result is a sensation of inner lightness and harmony, the very qualities that the sounds of classical music also evoke.

While the Cathedral of the Annunciation was being built, the Pskov builders were constructing, in 1484–85, the little Church of the Deposition of the Robe beside the Cathedral of the Assumption. The Church of the Deposition of the Robe served as the home church for the metropolitans and patriarchs and, like all the Kremlin cathedrals, was constructed on the site of an earlier church of the same name. The Church of the Deposition of the Robe, with its single cupola and lofty tower, is distinguished by its elegant proportions, its beautiful silhouette, and the severe nobility of its ornamentation. In the mid-seventeenth century the intimate interior of the church was painted by the czar's icon painters, who based their work on the apocryphal legends of the Mother of God and on "The Great Acathistos," the famous sixth- or early seventh-century Byzantine hymn to the Virgin. The iconostasis in the church was painted in 1627, in part by one of the finest icon painters of the time, Nazarii Istomin Savin.

The medieval architectural complex on Cathedral Square also contains an ancient civic building, the Palace of Facets, constructed in 1487–91 by the Italian architects Marco and Pietro Antonio Solari. The name of the building derives from the decoration on the main, eastern façade, which is covered with four-faceted white stones. The severe proportions and square shape of the palace give it a majestic simplicity. A grand and spacious (1,624 square feet) ceremonial hall occupies the second story,

from the center of which a square pillar rises to support the ceiling, in the tradition of Russian refectories. The walls and vaults of this chamber were covered in frescoes, and on sideboards around the pillar precious plates and dishes were displayed. It was among such splendor that the most important events of Russian history were solemnized, that meetings of state took place, that foreign embassies were received, and that military victories were celebrated. The ancient frescoes in the hall have not been preserved, and the murals that we see today were painted by artists from the village of Palekh at the end of the nineteenth century.

The Cathedral of the Archangel Michael was the last of the Kremlin cathedrals to be built. It was constructed by the Italian architect Alevisio Novi in 1505–08. The overall form of this five-cupolaed church with its six pillars retains the characteristics of a typical Russian design—like all the other churches built by Italian architects. Although the exterior of the Cathedral of the Archangel has many elements characteristic of fifteenth-century Italian palace architecture (exuberant shell motifs, highly ornate portals, rosettes, Corinthian capitals, laurel garlands, and Venetian windows), it preserves the general plan of an ancient Russian church.

There were a number of antecedents to Alevisio's cathedral. As early as the twelfth century a wooden church dedicated to the Archangel Michael, patron saint of the Russian army, stood on the edge of Borovitsky Hill, and in the fourteenth century this was replaced by a white stone structure—the largest of the Kremlin cathedrals at the time of its construction. The great prince Ivan Kalita was buried there in 1340, and thereafter the cathedral came to be known as the state necropolis, so that members of the Moscow princely dynasty were traditionally buried there. The new cathedral of 1508 maintained this function, and, for 350 years, until the capital was transferred to St. Petersburg at the beginning of the eighteenth century, it served as the burial place for the great princes and czars; the cathedral now contains forty-six tombs.

The frescoes in the Cathedral of the Archangel Michael date from the mid-seventeenth century and were executed by the finest painters of Moscow and provincial cities. They are based on frescoes of the 1560s, but they are distinctive, inasmuch as they treat social and societal themes of the sixteenth century. This, after all, was a period of ideological contradictions and of spreading heretical movements. In affirming the stability of the czarist autocracy and the dogma of the Christian creed in Russia, these murals appeared as a solemn rebuke to all unbelievers. One of the recurrent

themes in ancient Russian art is that of the defense of the fatherland, and the frescoes of the Cathedral of the Archangel Michael show battle scenes imbued with the heroic pathos of struggle and victory. The wall paintings in this princely burial place also include stylized "portraits" of the real historical persons interred there. Among the individual panel paintings, particular attention should be given to the early icon of the Archangel Michael with scenes from his life. It was painted by an unknown master of the late fourteenth or early fifteenth century.

The grand Bell Tower of Ivan the Great, with its three stories and gold cupola, has become the dominant architectural accent of the Kremlin. It was built in 1505–08, at the same time as the Cathedral of the Archangel Michael. By edict of Czar Boris Godunov in 1600 the tower was raised to a height of over 265 feet, so that it was the tallest building in all Russia. It served both as an alarm post and a watch tower, since from atop the tower the outskirts of Moscow were clearly visible. In 1543 a lower bell tower of the Novgorod-Pskov type was built next to the original tower, and with this striking edifice the circle of buildings on Cathedral Square was finished, providing the sense of completeness so characteristic of the architectural ensembles of ancient Russia.

The prodigious building activity in the Moscow Kremlin during the last quarter of the fifteenth century and beginning of the sixteenth produced its basic architectural profile, which was, as time went by, elaborated and perfected. The next edifice to be built on Cathedral Square was the Patriarch's Palace and house Church of the Twelve Apostles. Although it was built in 1652, its architectural details echo the designs of its older neighbors. Its cupolas are reminiscent of those on the Cathedral of the Archangel Michael, while the girdle of miniature columns encompassing the building recalls the Cathedral of the Assumption. The three-storied palace consists of chambers and cells connected by inside passages—a plan characteristic of the residential structures of ancient Russia. According to established tradition, the first story was used as a service floor; the second contained the ceremonial chambers and the house chapel; the third was reserved for the patriarch's private apartments. The largest chamber, called the Krestovyi, or Chamber of the Cross, functioned for the Russian Church as the Palace of the Facets did for the czar. It was in the chamber that the patriarch received the czar and embassies of foreign powers; it was here also that church councils were held.

The ceremonial chambers of the Patriarch's Palace now house the

Museum of Applied Art and Culture of the Seventeenth Century. The interiors of the patriarch's chancery and of a small richly arrayed church have been recreated there. One of the showcases is in the form of an antique sideboard on which a precious silver vessel is displayed, and other cases contain princely hunting accessories, old manuscript books, chess sets, clocks, and other objects of everyday use among the seventeenth-century aristocracy.

The main collections of decorative and applied art in the State Museums of the Moscow Kremlin are on view in the rooms of the Armory, and among the exhibits are masterpieces of Russian, oriental, and western European art created by artists from many periods. But the vast majority of the artifacts were created in the Kremlin workshops by Russian artisans. The history of the Armory collection goes back many centuries. Most of the treasures that belonged to the great princes were passed down from father to son. The oldest pieces are mentioned in the last wills and testaments of Ivan Kalita, Dmitrii of the Don, Ivan III, Ivan the Terrible, and other rulers. As Moscow assumed greater power and influence, so the riches of her great princes and czars multiplied. At first these were kept in a small white stone storeroom in the Cathedral of the Annunciation and in other vaults. But by the end of the fifteenth century the treasury of the great princes had reached such proportions that a special stone building (later called the Treasury Chamber) was constructed between the Cathedral of the Archangel Michael and the Cathedral of the Annunciation. This housed not only the works produced by Russian craftsmen, but also all the gold and silver that came from abroad in the form of ambassadorial gifts or commercial acquisitions. Apart from the Treasury Chamber, valuables were also kept in three other principal depositories: the Armory, the Stable Treasury, and the Bed-Linen, or Workshop, Chamber.

The first known documentary references to the Armory date from the beginning of the sixteenth century. In the early days the Armory was used simultaneously as a depository and as a workshop for the production of ceremonial and practical side arms and firearms as well as different kinds of armor. Arts and crafts workshops had been part of the Kremlin since earliest times. They boasted talented and highly qualified artisans brought from all corners of the Russian state, artisans who created the most diverse artifacts for the courts of the great princes and the metropolitans. Painters also worked with the armorers, painting the czar's residences and the

churches, icons, and book illustrations. At the end of the fifteenth and beginning of the sixteenth century the Stable Office, in charge of the czar's stables and of supplying horses for the army, was established next to the Armory. Its workshops produced ceremonial equestrian accessories for the royal hunts. A special two-storied building was constructed for the Stable Office not far from the Borovitsky Gates in the seventeenth century. The Bed-Linen Chamber (later named the Workshop Chamber) was responsible for storing and making bed linen for the czar and clothing for the members of his family. Skillful craftswomen wove precious lace and decorated clothes with gold and silver thread or with pearls. It was here too that unique ecclesiastical veils and Good Friday shrouds (*plashchanitsas*) were embroidered in colored silks.

The Silver and Gold chambers were established in the Kremlin at the beginning of the seventeenth century. In contrast to their antecedents, these chambers were not depositories or storerooms, but manufactories of the most precious gold and silver artifacts for the czars' and patriarchs' courts: crowns, scepters, orbs, precious plate, church utensils, and the like. The Kremlin workshops flourished, especially during the second half of the seventeenth century, when they represented a kind of Russian academy of the arts. For several centuries not only local craftsmen, but also those from other Russian cities and provinces, worked in the Kremlin ateliers; foreign specialists were invited as well. The Kremlin art collections were also constantly being supplemented by fine pieces produced by the skilled artisans of many Russian cultural and craft centers. Gifts from foreign powers and commercial imports also occupy a prominent position in the Kremlin collections. At the beginning of the eighteenth century the output of the Kremlin workshops declined significantly. In 1711 many artisans were transferred to the new capital, St. Petersburg. In 1727 the Armory, the Workshop Chamber, the Treasury Chamber, and the Stable Office were combined to form the Workshop and Armory Chamber, which functioned only as a depository for antiquities and works of art.

In 1806 the Russian government issued a decree specifying the conditions under which antiquities were to be preserved in the Workshop and Armory Chamber, which had, in effect, been transformed into a museum. The following year the first *Historical Description of the Ancient Russian Museum* was published. During the Napoleonic invasion in 1812 the Kremlin treasures were transferred to Nizhnii Novgorod and then, after

their return, were placed in a special building designed shortly before by the architect I. V. Egotov. In 1851 the architect K. A. Ton constructed a new building for the Armory on the site of the old Stable Office. In this white stone building, richly decorated and carved in the seventeenth-century Russian style, the Armory collections are preserved today.

From the moment the museum was established, the collection expanded dramatically. It was supplemented by objects from the Patriarch's Treasury and from disused churches and monasteries and by works from the royal court, from private collections, and from archaeological finds. The museum reserves are still being developed and expanded.

The State Museums of the Moscow Kremlin possess tens of thousands of Russian and non-Russian artifacts of the fifth to the twentieth century—arms and armor, gold and silver, precious textiles and embroideries, icons and manuscripts, state regalia, harnesses, carriages, porcelain and glass, coins and medals, clocks and snuffboxes, and wooden sculpture. Each item is under the constant supervision of Kremlin restorers. Indeed, scientific and restoration work on the Kremlin collections began immediately after the great Socialist October Revolution. As a result, many monuments, including the Church of the Deposition of the Robe, the Patriarch's Palace, and the Church of the Twelve Apostles, have been restored to their original appearance. Restoration and research have made possible the renewal of the ancient frescoes in the cathedrals of the Annunciation and the Assumption and the reconstruction of the burial vault of Ivan the Terrible in the Cathedral of the Archangel Michael and the central pillar in the Palace of Facets. Thanks to our restorers many hundreds of works of architecture, painting, and decorative art continue to be refurbished and renewed.

A. S. Nasibova

COLORPLATES

Icons

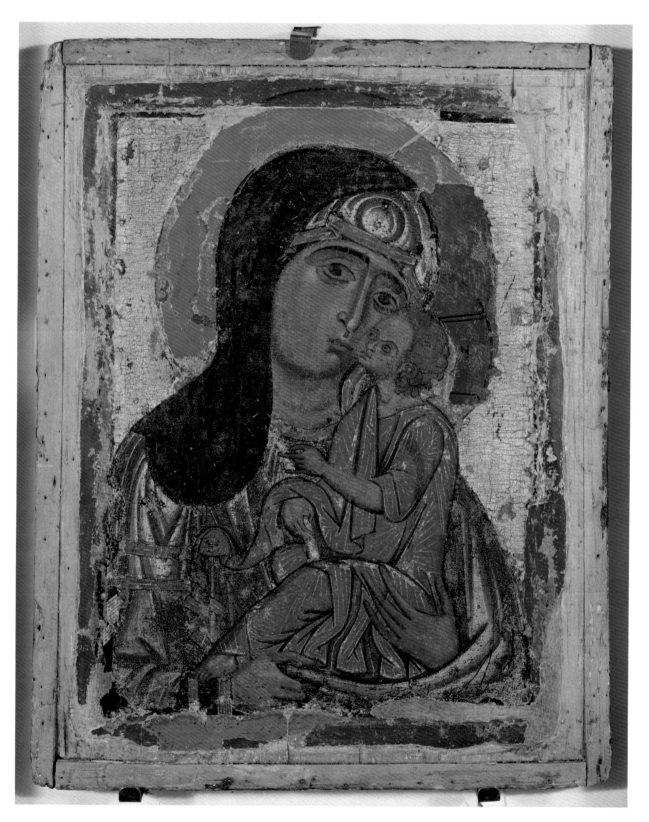

1. *Our Lady of Tenderness*. Tempera on canvas over wood.
 Mid-12th century (see p. 136)

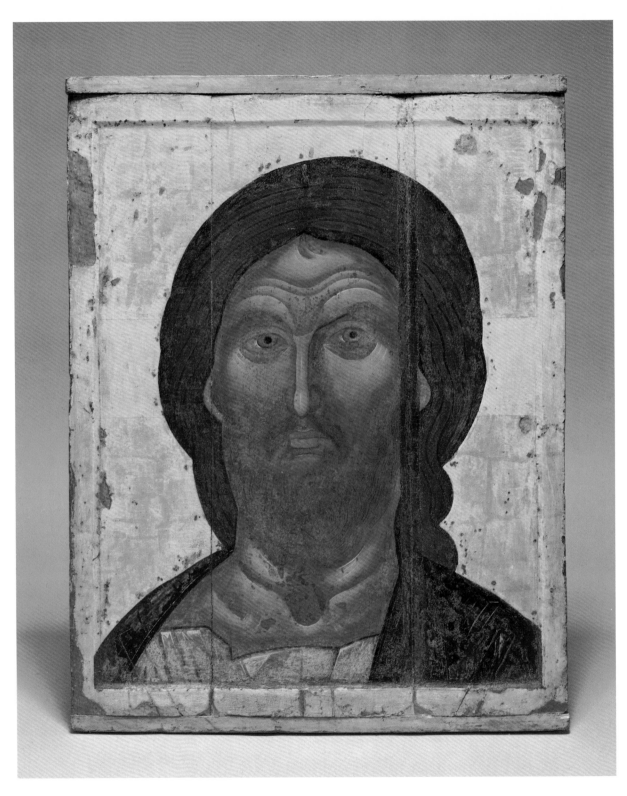

2. *The Savior of the Fiery Eye*. Tempera on wood.
Mid-14th century (see p. 137)

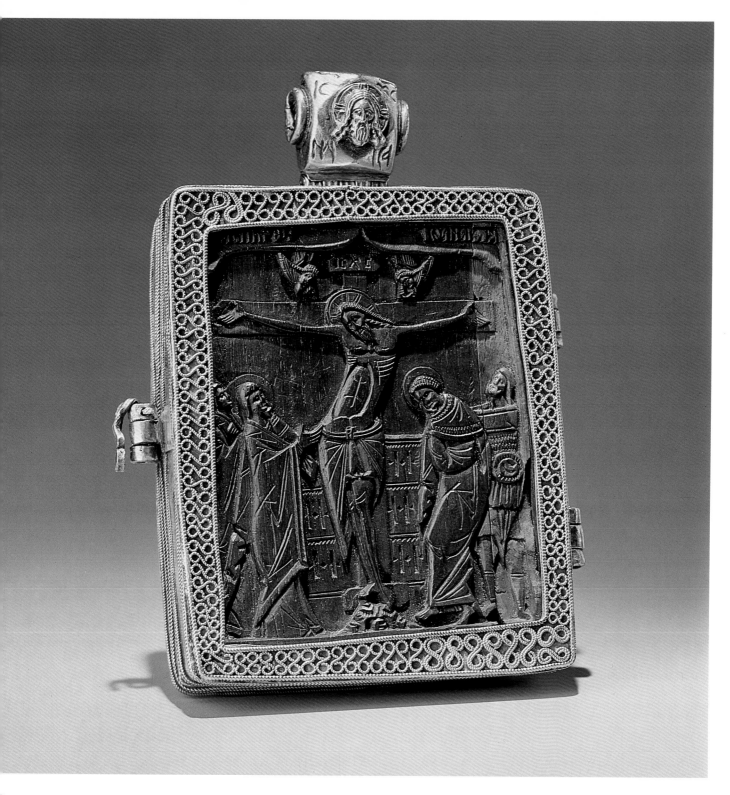

3. *Folding pectoral icon*. Carved wood, framed in silver-gilt filigree.
15th century (see p. 137)

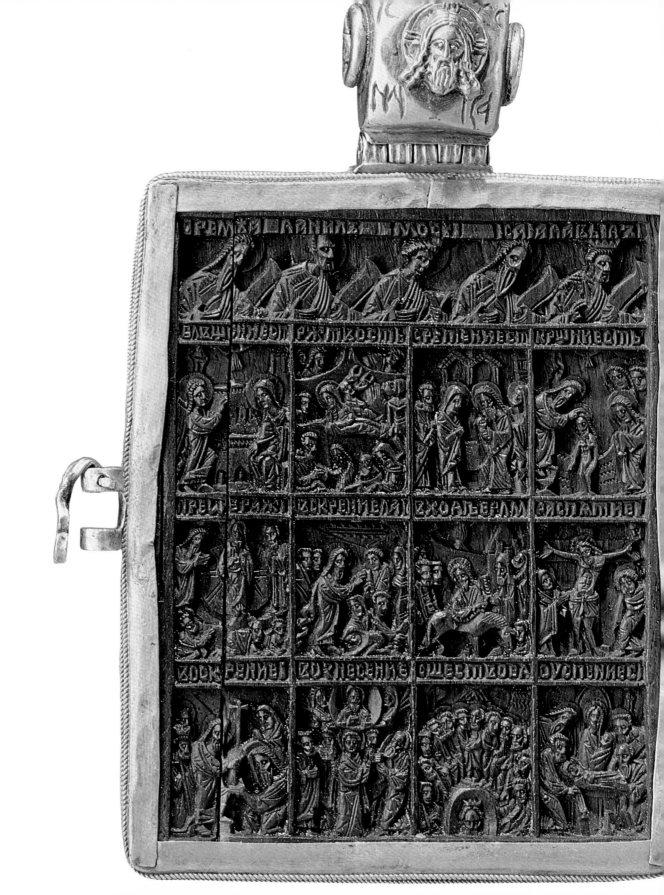

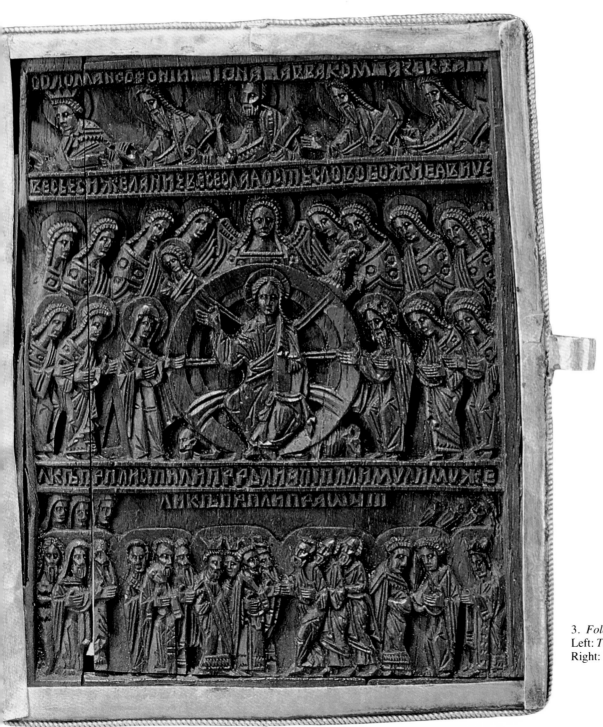

3. *Folding pectoral icon. Inside*
Left: *The twelve feast days*
Right: *"Praise the Lord"*

29

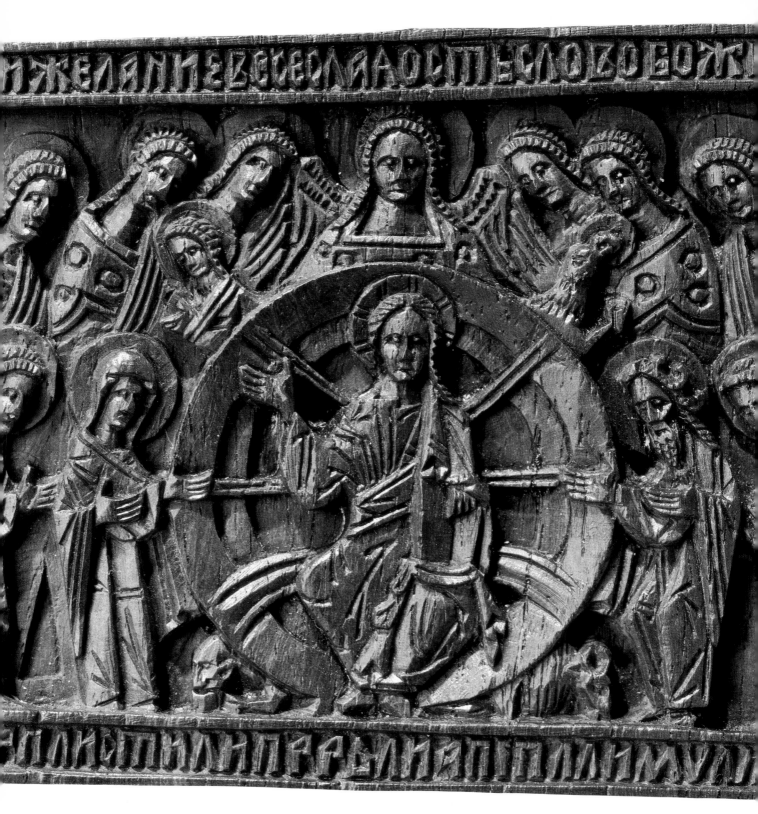

Detail of 3: *Folding pectoral icon. Inside: Figure of Christ from "Praise the Lord"*

4. *The Virgin of Bogoliubovo with Scenes from the Lives of Sts. Zosimas and Sabbatius of the Solovetsky Monastery.* Tempera on canvas over wood. 1545 (see p. 138)

31

5. *"Glory unto Thee."* Tempera on canvas (?) over wood.
First half of 16th century (see p. 138)

7. *The Assembly of the Virgin*. Tempera on wood with silver filigree.
1560s (see p. 140)

Overleaf: Detail of 7: *Singers, priests, and monks* ▷

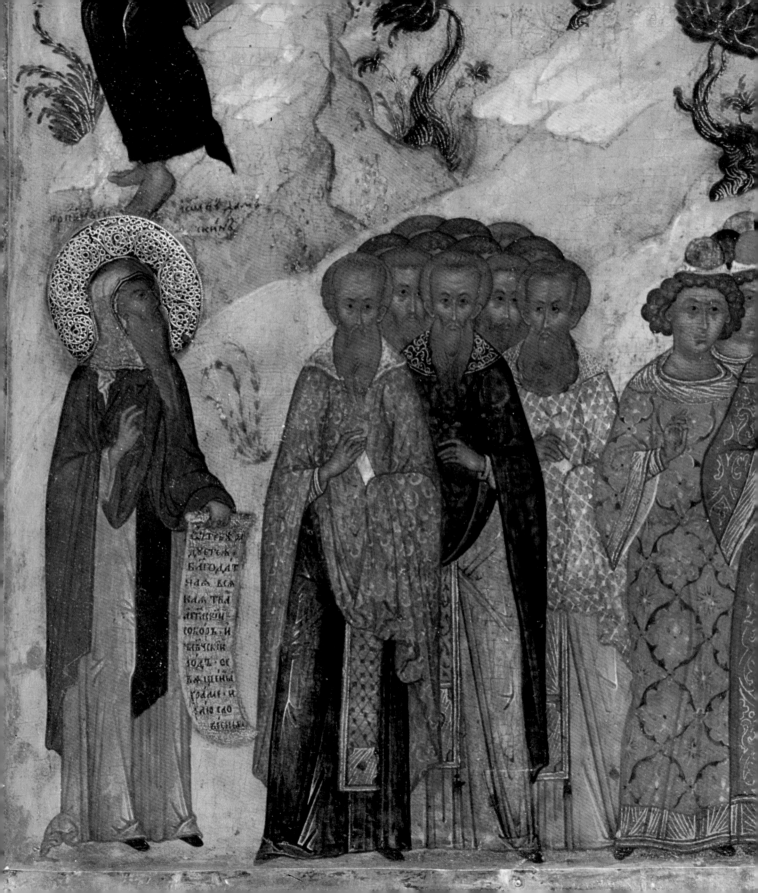

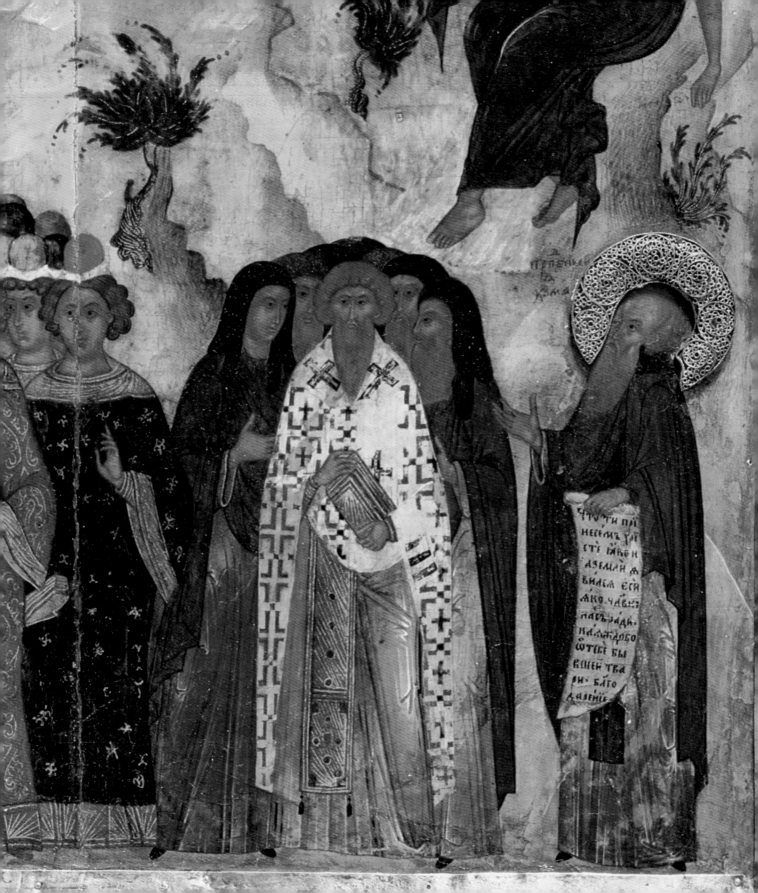

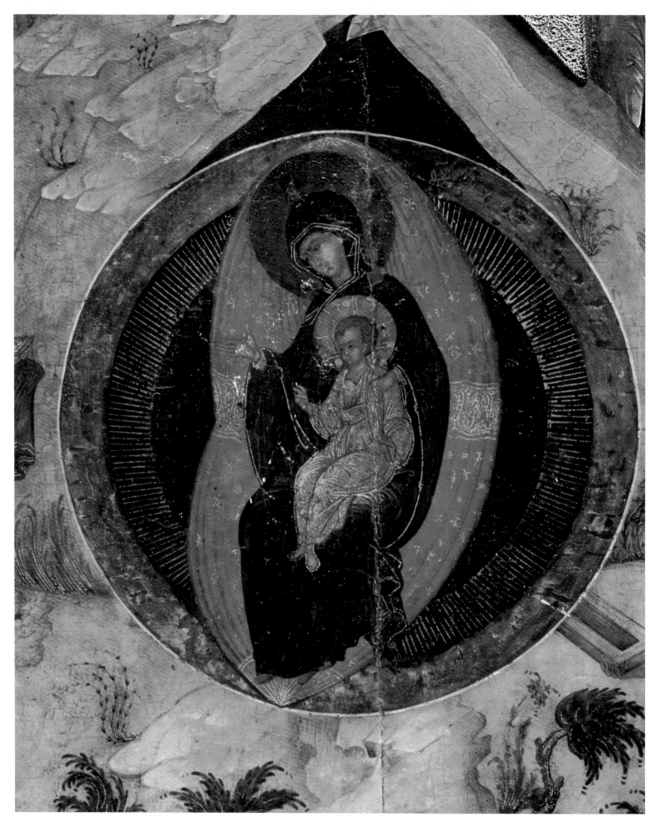

Detail of 7: *The Assembly of the Virgin: The Virgin and Child in the "circles" of their glory*

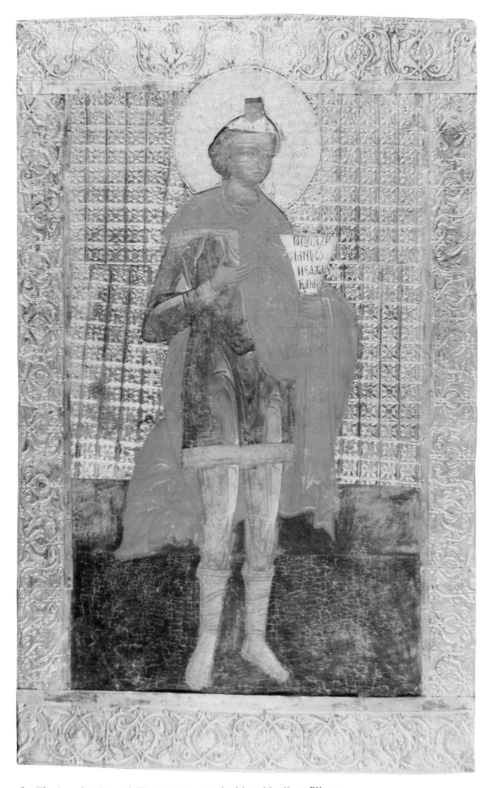

8. *The Prophet Daniel*. Tempera on wood with gold, silver filigree,
and silver gilt. 1560s (see p. 140)

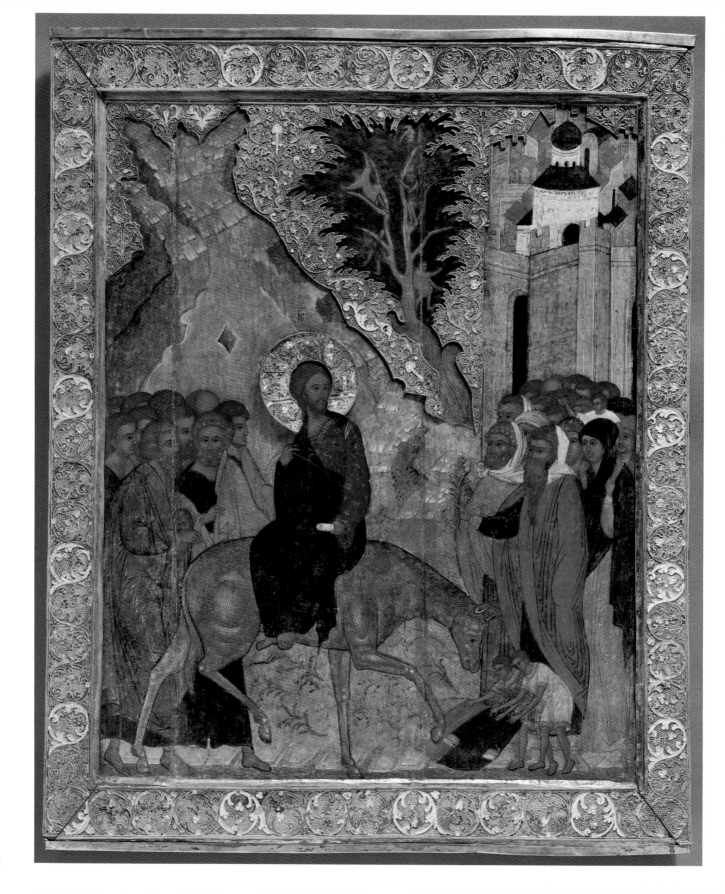

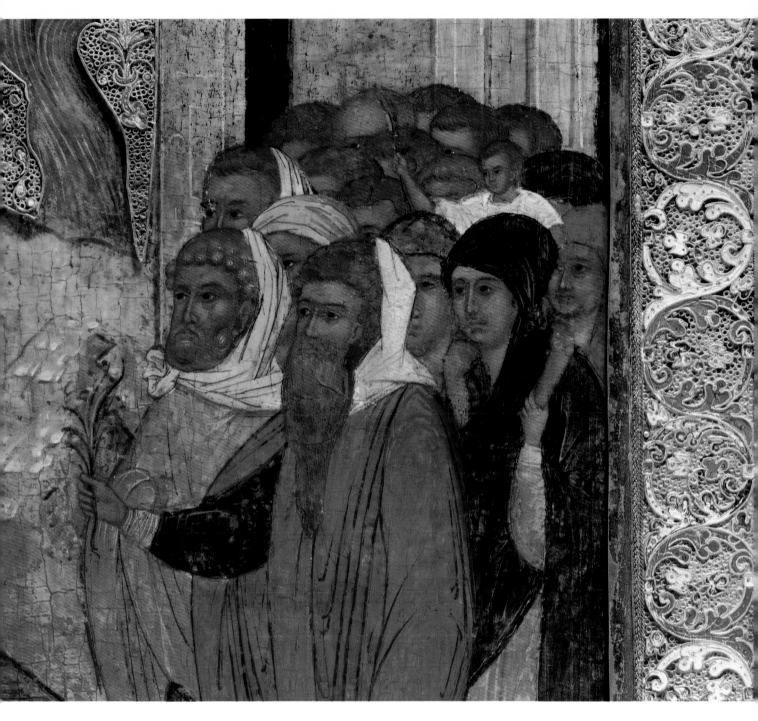

Detail of 9: *The people of Jerusalem*

9. *The Entry into Jerusalem*. Tempera on wood
with silver-gilt filigree and enameling. 1560s (see p. 141)

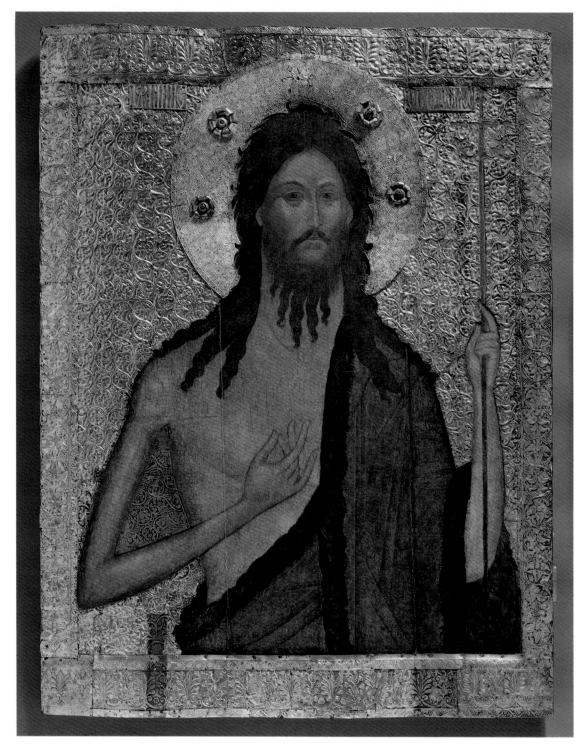

10. *John the Precursor*. Tempera on canvas over wood with
silver stamping, chasing, and filigree. 1560s (see p. 141)

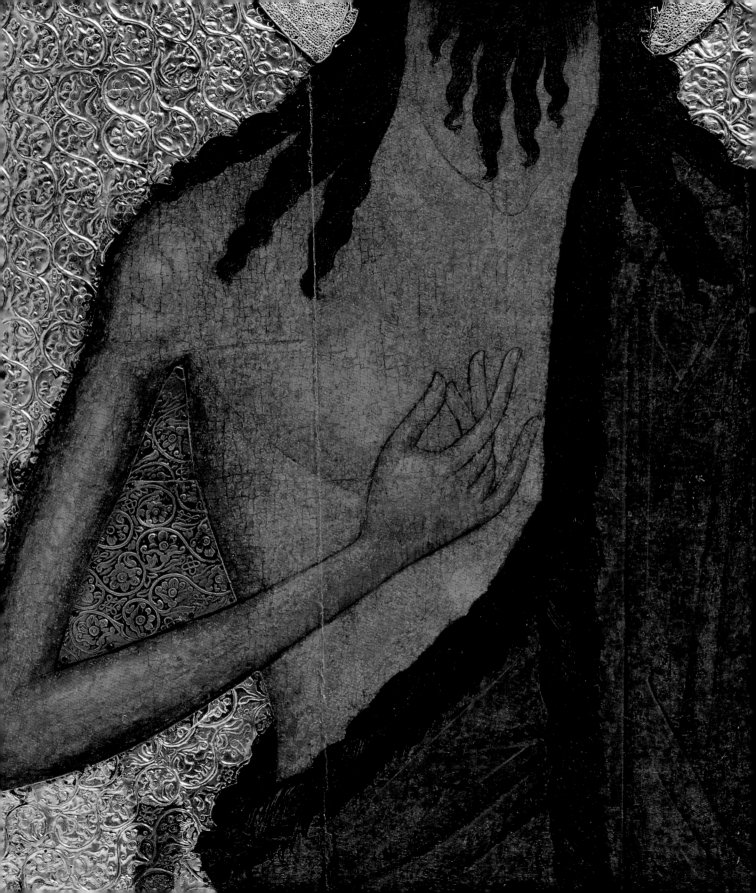

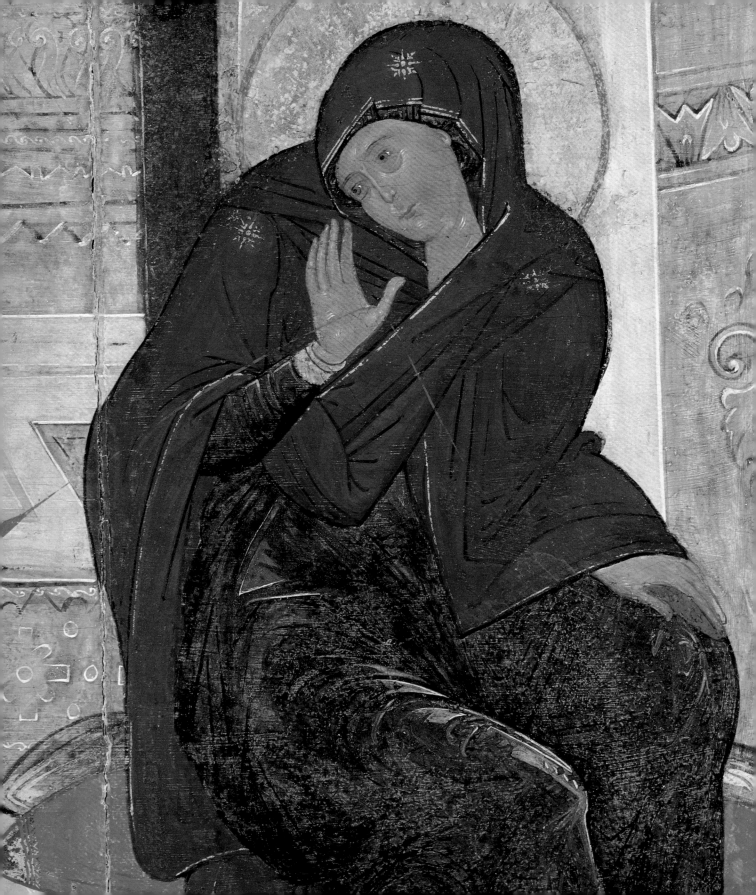

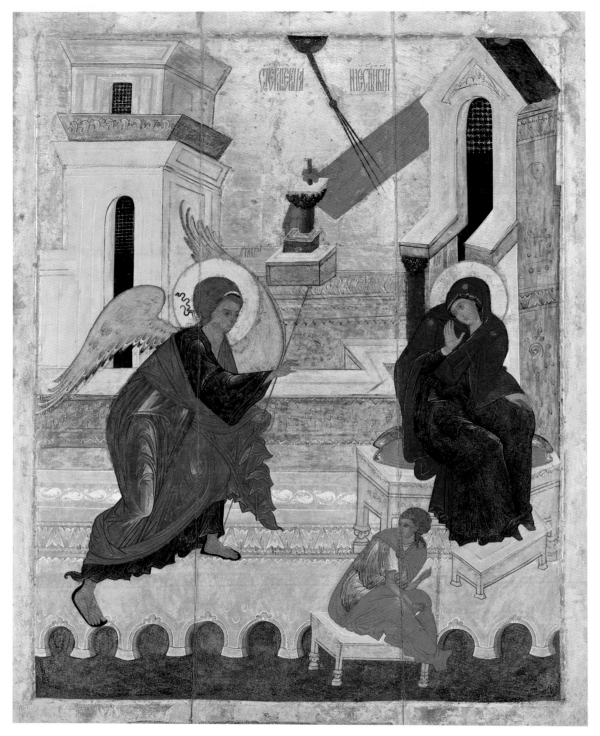

11. *The Annunciation*. Tempera on canvas over wood.
16th century (see p. 142)

(see p. 142)

Detail of 11: *The Virgin Annunciate*

12. *The Nativity of the Mother of God*. Tempera on wood.
First half of 16th century (see p. 142)

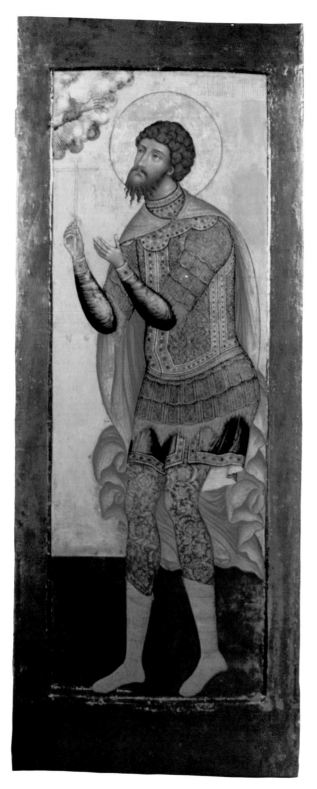

13. *St. Theodore Stratilates*. Tempera
on wood. 1676 (see p. 143)

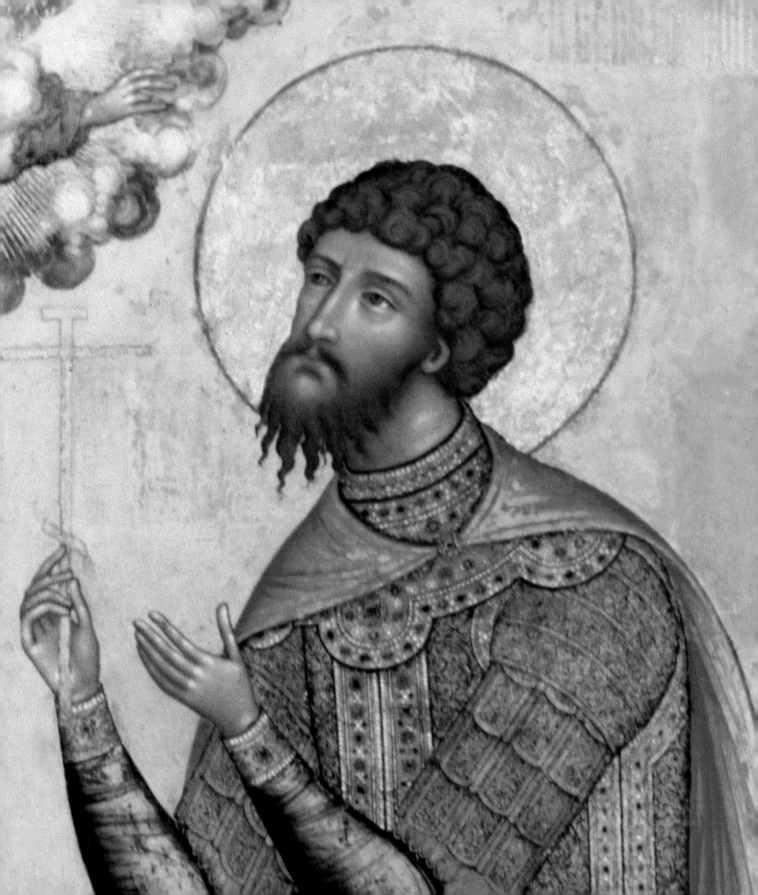

14. *St. John of Belogorod with the Czarevich Ivan Mikhailovich.*
Tempera on wood with chased silver-gilt mount.
Mid-17th century (see p. 144)

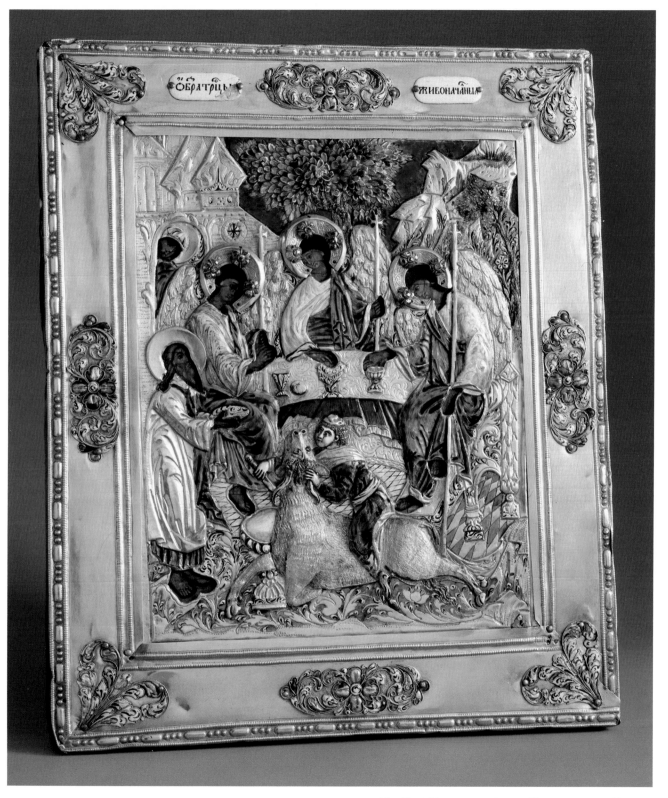

Detail of 15: *The slaughtering of the calf*

15. *The Old Testament Trinity*. Tempera on wood in gold chased and enameled frame set with jewels. Second half of 17th century (see p. 144)

49

Russian Gold and Silver

16. *Pair of gold rings worn on the temples*. Decorated with filigree and granulation. 12th century (see p. 154)

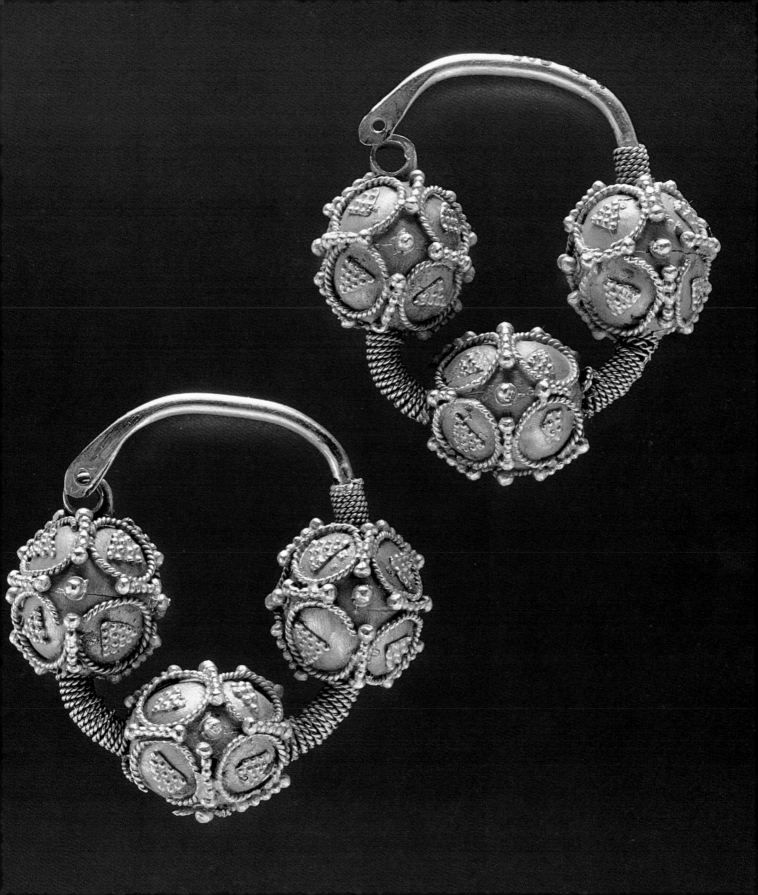

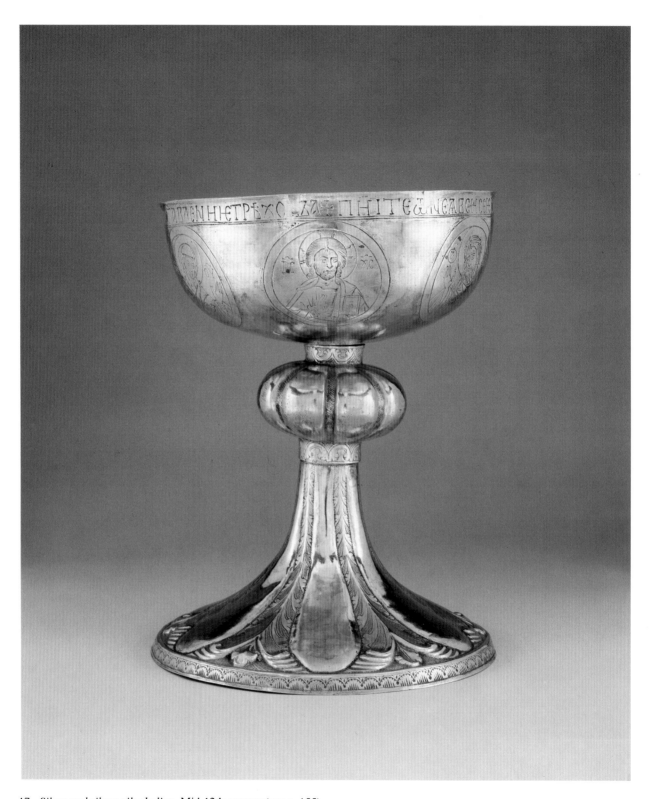

17. *Silver and silver-gilt chalice*. Mid-12th century (see p. 155)

Detail of 17: *Engraved roundel
depicting St. George the Martyr*

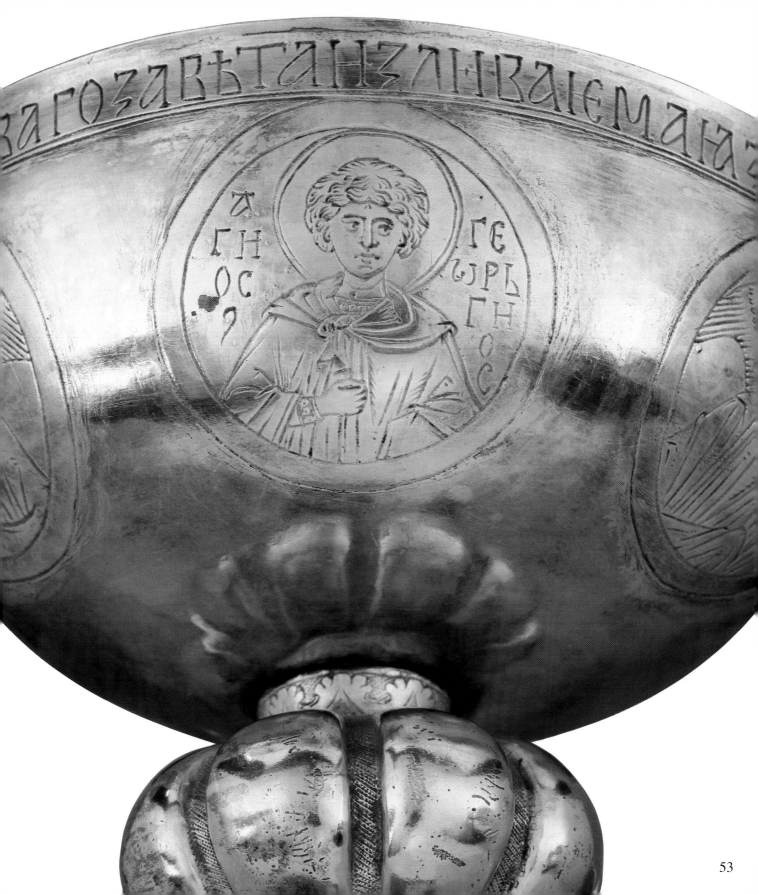

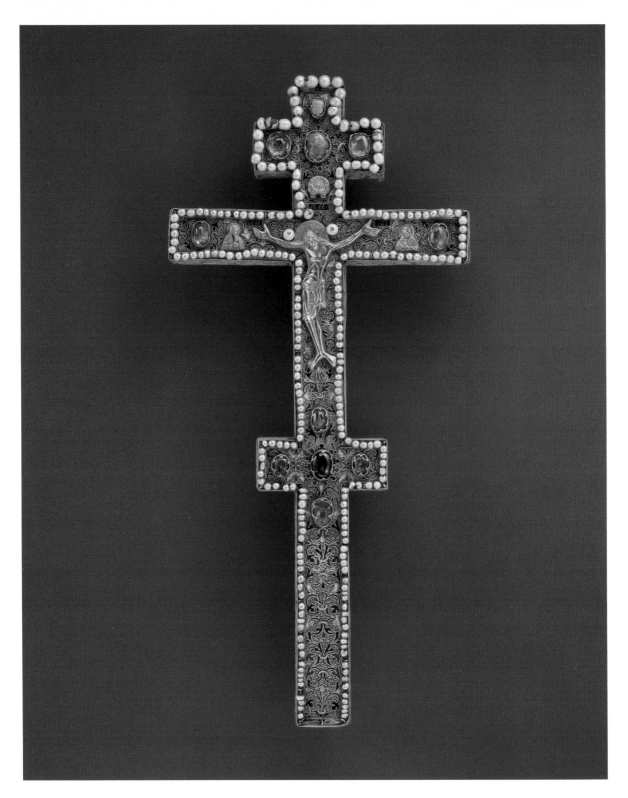

19. *Gold altar cross decorated with precious stones, pearls, filigree, and enameling.* 1562 (see p. 156)

20. *Altar Gospels in silver-gilt cover.* 1568 (see p. 156)

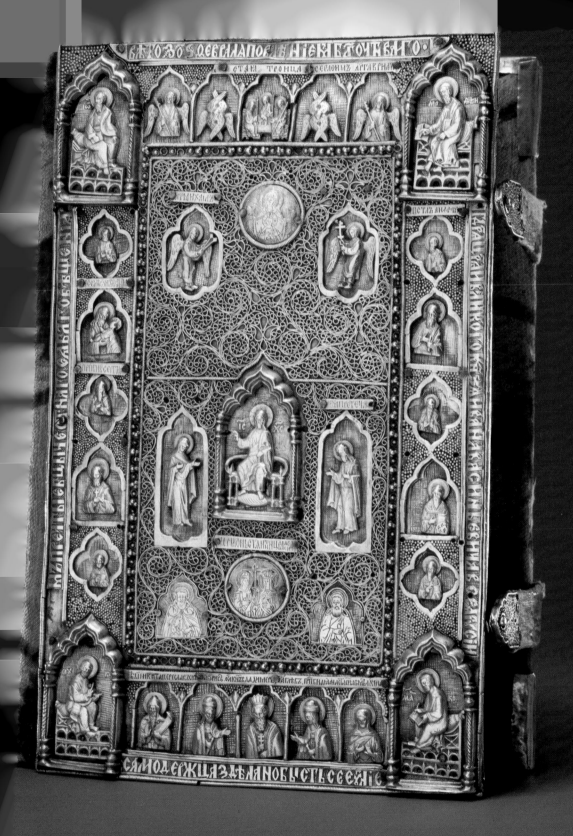

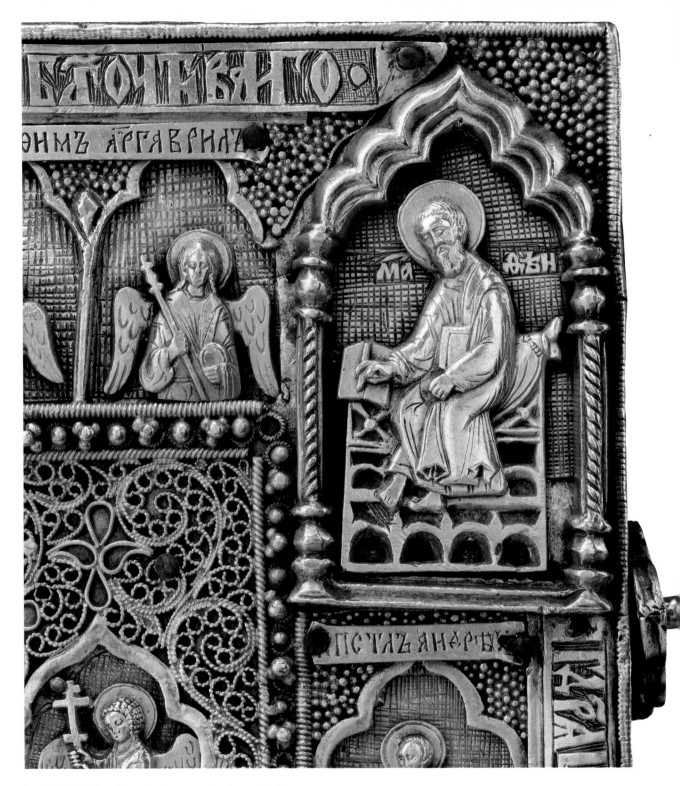

Detail of 20. *Altar Gospels: Reverse, showing symbol of the Evangelist Matthew*

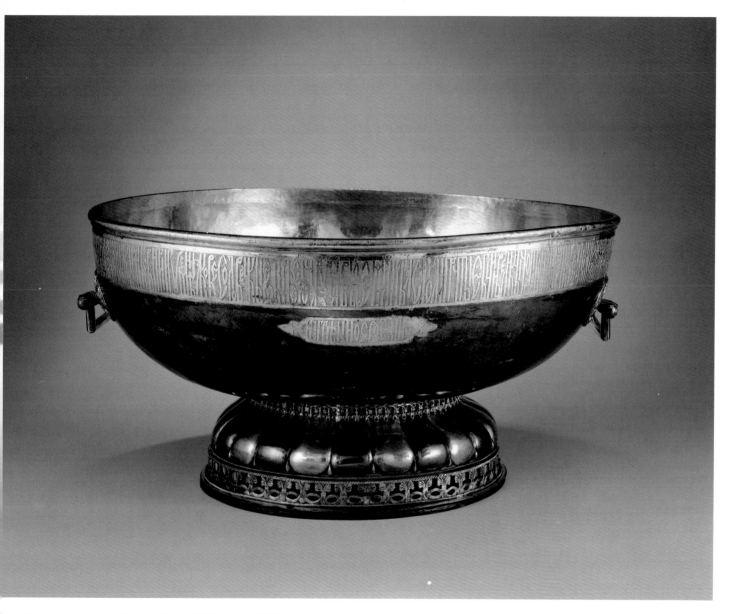

21. *Silver and copper holy water basin*. 1586 (see p. 157)

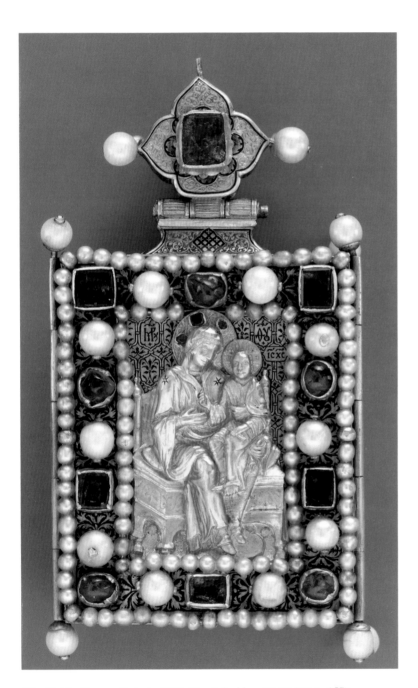

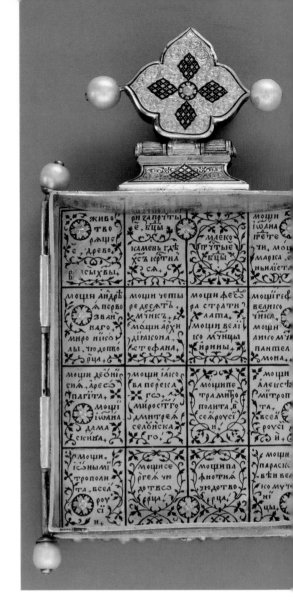

22. *Gold reliquary diptych*. 1589. Front, inside, reverse (see p. 157)

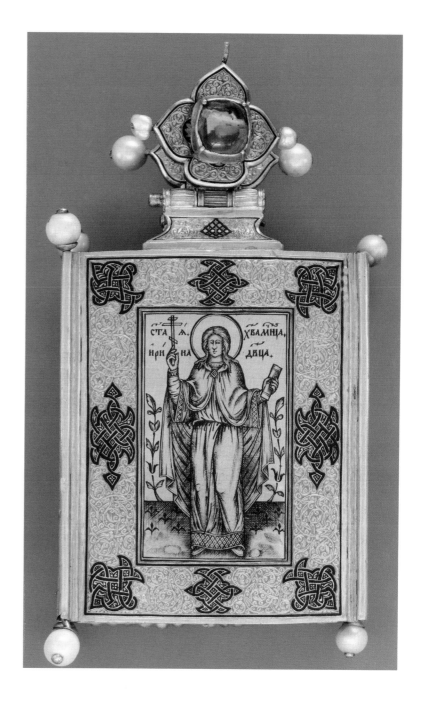

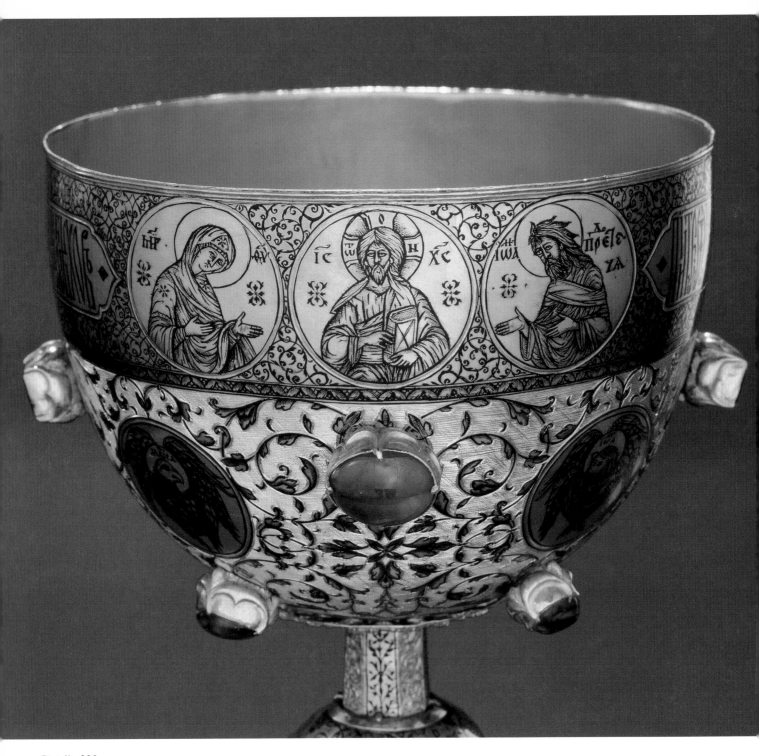

Detail of 23

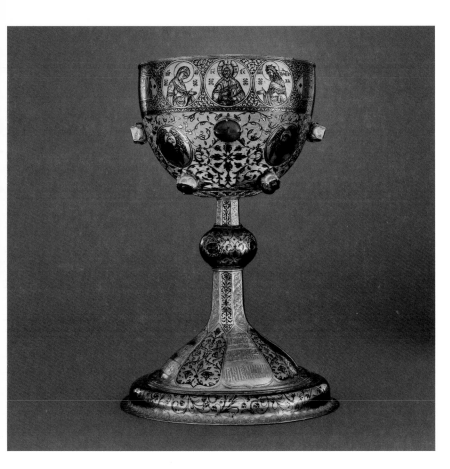

23. *Gold chalice decorated with niello and precious stones*. 1598 (see p. 158)

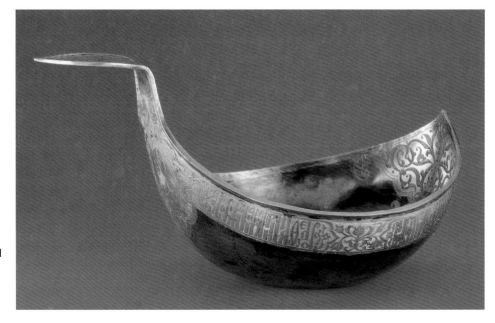

24. *Dipper (kovsh)*. Silver, engraved and gilded. Late 16th or early 17th century (see p. 158)

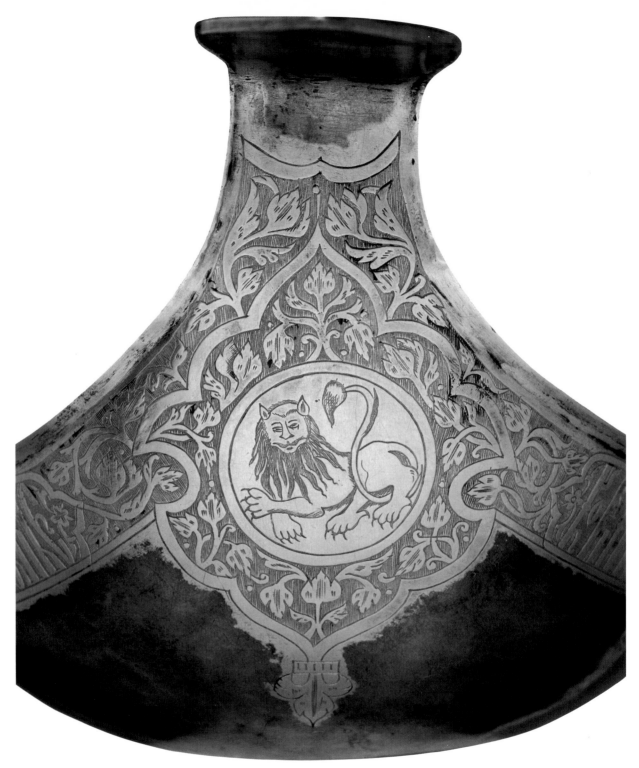

Detail of 24. *Dipper (kovsh)*

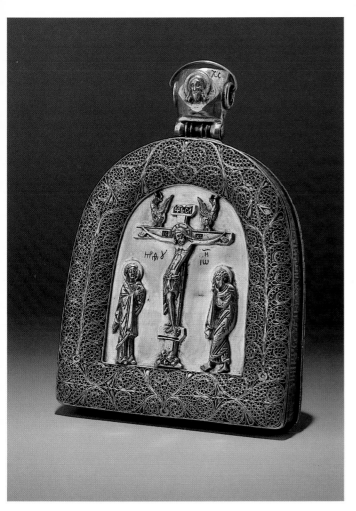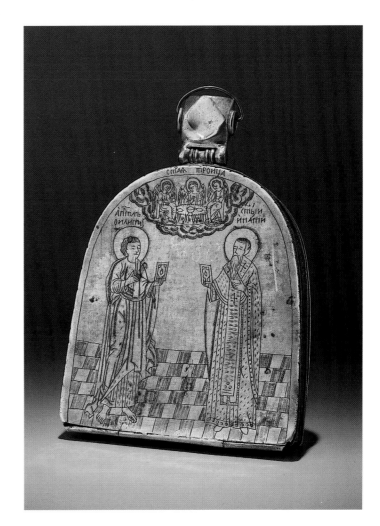

25. *Silver and silver-gilt pectoral icon (panagiia)*. Late 16th or
 early 17th century. Front, reverse (see p. 159)

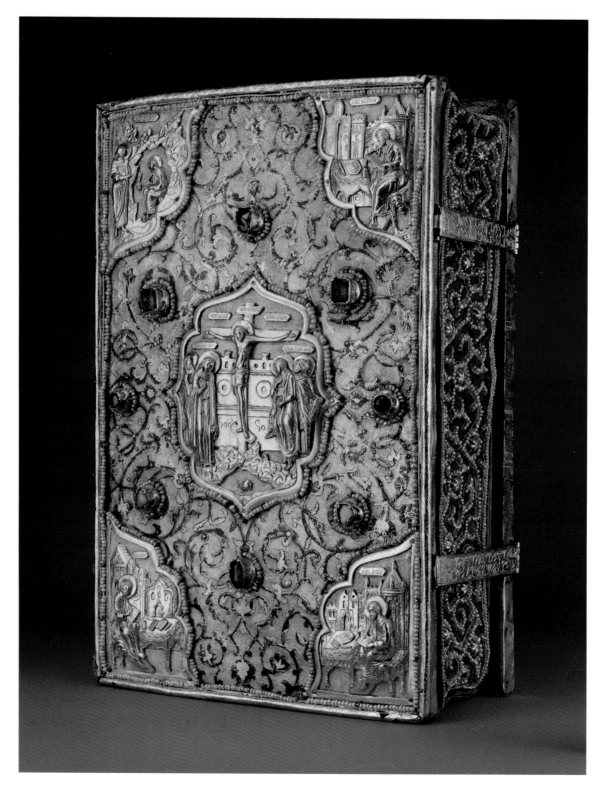

27. *Altar Gospels in decorated silver-gilt cover.*
 Cover: 17th century (see p. 160)

26. *Gospels. Manuscript page.*
Text: 16th century (see p. 159)

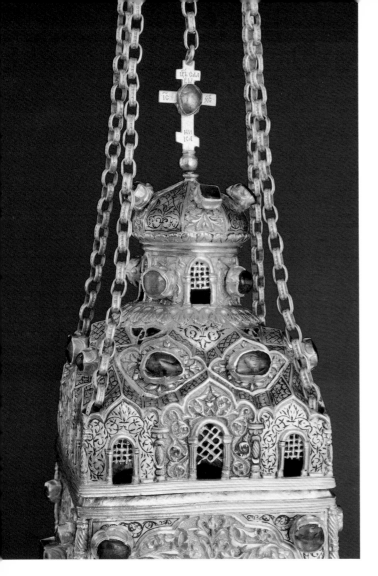

Detail of 28

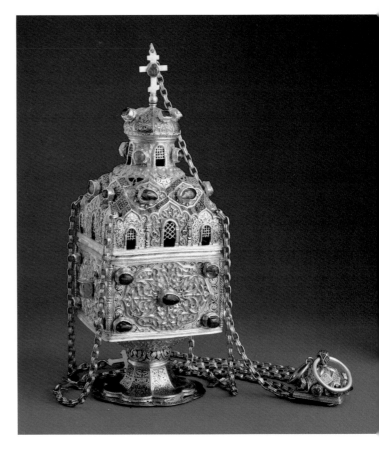

28. *Ornamented gold censer*. 1616 (see p. 160)

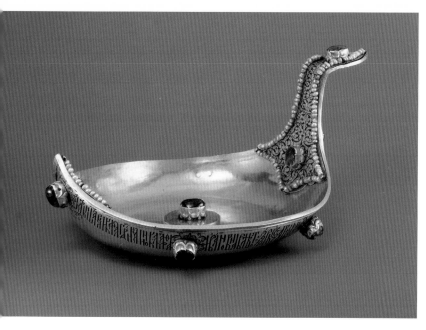

29. *Dipper (kovsh)*. Gold, nielloed and
set with pearls and precious stones.
1618 (see p. 161)

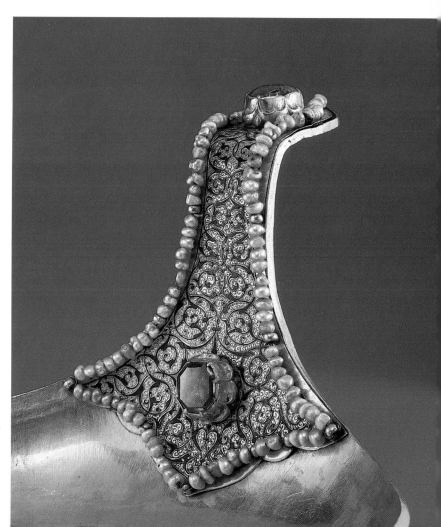

Detail of 29

32. *Engraved gold chain.*
 Before 1642 (see p. 162)

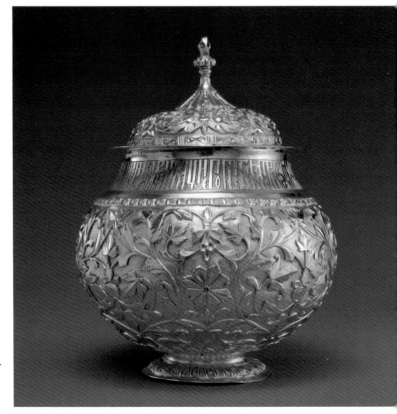

33. *Chased silver-gilt toasting bowl (brátina).*
 1642 (see p. 163)

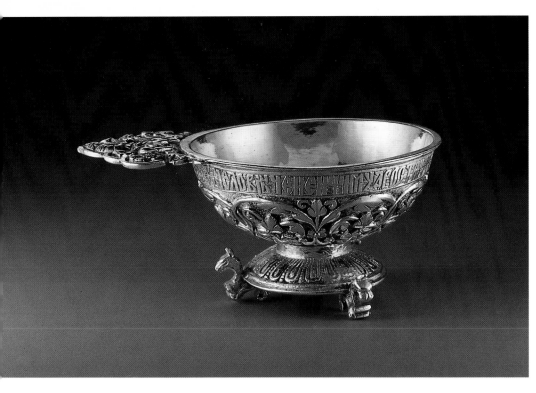

34. *Decorated silver-gilt cup (charka).*
 17th century (see p. 163)

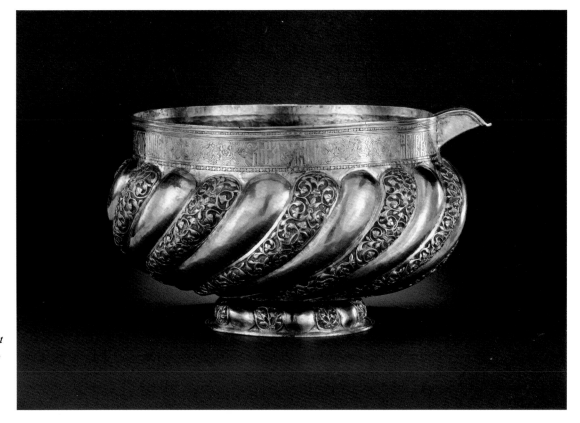

37. *Drinking bowl with spout
 (endová).* Silver, gilded,
 chased, and engraved.
 1644 (see p. 165)

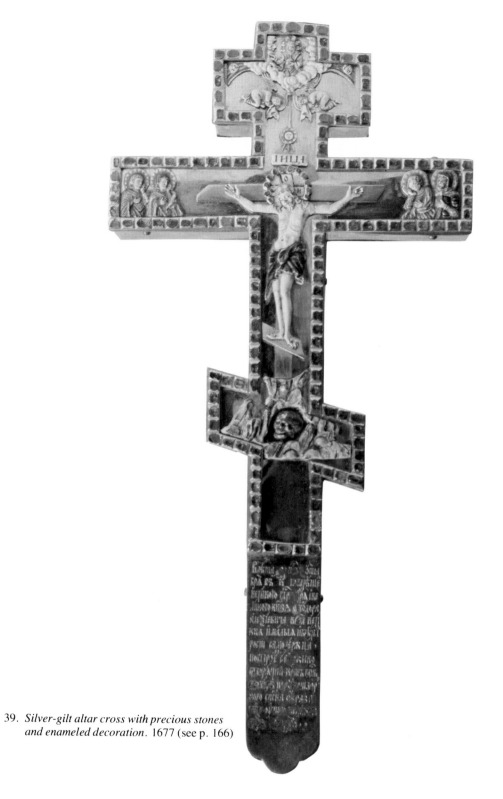

39. *Silver-gilt altar cross with precious stones
 and enameled decoration*. 1677 (see p. 166)

40. *"Cap of Monomach"* ▷
 from the minor robes of state.
 Gold, with pearls, precious stones,
 and sable. 1682-84 (?) (see p. 166)

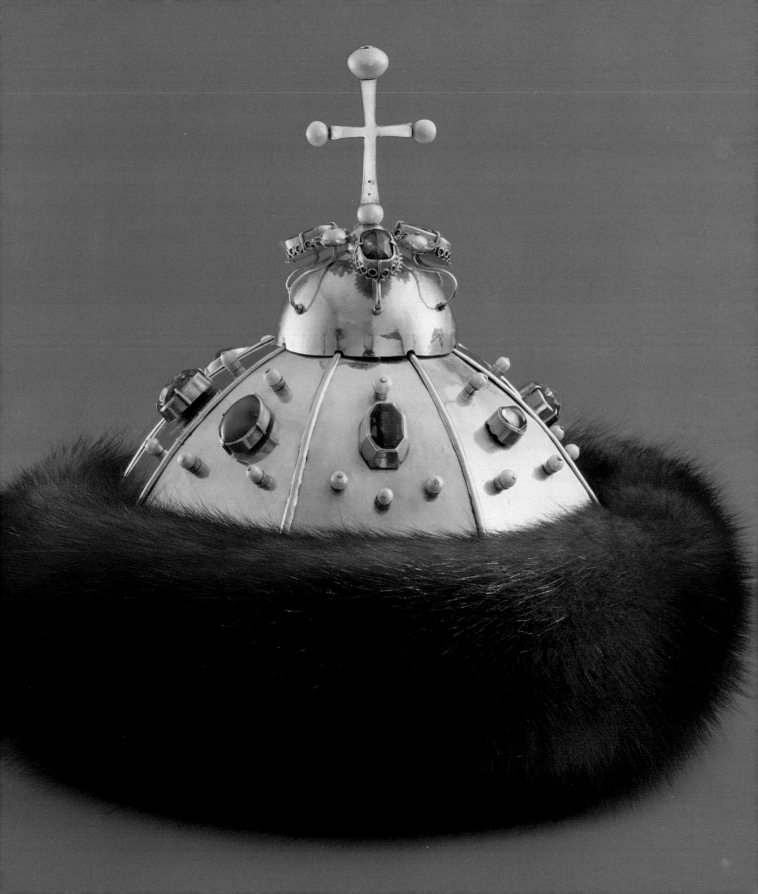

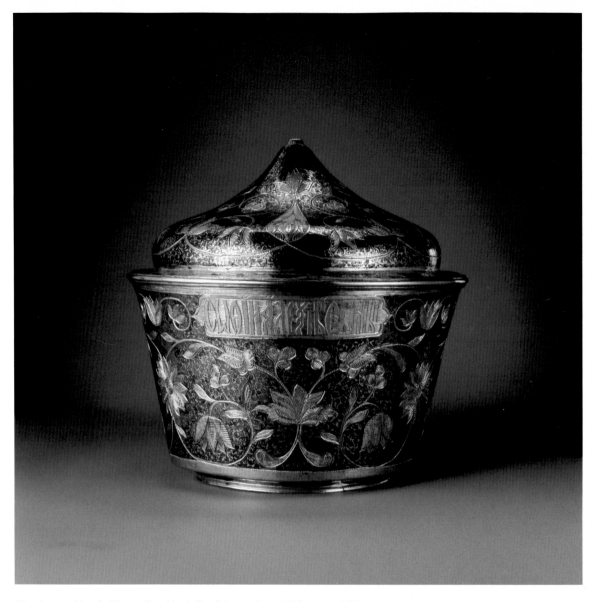

41. *Covered bowl*. Silver gilt with nielloed decoration. 1685 (see p. 167)

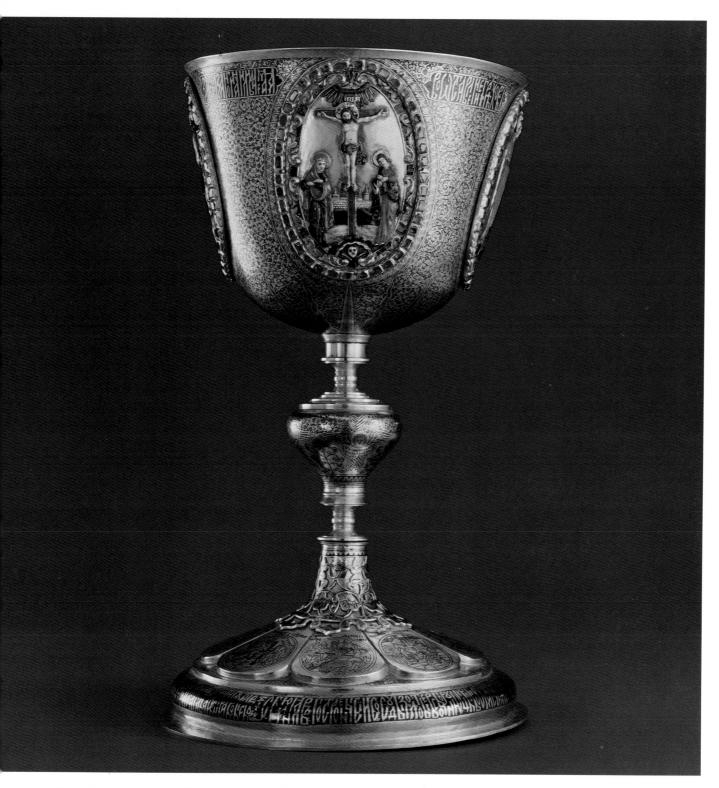

. Gold chalice with enameled and nielloed decoration. 1695 (see p. 168)

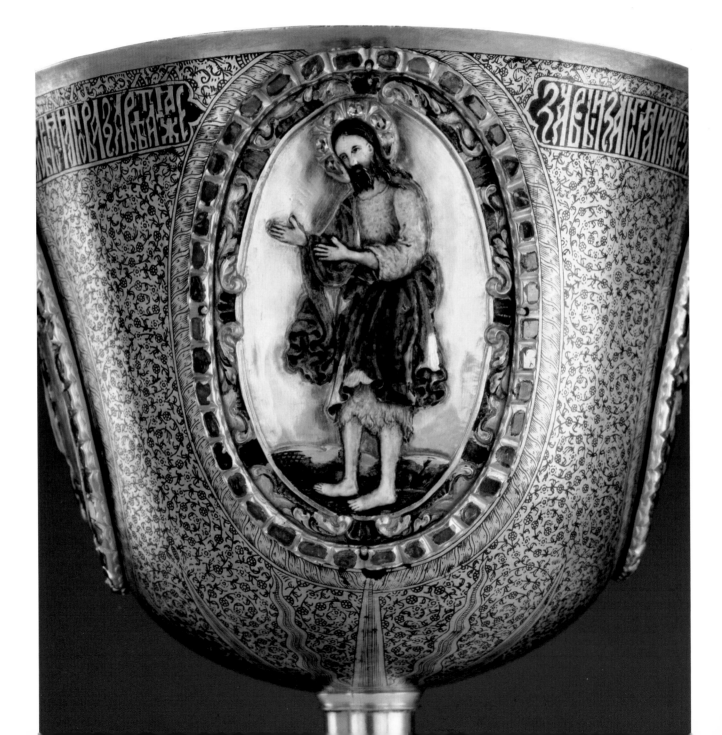

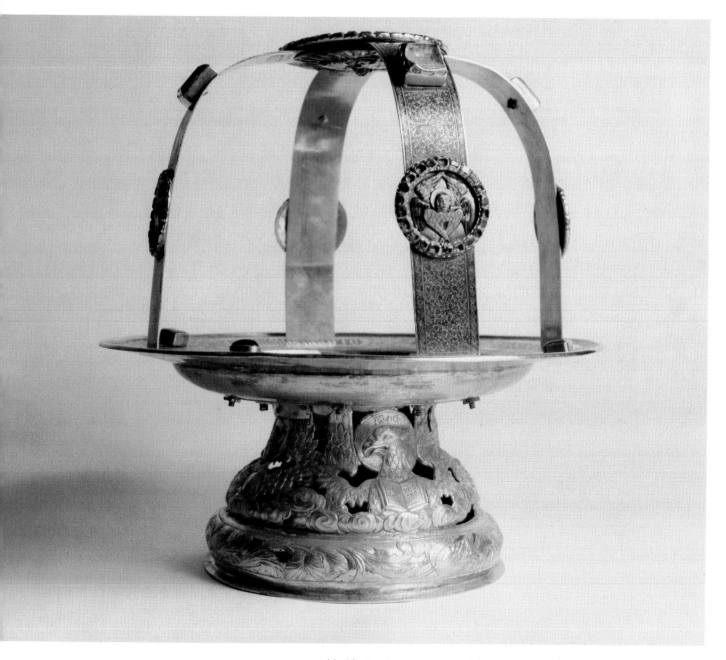

44, 46. *Paten and star-shaped frame to support the veil over communion bread.*
Chased gold and silver with precious stones and enameled and nielloed
decoration. Paten: late 17th century. Frame: 1695 (see p. 169)

etail of 43. *Chalice: Medallion depicting Christ*

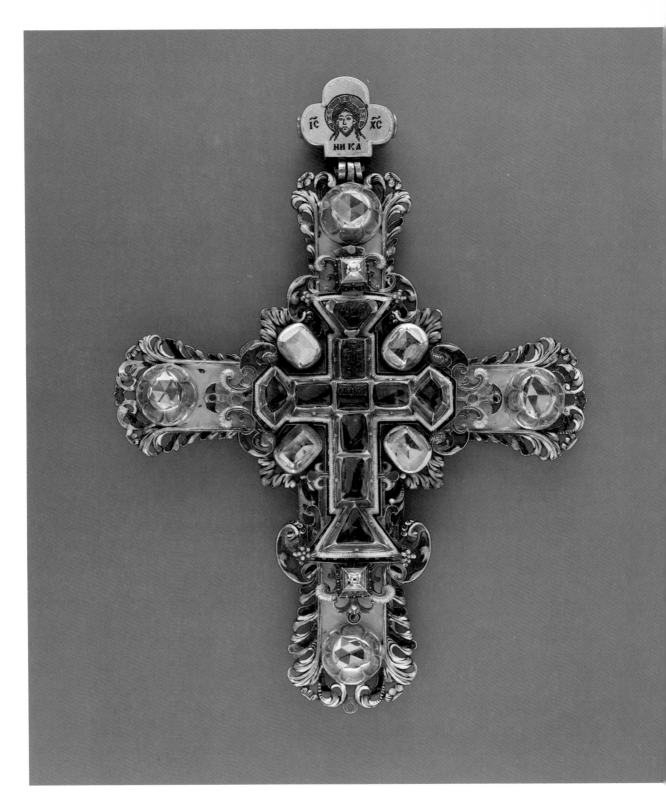

45. *Gold pectoral cross with precious stones and enameling.*
Last quarter of 17th century. Front, reverse (see p. 168)

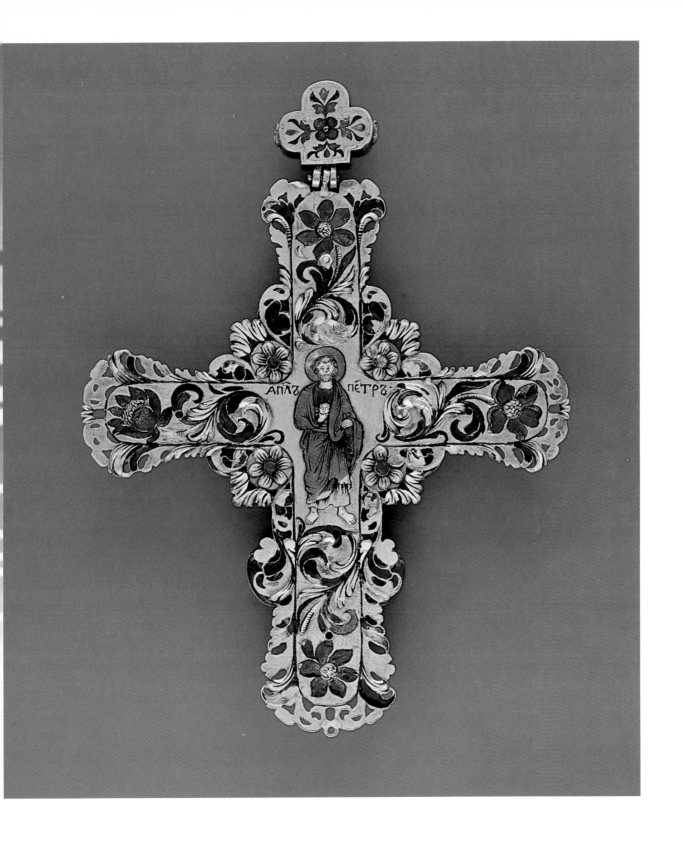

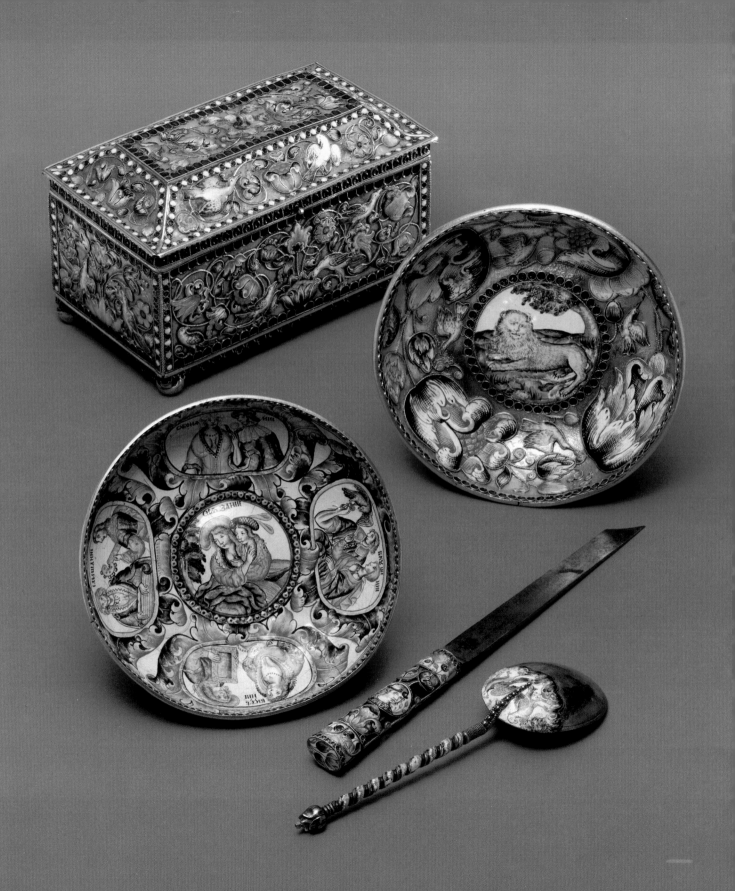

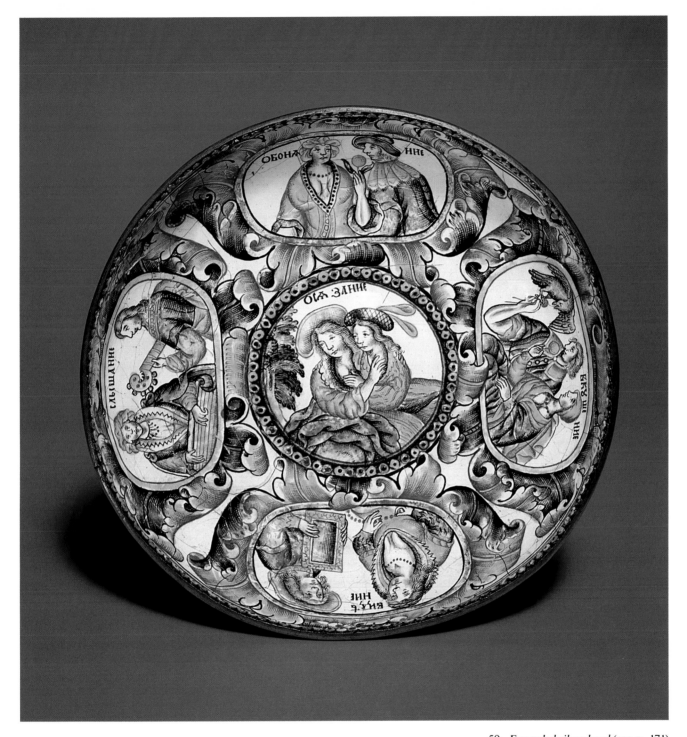

50. *Enameled silver bowl* (see p. 171)

◁ 47-51. *Enameled spoon, knife, bowls, and casket.*
Late 17th century (see pp. 170, 171)

79

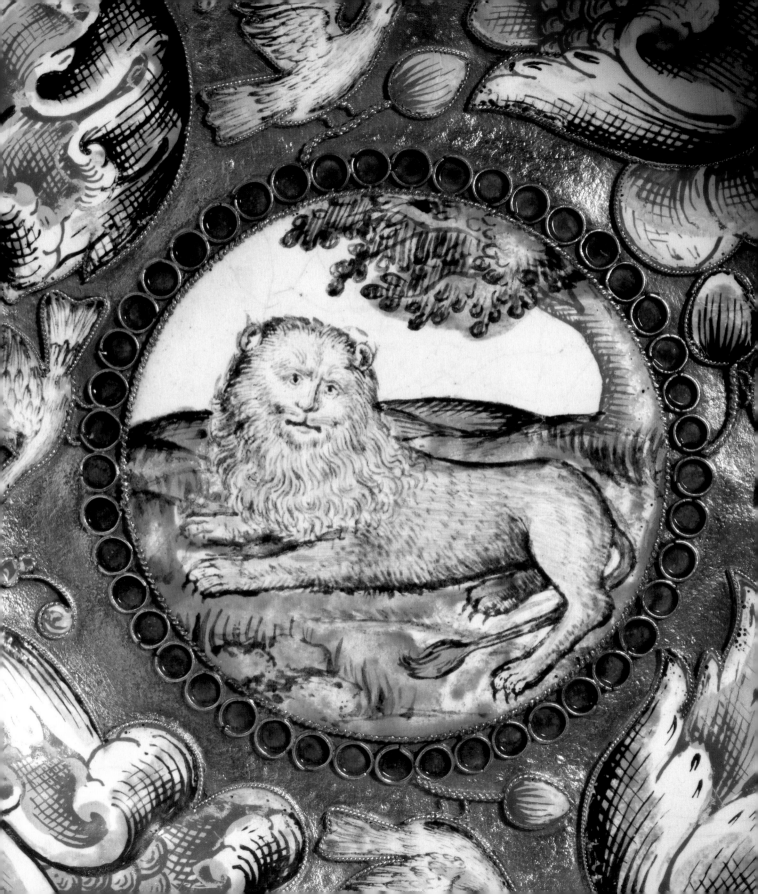

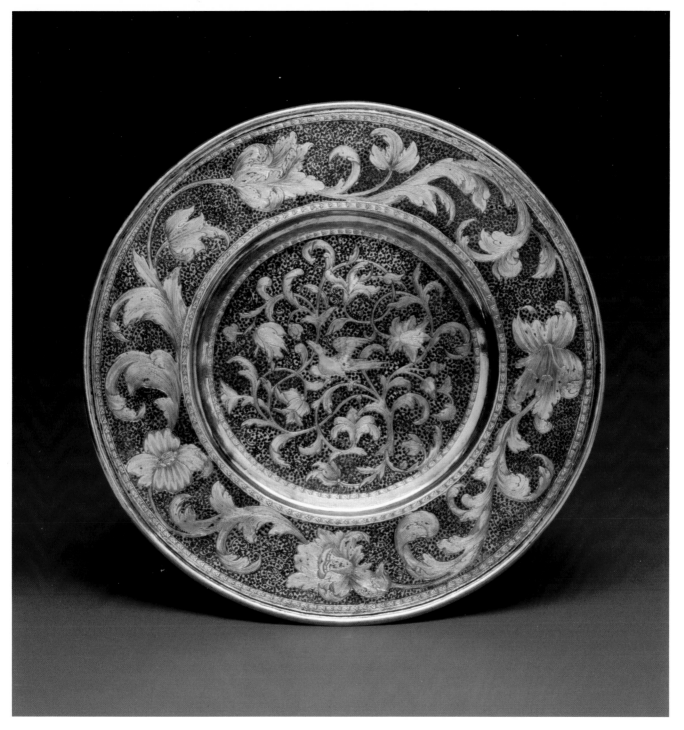

52. *Silver-gilt plate decorated with niello and engraving.*
Late 17th century (see p. 172)

Detail of 49. *Enameled silver-gilt bowl:*
Roundel depicting lion (see p. 170)

53. *Silver soup tureen with chased and filigreed decoration.* 1737 (see p. 172)

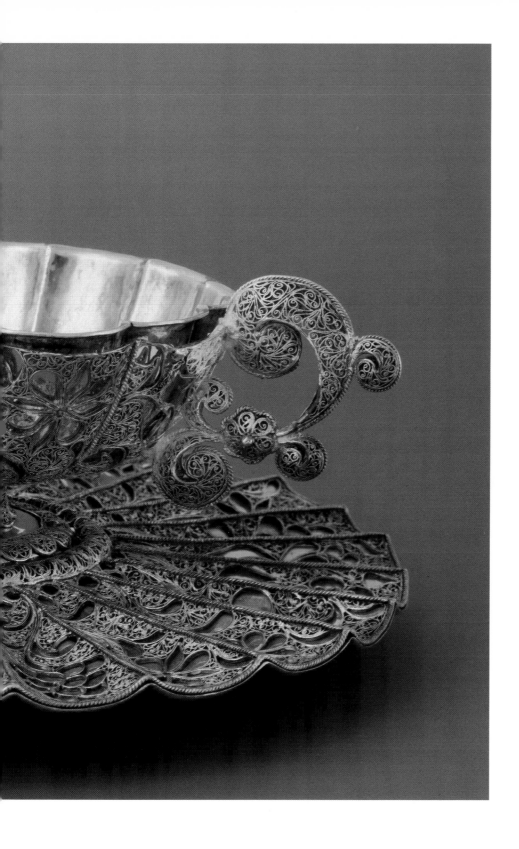

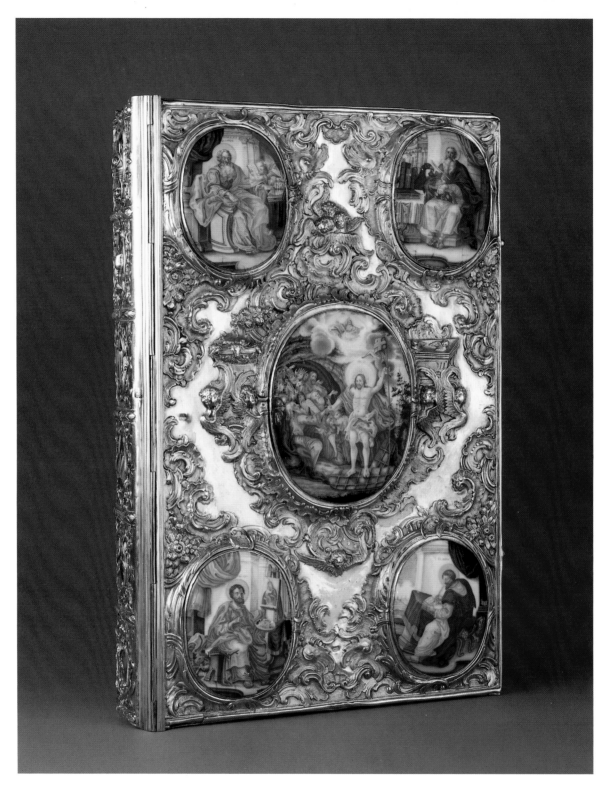

54. *Altar Gospels in silver-gilt cover with enameled medallions.*
 Cover: 1772. Text: 1681 (see p. 173)

Detail of cover of 54: *The Descent into Hell*

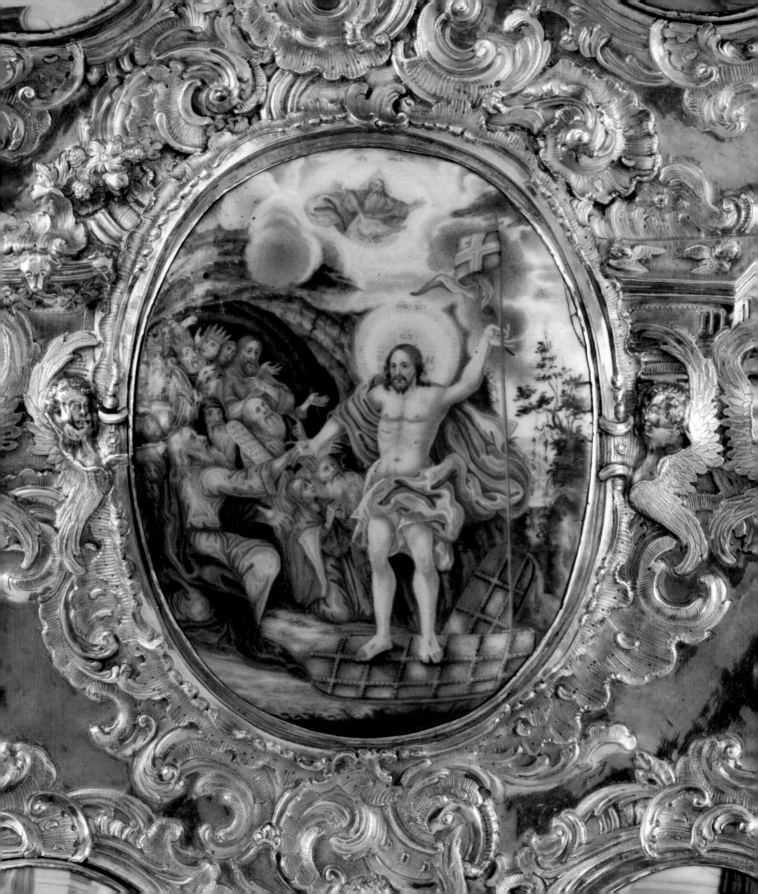

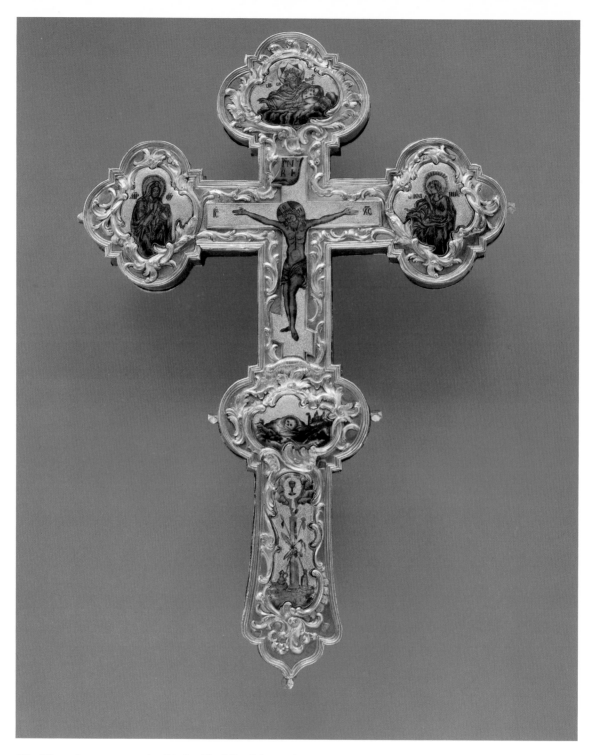

55. *Silver altar cross, partly gilded, with nielloed decoration.*
1774 (see p. 173)

Detail of 55: *Nielloed depiction of
St. John the Evangelist*

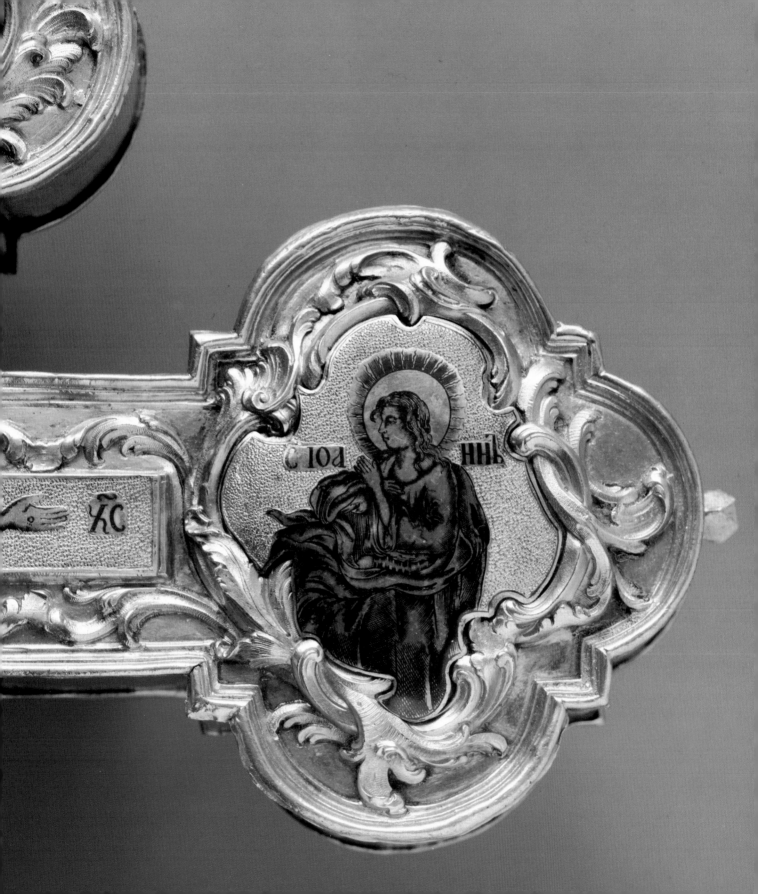

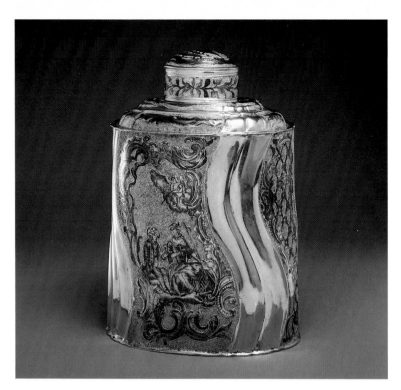

57. *Chased silver-gilt tea caddy with nielloed
 decoration.* 1776 (see p. 174)

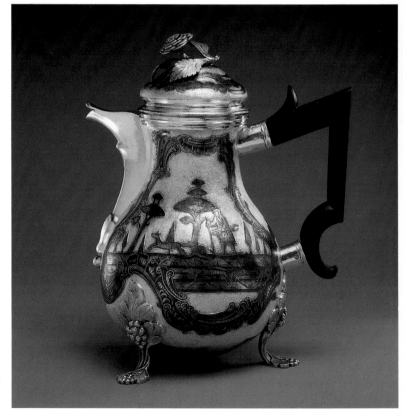

58. *Silver-gilt coffeepot with rocaille and
 nielloed decoration.* 1779 (see p. 175)

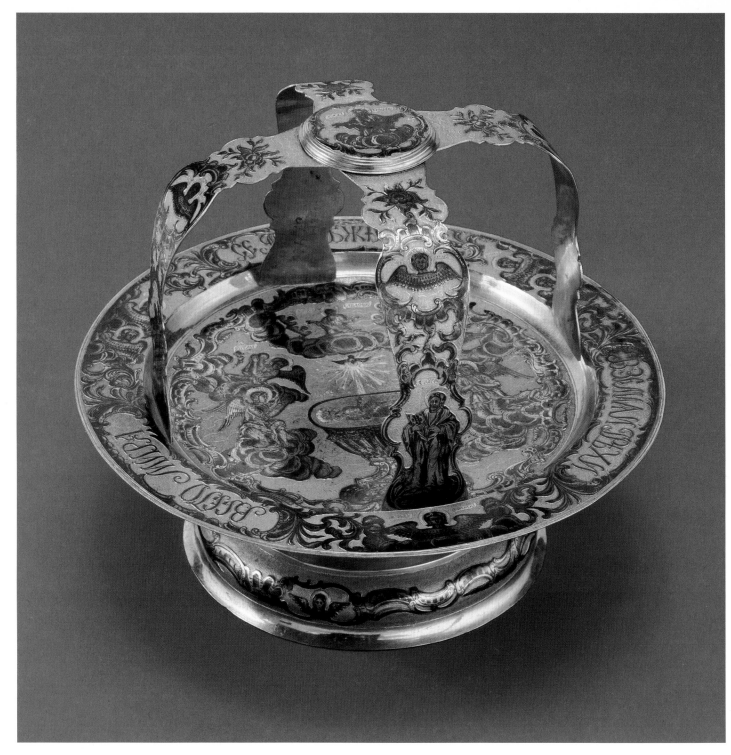

59,60. *Silver and silver-gilt paten and star-shaped frame to support the veil over communion bread.* Nielloed decoration. 1770s (see p. 175)

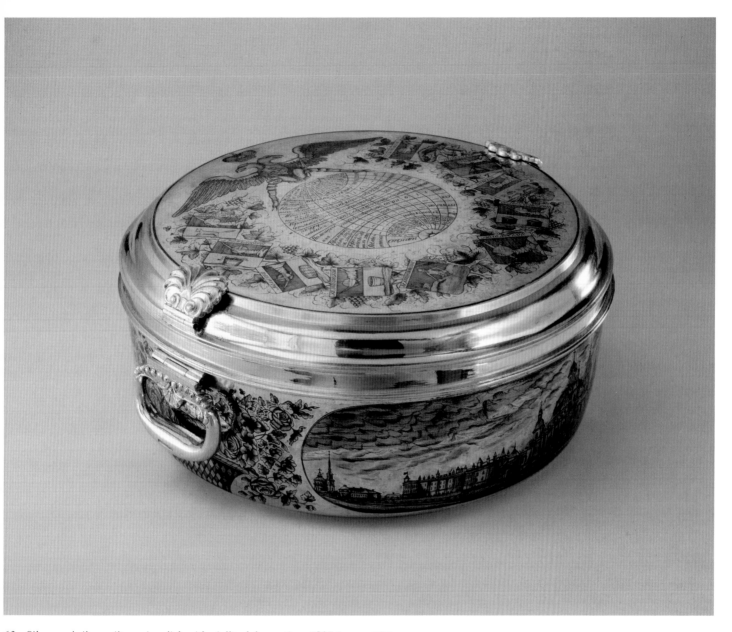

63. *Silver and silver-gilt serving dish with nielloed decoration*. 1837 (see p. 177)

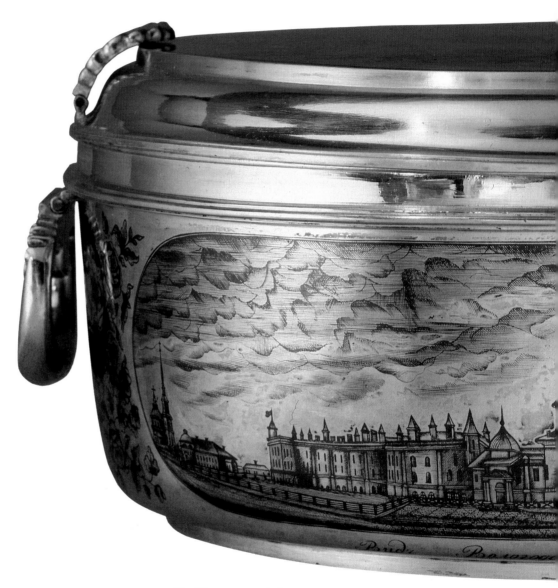

63. *Silver serving dish.*
 Nielloed depiction of the town of Vologda

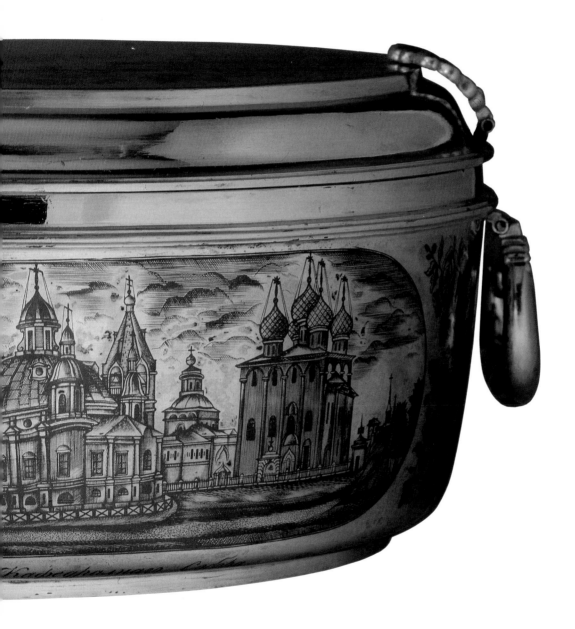

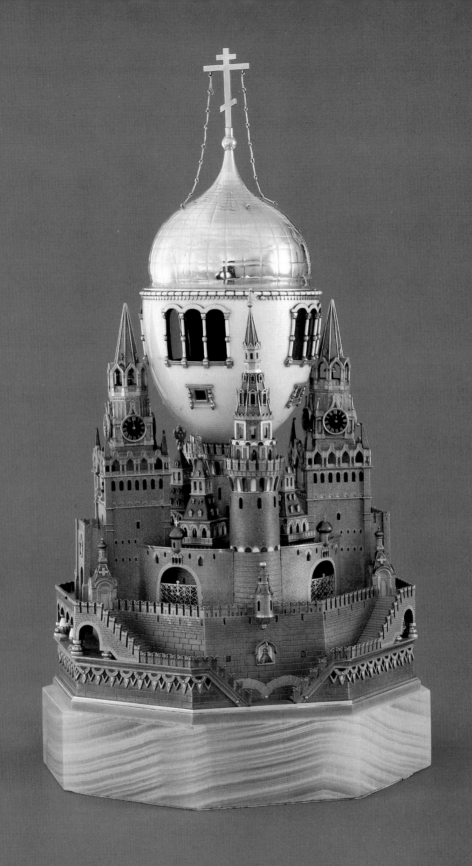

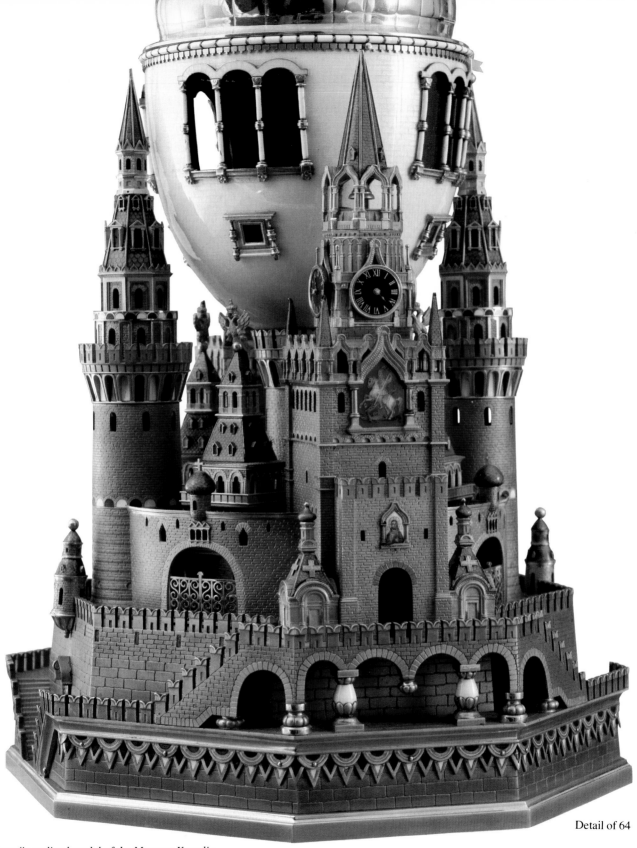

Detail of 64

64. *Fabergé's stylized model of the Moscow Kremlin.*
Precious metals, enameled, engraved, and painted. 1904 (see p. 177)

95

Arms and Armor

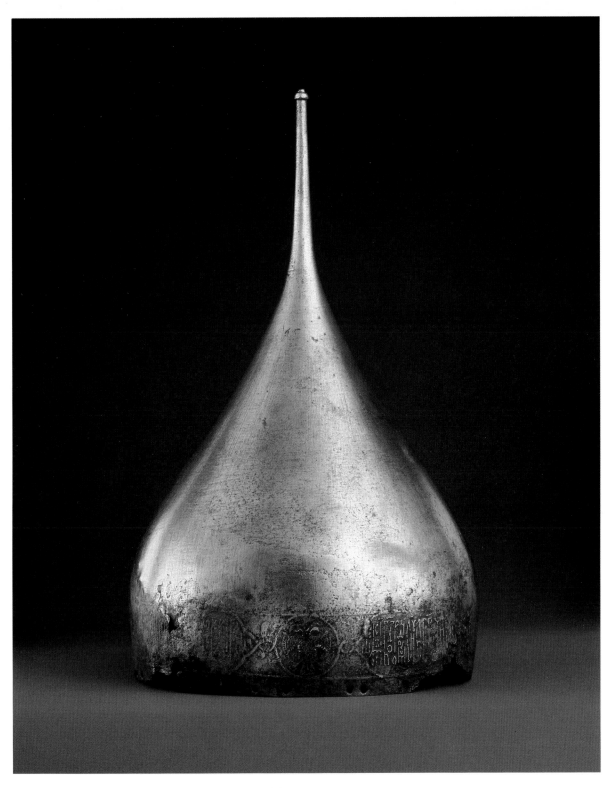

65. *Steel helmet (shishak) of the son of Ivan the Terrible.*
 1557 (see p. 183)

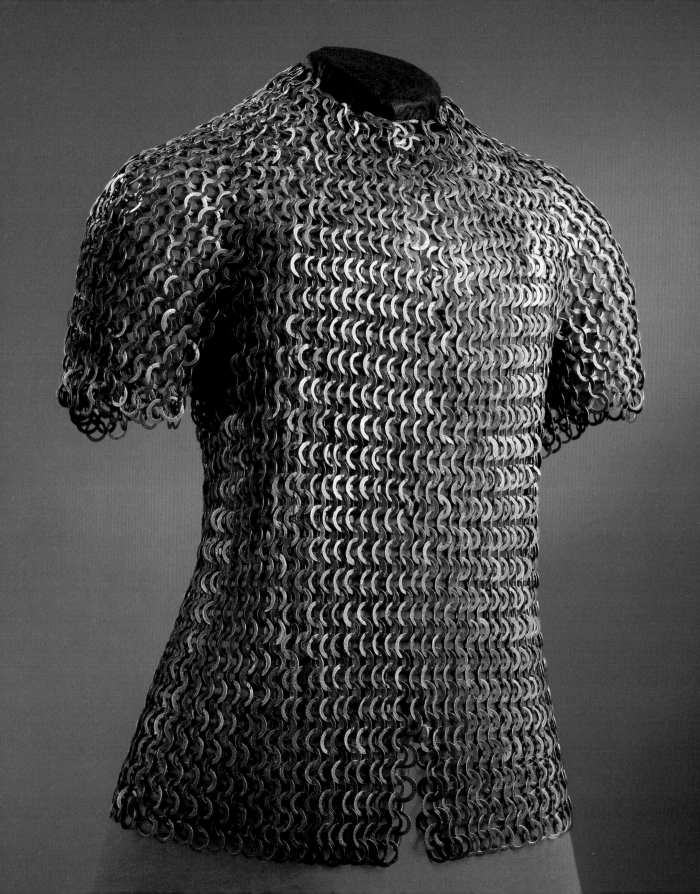

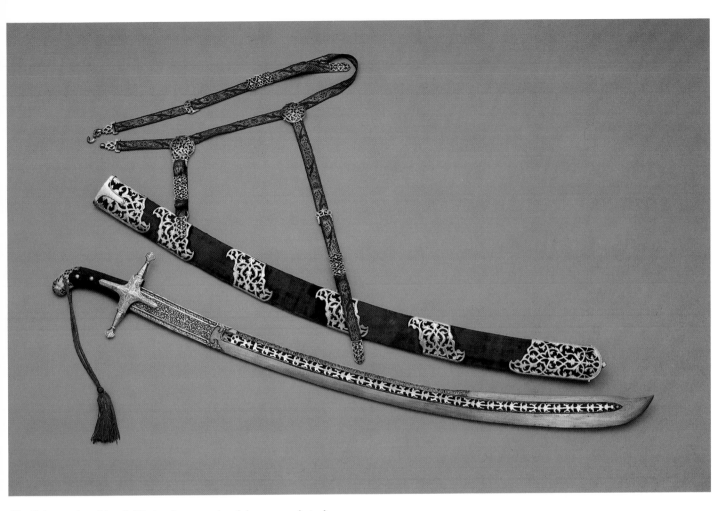

68. *Saber and scabbard*. Blade of engraved and damascened steel;
hilt and scabbard covered in green velvet. 1618 (see p. 185)

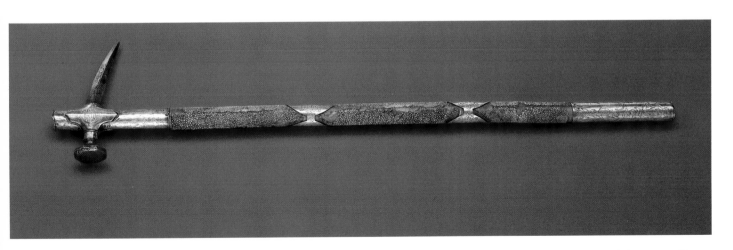

69. *Battle hammer (chekan) of gold-damascened iron*.
Second half of 17th century (see p. 185)

66. *Coat of iron chain mail (baydàna)*
once belonging to Boris Godunov.
Late 16th century (see p. 184)

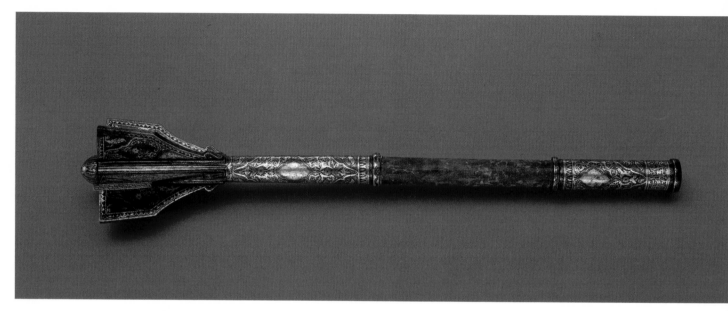

70. *Iron parade mace (shestoper) with gold-damascened
ornamentation.* 1660s (see p. 185)

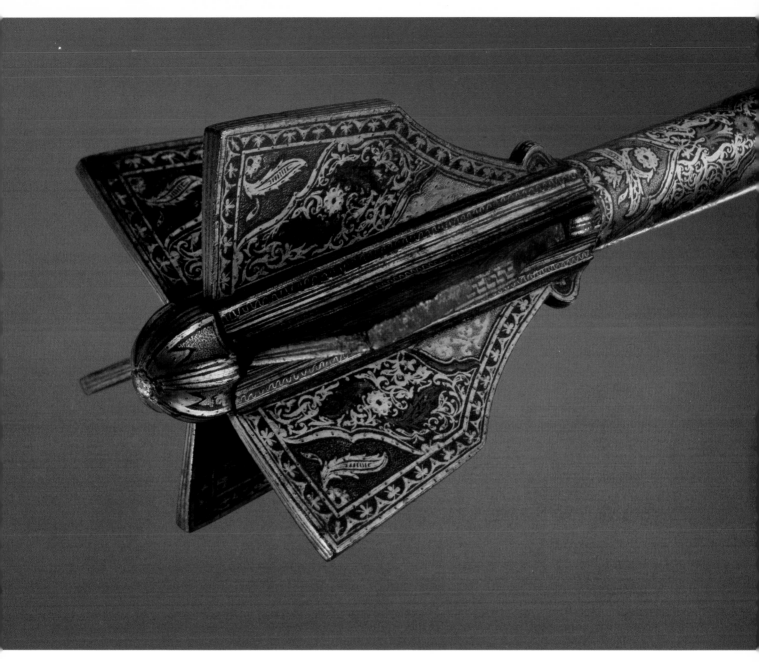

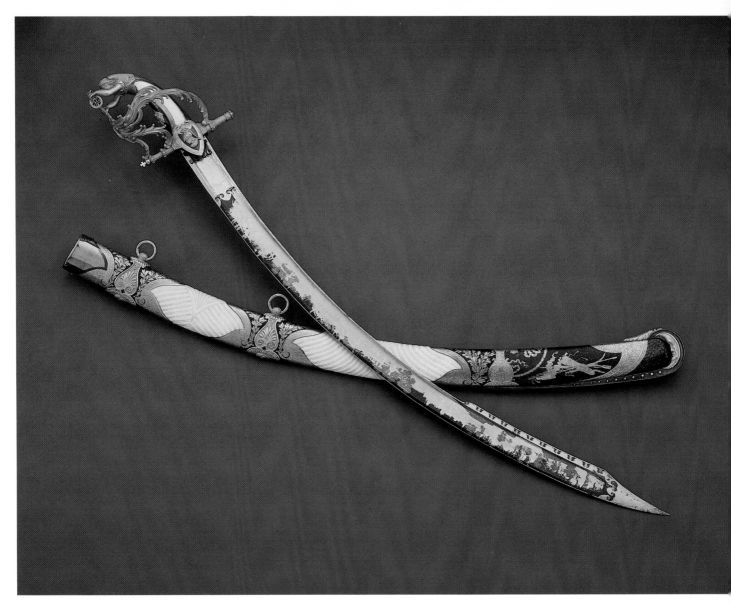

76. *Steel saber and scabbard.* 1829 (see p. 188)

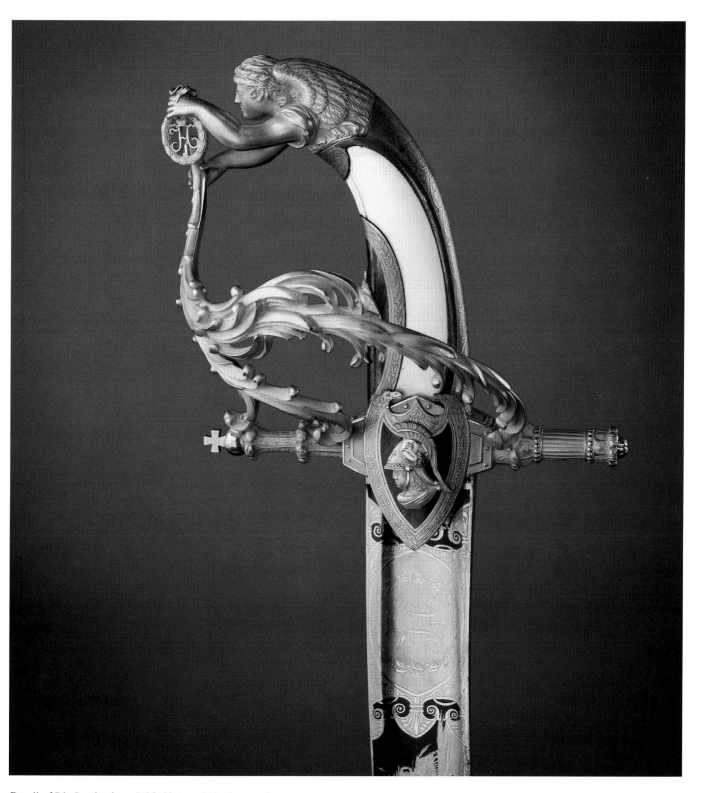

Detail of 76. *Steel saber: Gilded hilt with the figure of Victory*

Overleaf: Detail of 76: Blade decorated with a scene of ▷
the siege and storming of the fortress of Varna

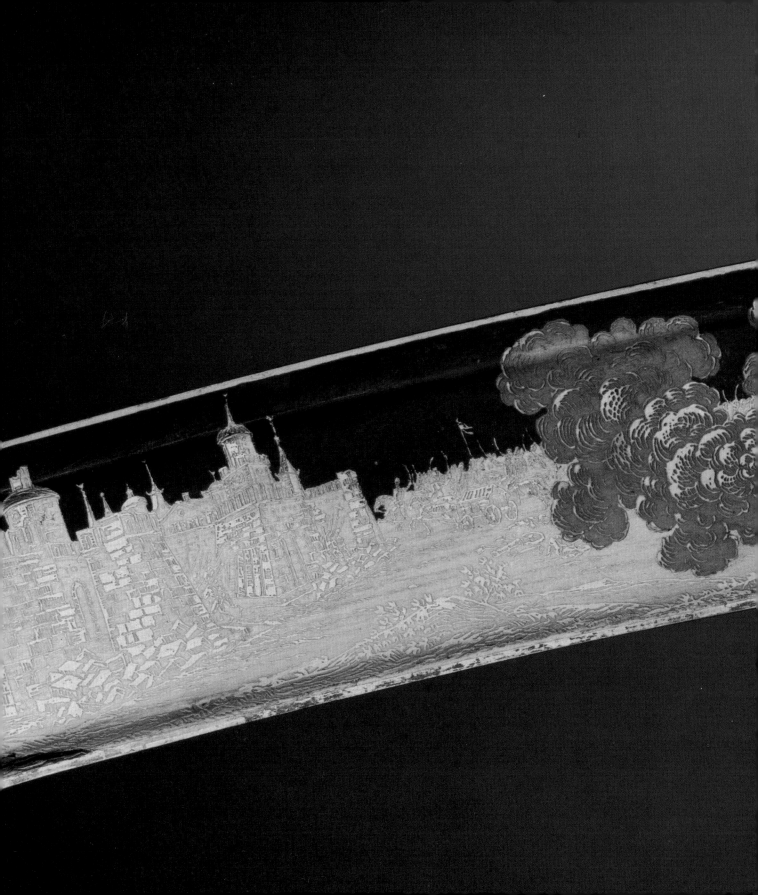

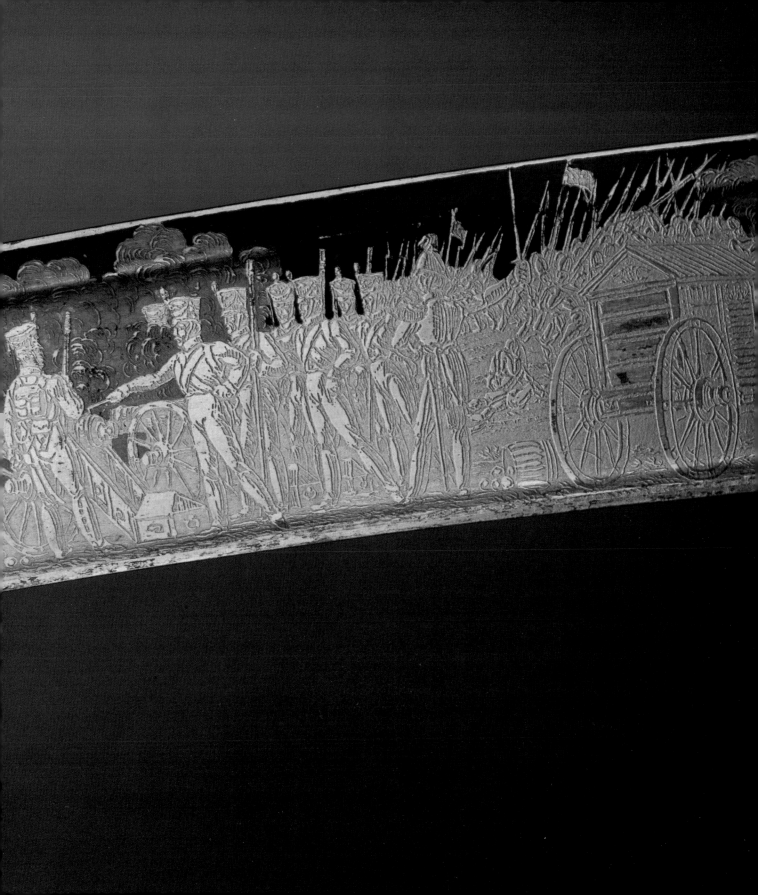

Ceremonial Equestrian Accessories

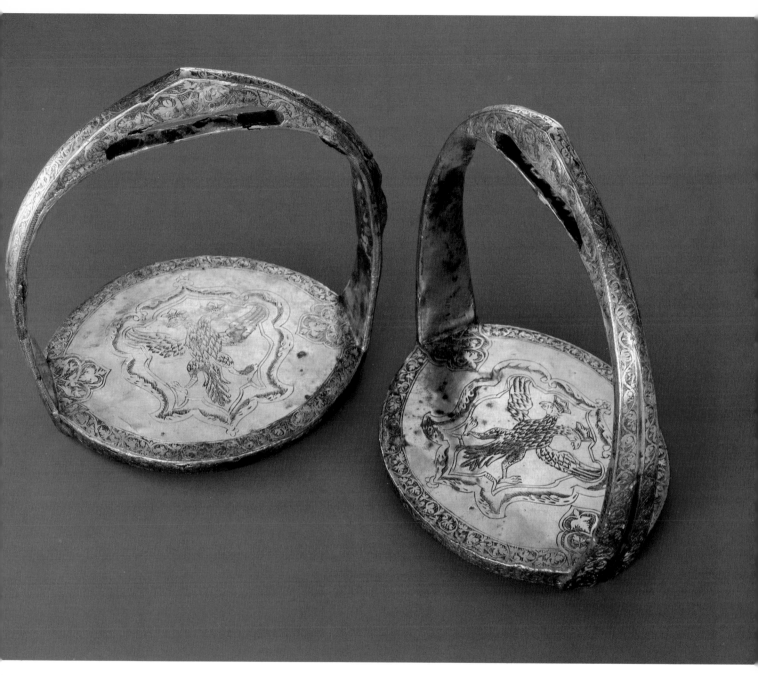

Pair of iron stirrups mounted in silver.
Second half of 17th century (see p. 193)

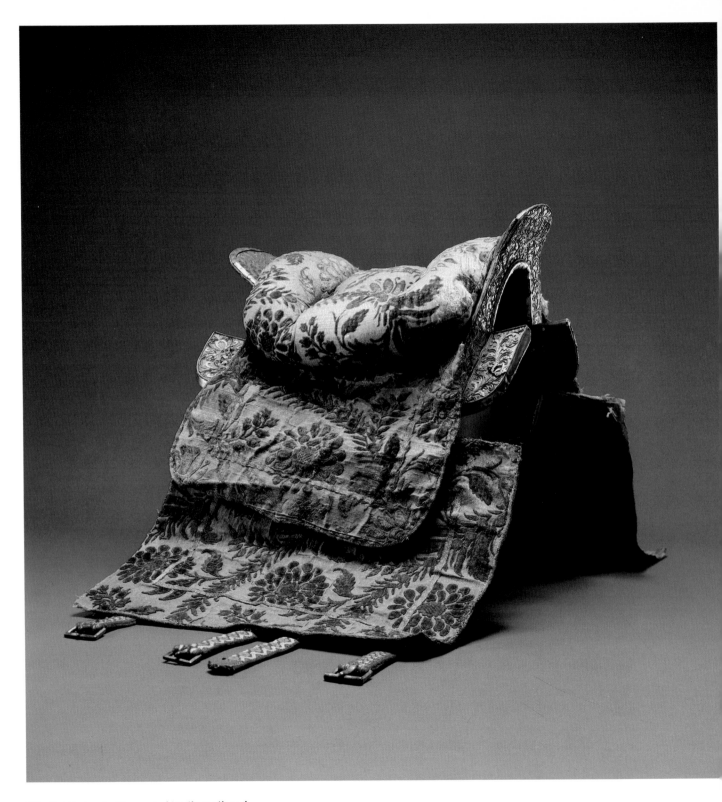

80. *Saddle (archak) mounted in silver gilt and covered in velvet.* 1682 (see p. 193)

Detail of 80: *Enameled and filigreed decoration on saddle bow*

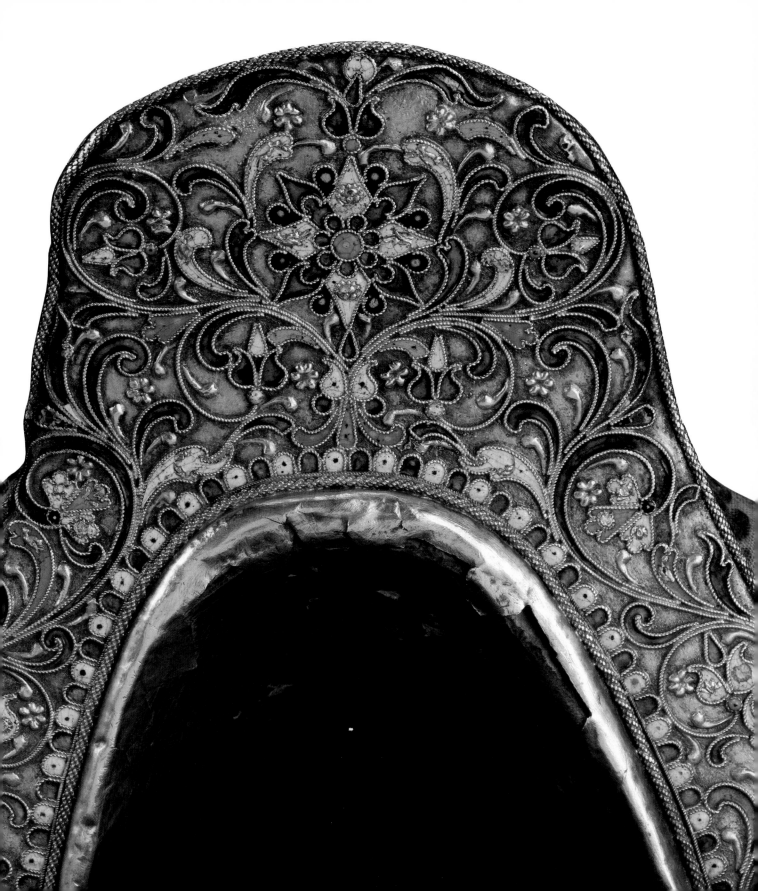

Textiles and Needlework

Detail of 82. *Embroidered damask veil (pelená) with the Appearance of the Virgin to St. Sergius.* Second half of 15th century (see p. 199)

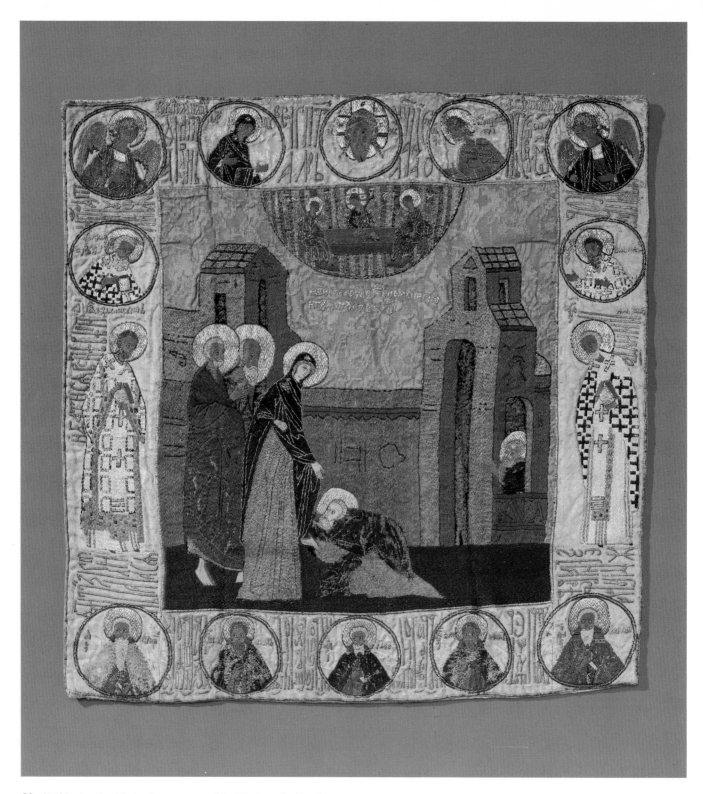

82. *Veil (pelená) with the Appearance of the Virgin to St. Sergius*

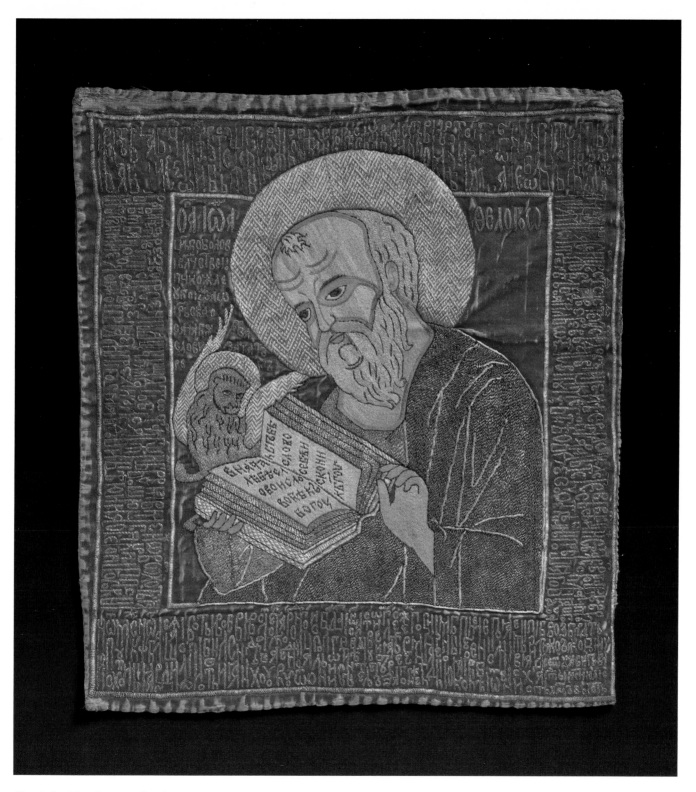

83. *Embroidered satin veil (pelená) with St. John the Evangelist.*
 Second half of 16th century (see p. 199)

Detail of 85. *Embroidered linen towel.*
Mid-17th century (see p. 200)

84. *Embroidered damask eucharist cover*
(pokrovéts) with the Agnus Dei.
1598 (see p. 200)

115

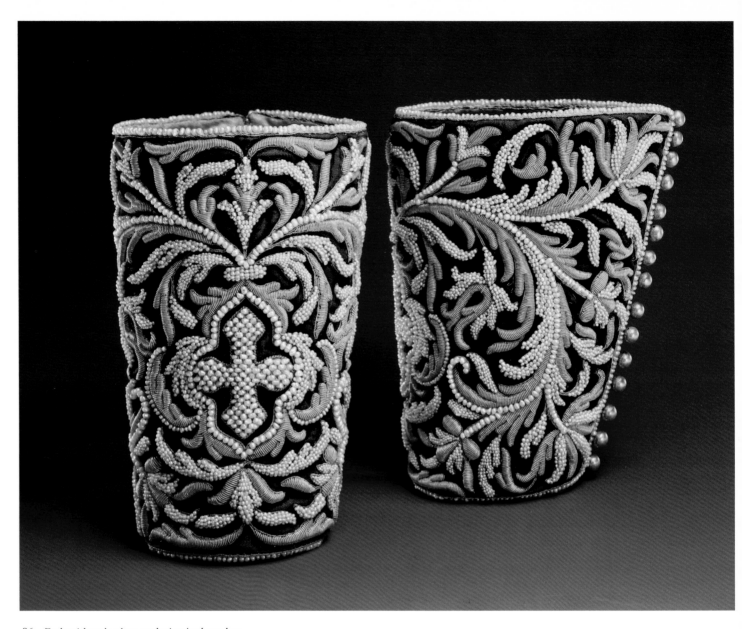

86. *Embroidered velvet ecclesiastical armlets
or cuffs*. 1670s (see p. 201)

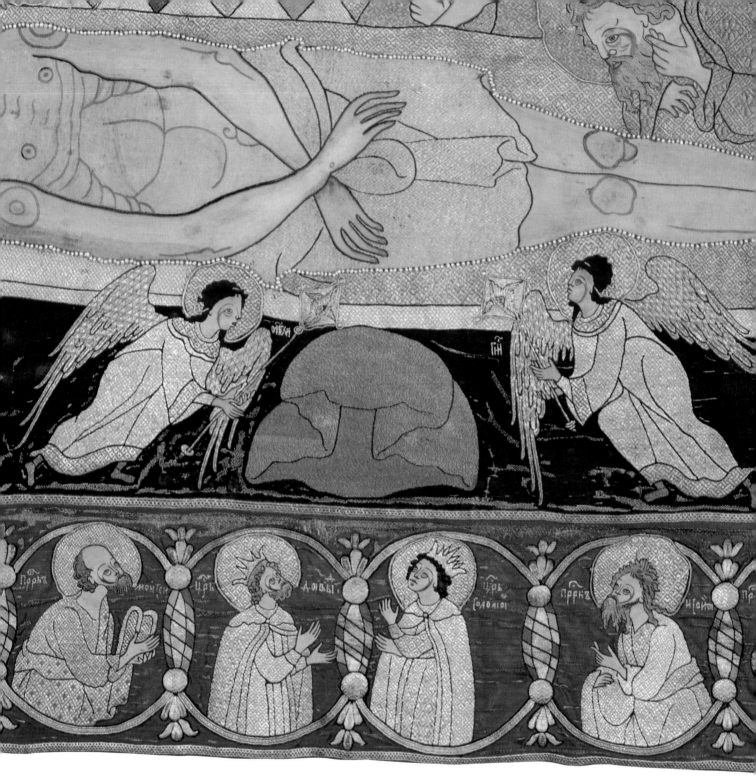

Detail of 87. *Good Friday shroud (plashchanitsa):*
Border depicting saints. 1678 (see p. 201)

117

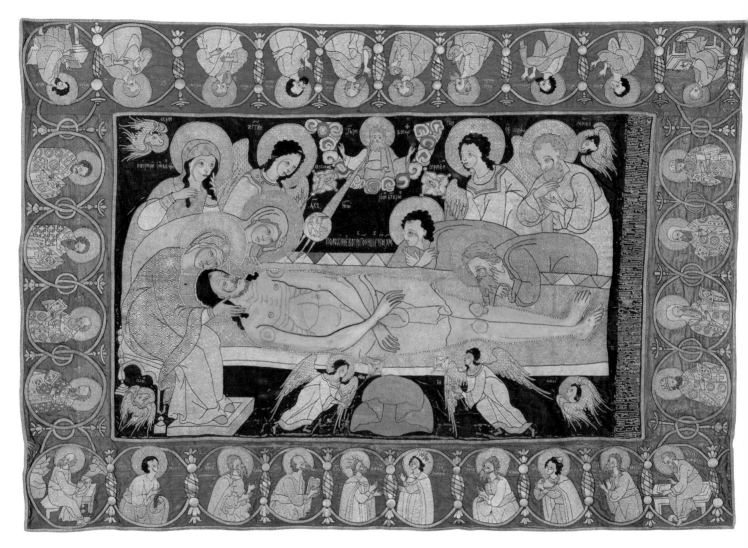

87. *Good Friday shroud*

Detail of 87: *The Virgin and one of the*
three Marys with the body of Christ

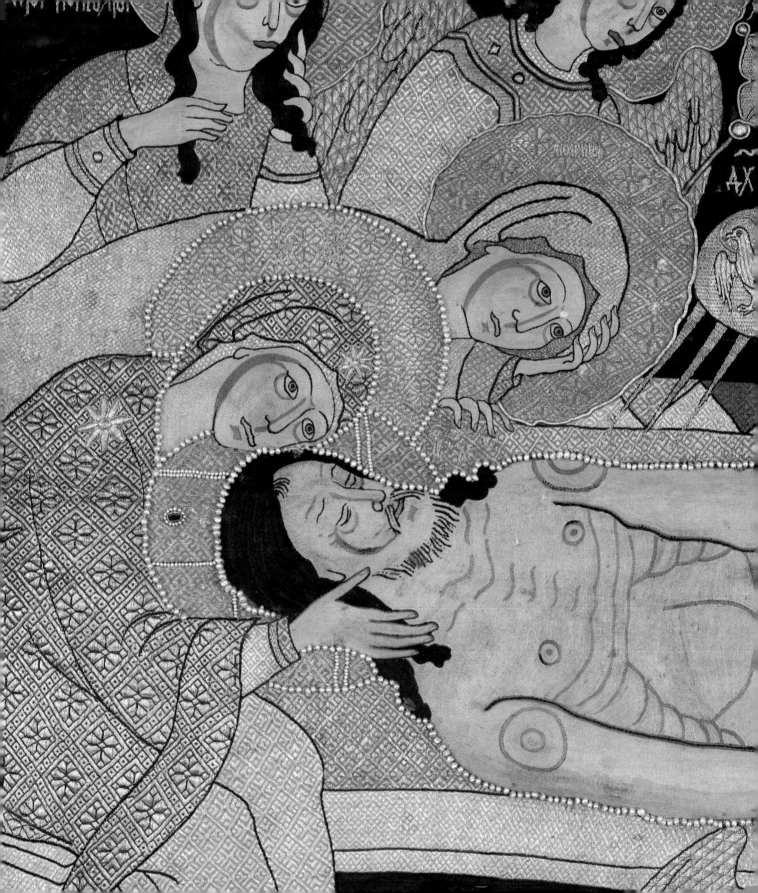

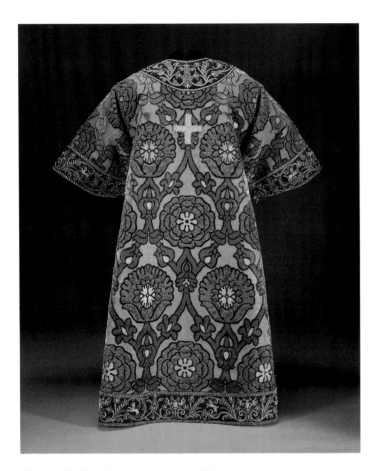

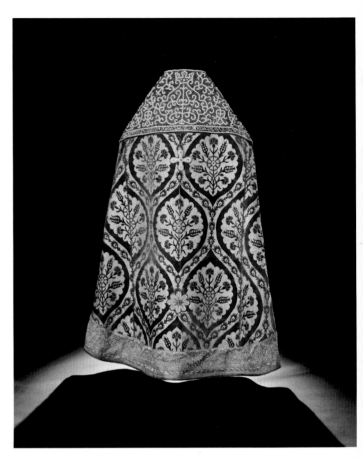

88. *Gold velvet bishop's vestment (sakkos).*
 Second half of 17th century (see p. 202)

89. *Gold cut-velvet cope (phelonion).*
 1680 (see p. 202)

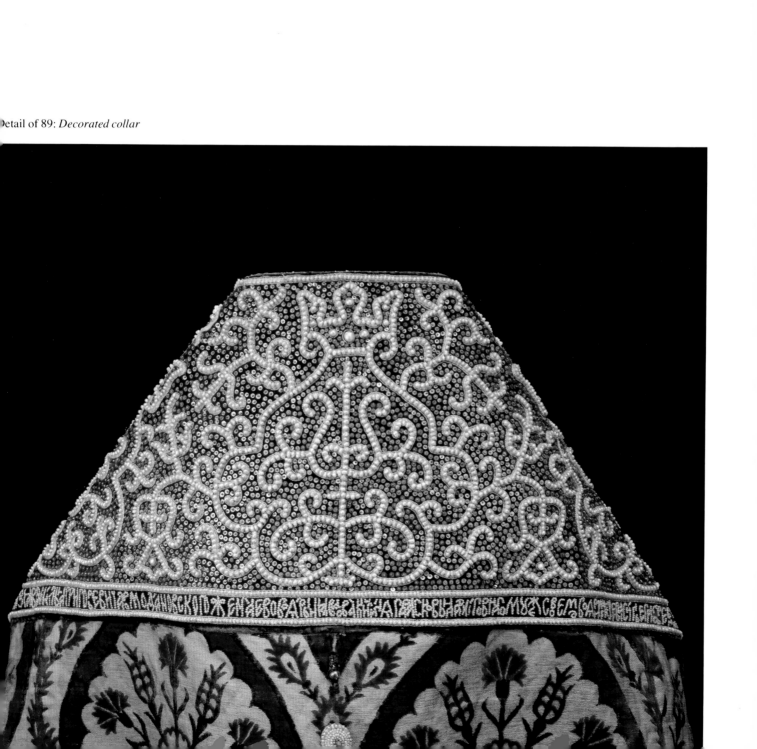

Detail of 89: *Decorated collar*

90. *Silver brocade bishop's vestment (sakkos).*
 1780s (see p. 203)

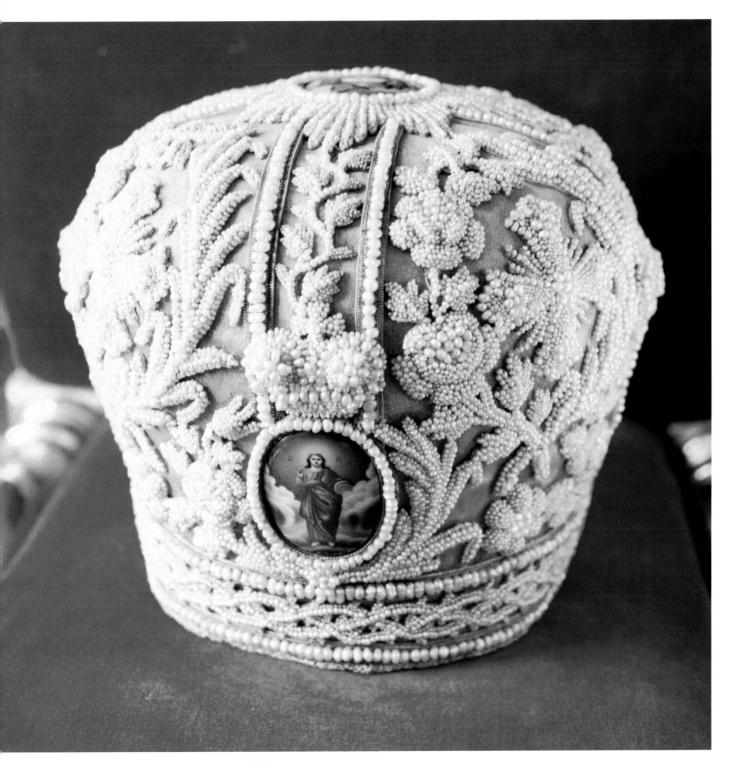

91. *Gold brocade miter*. Early 19th century (see p. 203)

123

Western European Silver

93. *Silver-gilt leopard-shaped vessel*
1600-01 (see p. 209)

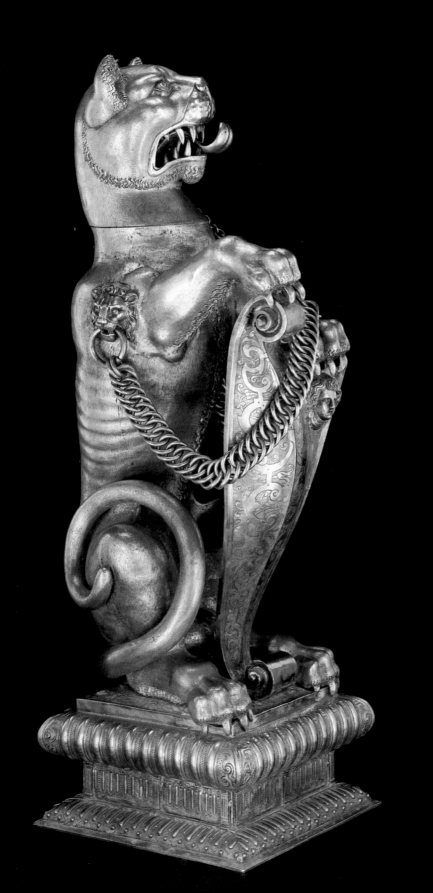

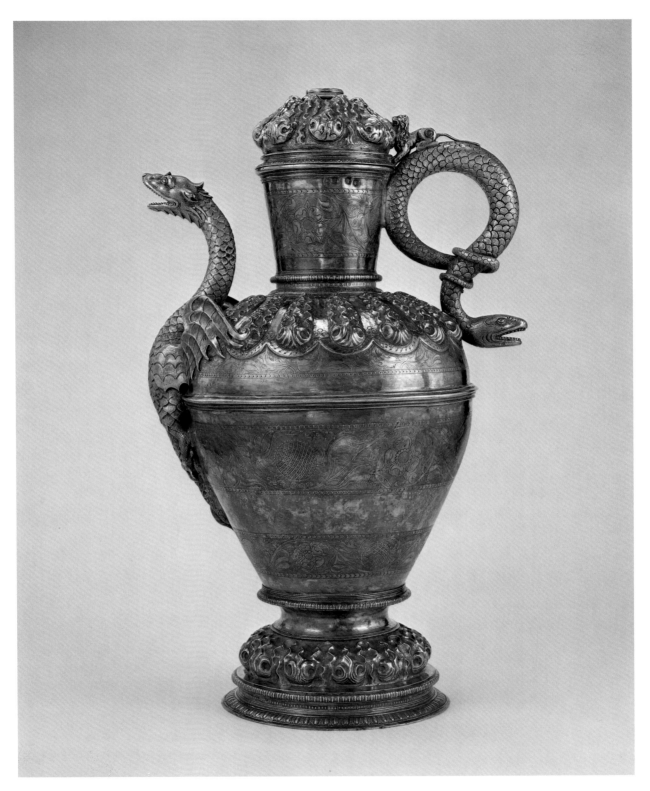

94. *Silver-gilt water jug.* 1604-05 (see p. 209)

Detail of 94: *Dragon-headed spout*

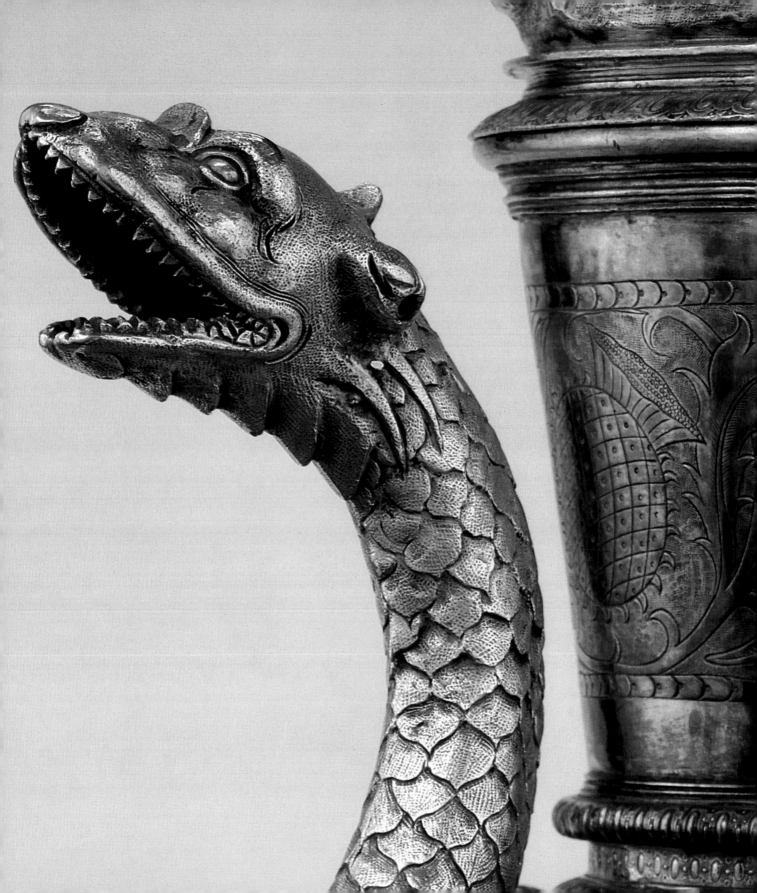

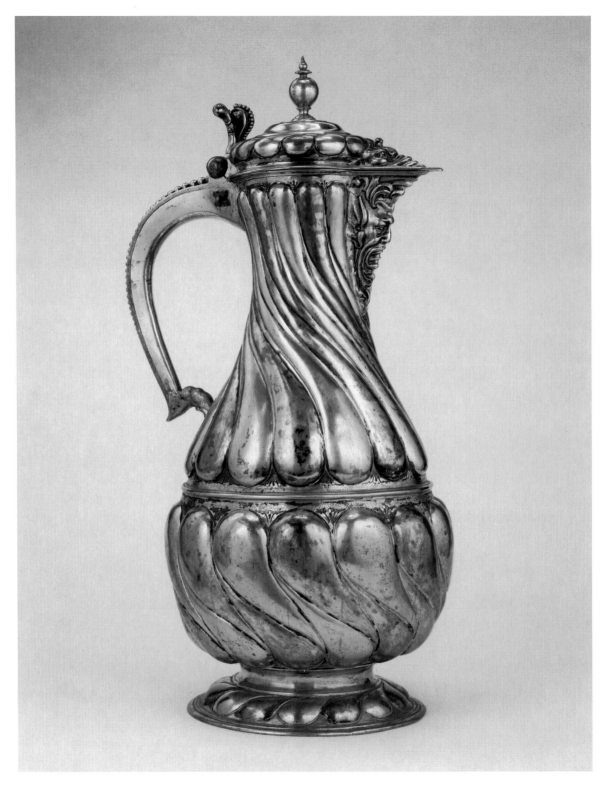

96. *Silver pitcher decorated with a mask.*
1630-50 (see p. 210)

TREASURES FROM THE KREMLIN

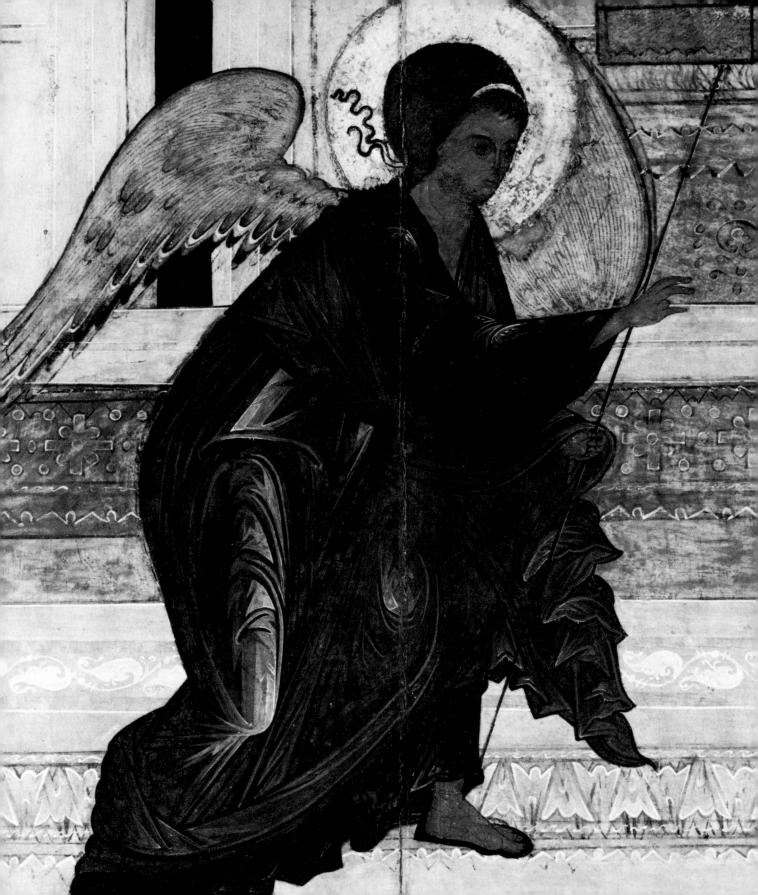

1. ICONS

The foundation of the extremely rich collection of ancient Russian panel paintings in the Kremlin Museums are the icons that have accumulated over the centuries in the cathedrals of the Assumption, the Annunciation, and the Archangel Michael.

It is difficult to overestimate the historical and artistic importance of this collection. Each stage of the long development of ancient Russian art is represented in it by works of the highest artistic caliber, from the monumental icons of the late eleventh and early twelfth centuries to the elegant, decorative icons of the late seventeenth and early eighteenth centuries—the final phase of the icon tradition in Russia at the dawn of a new period in history. Apart from works by Russian artists, the Kremlin Museums also contain icons from Byzantium and from the south Slav countries. These made their way to Russia as a result of its close diplomatic, commercial, and cultural ties with the eastern members of Christendom.

As the Russian state developed—as Moscow assumed increasing power as the capital of a united Russia and as the axis of the economic, sociopolitical, spiritual, and cultural life of the Russian people—the collection of ancient Russian paintings preserved in the Kremlin cathedrals gradually took shape. Moscow always attracted the finest artistic talents of ancient Russia to her workshops and also invited artists from abroad, most of them from the eastern Christian countries.

Pride of place in the Kremlin collection must go to the icons painted by the outstanding artists of ancient Moscow—Andrei Rublev, Theophanes the Greek, Prokhor of Gorodets, Dionysius, Nazarii Istomin Savin, Simon Ushakov, and Tikhon Filatiev. Besides the icons painted in the fourteenth to seventeenth centuries specifically for the Kremlin, the collection in-

131

Detail of 11. *The Annunciation*.
The annunciating angel (see p. 142)

cludes unique specimens of panel painting from other artistic centers of ancient Russia, from Novgorod the Great, Pskov, and Vladimir-on-Kliazma. Icons from these cities were brought to Moscow in the fifteenth and sixteenth centuries. This was a period when states and principalities, formerly independent, became part of the single, centralized Russian state. Many icons were brought from Novgorod at the end of the fifteenth century during the reign of the great prince of Moscow Ivan III and then again in the mid-sixteenth century during the reign of Ivan the Terrible.

Chronicles and other documents of the late fifteenth century onward tell us about the grand iconostases executed for the Kremlin cathedrals. In the seventeenth century the central iconostases of the cathedrals of the Assumption and the Archangel Michael contained up to one hundred icons each. In order to implement such "large state commissions," the best painters from many towns were summoned "for the speedy execution of state affairs." Painters from Kostroma, Yaroslavl, Vologda, Rostov, Suzdal, Vladimir, and elsewhere came to work under the "official icon painters"—the leading icon painters of the Armory—although the visiting painters were often no less skilled and talented than their supervisors. The official icon painters fulfilled commissions from members of the czar's family and from the patriarch. The elaborate, monumental works commissioned by the Church were housed in the Kremlin cathedrals.

By the beginning of the eighteenth century the paintings collections in the Kremlin cathedrals had assumed their final form and did not change substantially in the eighteenth and nineteenth centuries. After the October Revolution, when the Kremlin cathedrals were transformed into museums, the collections were supplemented by systematic acquisitions from museum expeditions. Like other major Soviet museums, the Kremlin Museums appropriated valuable artifacts from disused monasteries such as the Kirillo-Belozersk and Solovetsky monasteries. The icons accessioned by the Kremlin Museums from the northern artistic centers (former monasteries and fortresses in northern Russia) have no less aesthetic value than the Moscow works. They testify to the high level of ecclesiastical culture in the outlying provinces of ancient Russia.

The thirteen examples of ancient Russian painting in the exhibition have been selected with a view toward indicating—as far as is possible—the diversity and distinctiveness of the Kremlin icon collection. Moreover, the chronological presentation of the icons provides some idea of the course

of development that ancient Russian art followed from the twelfth through seventeenth centuries.

One of the oldest examples of painting in the Kremlin Museums is the twelfth-century Novgorod icon *Our Lady of Tenderness* (1), which dates from the pre-Mongol period. The icon was concealed by a massive silver cover in 1875 and for many years was never removed from the iconostasis of the Cathedral of the Assumption. It did not attract scholars' attention since all that could be seen through the layer of dark oil varnish were the overpaintings of the seventeenth through nineteenth centuries. Restoration and cleaning of the icon were undertaken in 1966, and the result was one of the most sensational discoveries in Russian art in recent years. In this icon the image of the Virgin is distinguished by a great emotional and lyrical force; Mary astonishes us by her moving youthful beauty, her sincerity, and spontaneity. The color scheme, dominated by deep blue and gold, relies on a series of resonant combinations that provide a rich decorative effect. Such elements recall the traditional color schemes of eleventh-century Byzantine and Kiev mosaics and of cloisonné enamels on gold, which were also popular at the time. This in turn proves that the icon was painted no later than the mid-twelfth century. It could have come to the Cathedral of the Assumption in the Moscow Kremlin at the end of the fifteenth century, during the reign of Ivan III, or in the 1550s–70s, when Russia was ruled by Ivan the Terrible and sacred objects were brought from Novgorod to Moscow. *Our Lady of Tenderness,* like many other excellent examples of ancient Russian icon painting from the pre-Mongol period, remained in obscurity for centuries and was discovered, cleaned, and researched only during the Soviet period.

The next to earliest icon in the exhibition is *The Savior of The Fiery Eye* (2). This is one of a number of icons that were painted in connection with the building of the first Cathedral of the Assumption in 1326. Specialists usually date the work to the mid-fourteenth century, and it is known to have been made in the painting workshops established by the metropolitan Feognost in Moscow in the 1340s. The Feognost workshops played an important role in the development of an independent Moscow school of painting during the fourteenth century, and a whole generation of brilliant Moscow painters from the late fourteenth and early fifteenth centuries—including the great Andrei Rublev—were nurtured on the icon painting of that time. *The Savior of the Fiery Eye* was painted by a Russian

artist. The title of the icon aptly describes the image of Christ, at once sorrowful and severe, dramatic and expressive.

Several cycles of icons were painted at the end of the fifteenth and during the sixteenth century for the new palaces and churches of the Kremlin, and some of these are still to be found in the Kremlin cathedrals. In the 1560s four small side chapels were built over the vaulted gallery surrounding the Cathedral of the Annunciation, and iconostases were placed in them. Those that have survived belong to the side chapels of The Synaxis of the Virgin, The Archangel Gabriel, and The Entry into Jerusalem. The exhibition includes four icons from the above side chapels: *The Synaxis, or Assembly, of the Virgin* (**7**), *The Prophet Daniel* (**8**), *The Entry into Jerusalem* (**9**), and *John the Precursor* (**10**). These works share a common style; their delicate compositions and saturated coloring demonstrate the finest traditions of fifteenth- and early sixteenth-century painting. The icon cover, or *oklad*, came to play a greater role in the general design of the icon; elegant silver-gilt covers and crowns were made at this time. They cover the margins and background of the icon, complementing the colors of the paint with their luster and brilliance.

The Virgin of Bogoliubovo with Scenes from the Lives of Sts. Zosimas and Sabbatius of the Solovetsky Monastery (**4**), *"Glory unto Thee"* (**5**), and *The Annunciation* (**11**) were also painted in the sixteenth century, although at the Solovetsky Monastery in the far north of Russia. These icons betray a familiarity with earlier Moscow styles; the elongated proportions of the figures and the smooth, unhurried rhythms recall the works of Dionysius. *The Virgin of Bogoliubovo with Scenes from the Lives of Sts. Zosimas and Sabbatius of the Solovetsky Monastery* bears an inscription that includes the date of its execution, 1545. By this time icons with scenes from the lives of the Russian saints were very popular, and the Kremlin Museums possess a number of such works painted for the Cathedral of the Assumption. The scenes in *The Virgin of Bogoliubovo* illustrate the heroic deeds of the monks—the overcoming of the hardships of hermit life on the deserted Solovetsky Islands, episodes of miraculous healing, and the rescue of unfortunates from the sea. The icon, therefore, had a didactic and moral function, as did most other Russian painting of the mid-sixteenth century.

The latest icons in the exhibition are from the seventeenth century— *St. Theodore Stratilates* (**13**), *St. John of Belogorod and the Czarevich*

Ivan Mikhailovich **(14)**, and *The Old Testament Trinity* **(15)**. Such works combine the rich, traditional principles of composition and color established through the long history of ancient Russian painting with an innovative search for naturalistic imagery.

O. V. Zonova

1. ICONS

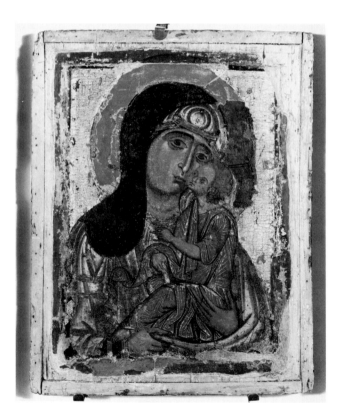

1. *Our Lady of Tenderness*
(Colorplate, p. 25)

A half-length representation of the Virgin, who wears a light blue mantle and an ornamented brown veil. The Child wears a long tunic and carries a scroll in his right hand. He raises his left hand in a gesture of speech.

Cathedral of the Assumption, Moscow Kremlin (Inv. no. 1075)
Novgorod School, mid-12th century
Wood, gesso over canvas; egg tempera
22¹/₁₆ x 16¾ in. (56 x 42.5 cm.)

Exhibited: *The Painting of Ancient Novgorod*, USSR, 1972; *The Restoration of Art Works in the State Museums of the Moscow Kremlin*, USSR, 1972–73; *The Painting of Pre-Mongolian Russia*, USSR, 1973; *The Restoration of Works of Art in the Museums of the USSR*, USSR, 1977

2. *The Savior of the Fiery Eye*
(Colorplate, p. 26)

The head of Christ fills almost the entire surface. The sharp asymmetry of the facial features, the deep furrows on the brow and neck, and the dramatic contrast of the white lead highlighting with the greenish ocher colors of the face produce great tension and expressivity.

Cathedral of the Assumption, Moscow Kremlin (Inv. no. 956)
Moscow School, mid-14th century
Wood, gesso; egg tempera
39⅜ x 30⁵⁄₁₆ in. (100 x 77 cm.)

Exhibited: *Balkan Painting of the 14th and 15th Centuries in Ancient Russia,* USSR, 1972

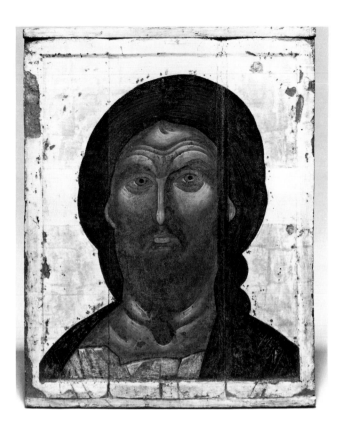

3. *Folding pectoral icon*
(Colorplates, pp. 27–30)

This wooden diptych is framed by silver-gilt filigree. On the front is a carved scene of the Crucifixion. On the inner side of the panels are compositions that represent the themes "Praise the Lord" and the twelve feast days as well as depictions of the prophets holding scrolls.

Provenance: The Kirillo-Belozersk Monastery
Accessioned from the Fund of Ecclesiastical Treasures
 (Inv. no. 16654)
Novgorod School, 15th century
Wood, silver; carving, chasing, gilding, filigree
2¾ x 3⁷⁄₁₆ in. (7 x 8.8 cm.)

Icons 137

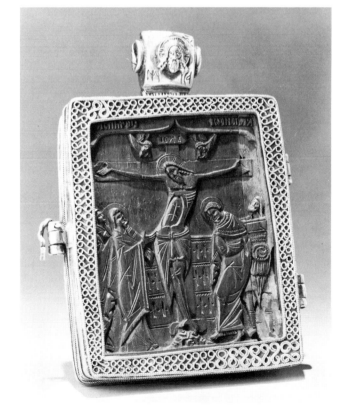

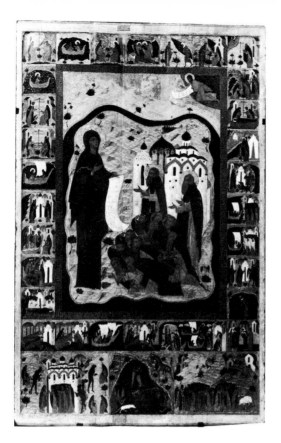

4. *The Virgin of Bogoliubovo with Scenes from the Lives of Sts. Zosimas and Sabbatius of the Solovetsky Monastery*
(Colorplate, p. 31)

The Virgin is shown in the central panel against the background of the Solovetsky Monastery as she appears to St. Zosimas and St. Sabbatius and their brothers. The margins contain scenes from the lives of Zosimas and Sabbatius, while the lower compositions are of a didactic nature. Below the central panel is an inscription that tells us that the icon was painted in 1545. Elements of the northern icon style as well as that of the Moscow School are combined in this work.

Provenance: Solovetsky Monastery
Accessioned in 1923 (Inv. no. 5133)
Russian School, 1545
Wood, gesso over canvas; egg tempera
84¼ x 54⅛ in. (214 x 137.5 cm.)

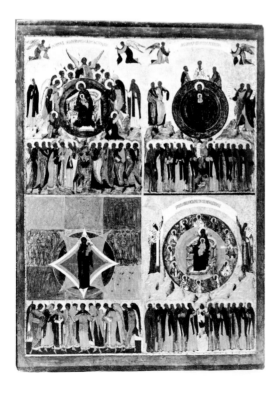

5. *"Glory unto Thee"*
(Colorplate, p. 32)

The icon consists of four scenes, each corresponding to a verse from the hymn "Glory unto Thee," dedicated to the Virgin. The Virgin and Child are at the center of each composition surrounded by angels, archangels, prophets, apostles, saints, monks, and hermits. The color scheme is dominated by red, green, and ocher tones. The faces are painted in light ocher on a brown ground.

Provenance: Solovetsky Monastery
Accessioned in 1923 (Inv. no. 5132)
Russian School, first half of 16th century
Wood, gesso over canvas (?); egg tempera
61⁷⁄₁₆ x 45¼ in. (156 x 115 cm.)

Exhibited: *Masterpieces Reborn,* USSR, 1977

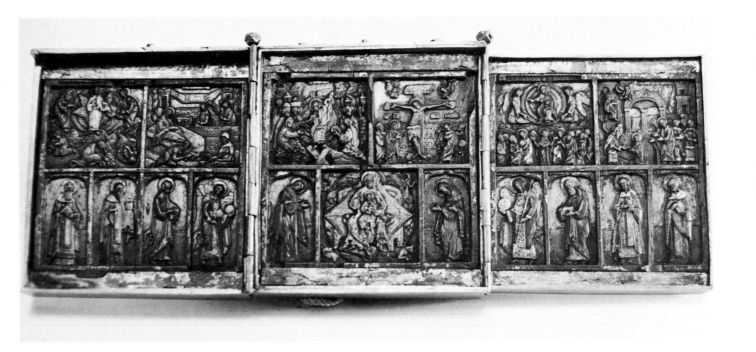

6. *Folding icon*

A rectangular wooden carved folding triptych in a plain brass mount representing a miniature iconostasis with feast day and Deësis tiers. The images are depicted in shallow relief in red and green tempera. The upper tier contains the Transfiguration, the Nativity of Mary (left wing), the Baptism, the Crucifixion (central panel), the Ascension, and the Leading into the Temple (right wing). The lower tier shows the Archangel Michael, the apostle Peter, Vasilii the Great, Gregory (left wing), God the Father enthroned with Christ and Attendants (central panel), the Archangel Gabriel, the apostle Paul, John Zlatoust, and Nicholas the Miracle Worker (right wing).

Accessioned from the State Art Depository in 1928 (Inv. no. 3459)
Woodcarving: Russian School, 16th century
Frame: Russia, 19th century
Wood, brass; woodcarving, egg tempera
3¹⁵/₁₆ x 11⁵/₁₆ in. with frame (10 x 28.7 cm.);
 2⅜ x 8¼ in. without frame (6 x 21 cm.)

Exhibited: *L'Art russe des Scythes à nos jours,* Paris, 1967–68

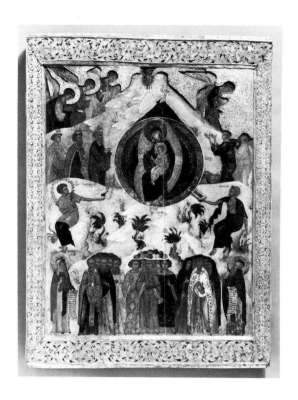

7. *The Synaxis, or Assembly, of the Virgin*
(Colorplates, pp. 33–36)

At the center of the composition, in the "circles" of their glory, are the Virgin and Child. They are shown against a background of hillocks and are surrounded by angels, the Magi, the Shepherds, and figures personifying the earth and the desert. In the lower part of the icon are singers, priests, and monks praising the Virgin. The composition is decorated with silver filigree details. The frame is silver gilt and enamel.

Inv. no. 5062
Provenance: Side chapel of the Assembly of the Virgin in the
 Cathedral of the Annunciation, Moscow Kremlin
Moscow School, 1560s
Wood, gesso, silver; egg tempera, filigree, filigree enamel, gilding
35¼ x 25½ in. (89.5 x 64.8 cm.)

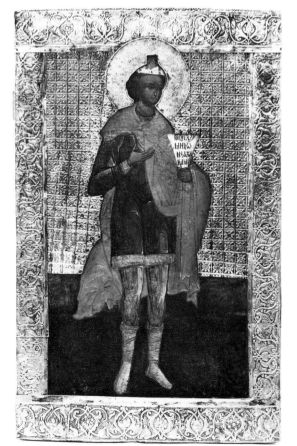

8. *The Prophet Daniel*
(Colorplate, p. 37)

Daniel is depicted full length, turned slightly to the right, and holding an open scroll. The face of the prophet is in light ocher on an olive ground. His clothes are decorated with borders outlined in gold. The margins and background are covered with silver-gilt stamped mountings. The halo is silver filigree.

Inv. no. 5128
Provenance: Side chapel of the Archangel Gabriel in the
 Cathedral of the Annunciation, Moscow Kremlin
Moscow School, 1560s
Wood, gesso, silver; egg tempera, filigree, gilding, stamping
24¼ x 14¹⁵⁄₁₆ in. (61.5 x 38 cm.)

9. *The Entry into Jerusalem*
(Colorplates, pp. 38, 39)

The composition is the traditional one: Christ rides on a donkey in the center while the apostles follow him and the people of Jerusalem greet him. The color scheme is based on subdued tones of brown, olive, and green with cinnabar and white. The faces are painted in pinkish ochers on an olive ground. The background and margins are covered by silver-gilt filigree and enamel mounts.

Inv. no. 5083
Provenance: Side chapel of the Entry into Jerusalem in the
 Cathedral of the Annunciation, Moscow Kremlin
Moscow School, 1560s
Wood, gesso, silver; egg tempera, filigree, enameling, gilding
33⅝ x 26¼ in. (85.5 x 66.6 cm.)

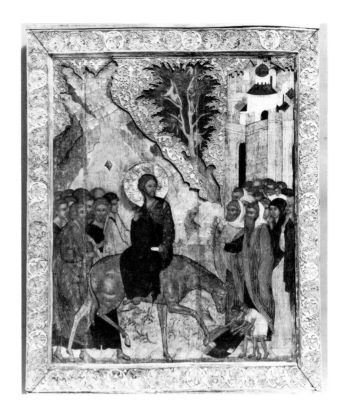

10. *John the Precursor*
(Colorplates, pp. 40, 41)

The saint is depicted half length and full face. In his left hand he holds the flowering cross. The powerful face, the almost naked torso, and the thin hands of this ascetic are painted in smooth yellow ochers on a green ground. The yellow and green color scheme is complemented by the silver-gilt stamped mount covering the background and margins. The filigree halo is decorated with chased rosettes.

Inv. no. 5085
Provenance: Side chapel of the Entry into Jerusalem in the
 Cathedral of the Annunciation, Moscow Kremlin
Moscow School, 1560s
Wood, gesso over canvas, silver; egg tempera, stamping,
 filigree, chasing, gilding
39¾ x 29½ in. (101 x 75 cm.)

Icons 141

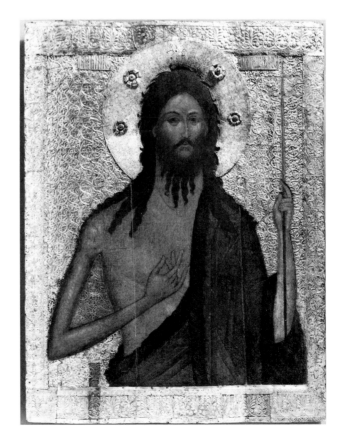

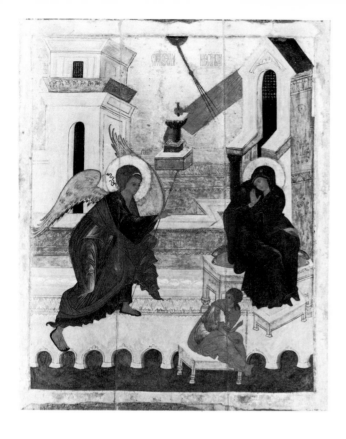

11. *The Annunciation*
(Colorplates, pp. 42, 43)

The figures of the Archangel Gabriel, the Virgin, and the maid-servant at her feet are shown in a composition full of movement. Red, green, and ocher tones dominate. The faces are painted in thick ochers with red admixture on an olive ground.

Accessioned from the Solovetsky Monastery in 1923
 (Inv. no. 5010)
Russian School, 16th century
Wood, gesso over canvas; egg tempera
57½ x 44⁵⁄₁₆ in. (146 x 112.6 cm.)

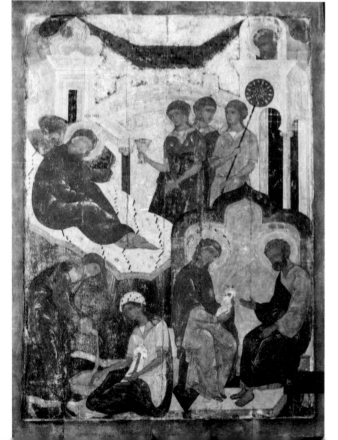

12. *The Nativity of the Mother of God*
(Colorplate, p.44)

This is a complex composition containing many figures. In the center St. Anne appears on a high couch. At the lower left the bathing of the infant is depicted; Sts. Joachim and Anne can be seen attending Mary on the right. The faces are painted in strong, thick ochers on a dark ground. The graphic facial features are delineated by thin brown lines contoured with red.

Inv. no. 5466
Pskov School, first half of 16th century
Wood, gesso; egg tempera
57⅛ x 40¾ in. (145 x 103.5 cm.)

13. *St. Theodore Stratilates*
(Colorplates, pp. 45, 46)

St. Theodore is depicted full length in a three-quarter turn and in a praying position. He wears gold armor decorated with a fine foliate ornament imitating niello. His face and hands are painted with chiaroscuro. The artist's signature is in the lower left corner. This work was painted for the iconostasis of the Cathedral of the Annunciation in the Moscow Kremlin as the patron-saint icon of Czar Fedor (Theodore) Alexeevich. In 1683, after the czar's death, the icon was transferred to the Cathedral of the Archangel Michael.

Inv. no. 70
Moscow School, Kremlin workshops, 1676
Artist: Simon Ushakov
Wood, gesso; egg tempera
61⁷/₁₆ x 21¹/₁₆ in. (156 x 53.5 cm.)

14. *St. John of Belogorod and the Czarevich Ivan Mikhailovich*
(Colorplate, p. 47)

The czarevich and his patron saint are depicted in prayer, their faces raised to the Savior, who blesses them. Their dark green and red clothes are decorated with imitation pearls and precious stones. The background and margins are covered with a silver-gilt, chased mount. The chased inscription on the four rectangular panels near the top reads: "The Holy Ivan of Belogorod"; "The Righteous Czarevich Ivan Mikhailovich."

Inv. no. 88
Provenance: Cathedral of the Archangel Michael,
 Moscow Kremlin
Moscow School, mid-17th century
Wood, gesso, silver; egg tempera, chasing, gilding
48¹³/₁₆ x 29¾ in. (124 x 75.5 cm.)

15. *The Old Testament Trinity*
(Colorplates, pp. 48, 49)

The composition is the traditional one. Sarah is depicted in the background, on the left, with Abraham below her holding a dish of food. In the foreground the servant slaughters the calf. The faces are in dark ochers with white lead highlights on a brown ground. The gold, chased frame is decorated with precious stones and multicolored enamel.

Inv. no. 11962
Provenance: Formerly palace property
Moscow School, Kremlin workshops, second half of 17th century
Wood, gesso, gold, jewels, textile; egg tempera, chasing,
 engraving, enameling on relief
11⅛ x 8¹⁵/₁₆ in. (28.2 x 22.8 cm.)

144 Treasures from the Kremlin

Detail of 20. *Altar Gospels. Roundel depicting Virgin and Child* (see p. 156)

2. RUSSIAN GOLD AND SILVER

The Russian metalwork in the exhibition indicates the wealth and diversity of the Russian gold and silver collection in the Kremlin Museums, which contain secular and ecclesiastical pieces created in various artistic centers throughout Russia. The works span eight centuries, and many of them have unique artistic and historical significance. Their forms and ornamentation attest the very distinctive nature of the Russian applied arts and their organic connection with popular arts and crafts.

The earliest piece included here dates to the twelfth century, to the period just before the Mongol invasion of Russia. Russian art, particularly Russian applied art, had already attained great heights by drawing on the strong traditions of the thousand-year-old pagan Slavic culture and by assimilating and interpreting the artistic legacy of Byzantium. The famous Kiev cloisonné enamels and the pieces of jewelry that have come down to us from ancient Vladimir, Novgorod, and old Riazan indicate the high level of artistic culture at that time, the originality and maturity of aesthetic conception, and the complete mastery of technique attained. We know about jewelry of the ancient period mainly from Russian treasure troves that have yielded various ornaments as well as coins. The golden three-beaded rings worn on the temples (16), which would have been part of the rich attire of an ancient Russian lady, are characteristic of the work of the pre-Mongol period. They were found in excavations in Kiev, a city that in the tenth and eleventh centuries was the center of the powerful Slav culture.

The breakup of feudal Russia, which took place mainly in the twelfth century, caused the establishment of local artistic schools, always distinguished by their own idiosyncratic features. An exceptional example of a pre-Mongol silver vessel is the chalice (17) created by craftsmen from the Vladimir-Suzdal principality. The cup bears half-figures of the Deësis

executed in restrained outlines. The engraving and certain stylistic elements indicate that the piece is from the twelfth century: the presence of St. George among the images and the fact that the chalice comes from the Cathedral of the Savior and the Transfiguration in the town of Pereslavl-Zalesski (built by order of Prince Yurii Dolgorukii) allow us to associate this work with the name of the prince who, according to tradition, was the founder of the city of Moscow. The lucid, classical lines, which signify the full flowering of an artistic style, are especially attractive in this work. The severe and noble beauty of the chalice recalls the churches of the Dolgorukii period, with their stern simplicity and majestic serenity.

The Tartar yoke long impeded the development of Russian culture, although it did not stifle the creativity of the Russian people. A new epoch of national awareness began when Moscow assumed the role of unifier of the Russian lands and became a major cultural center and the crucible in which Russian art as such was forged. The Kremlin workshops began to attract the finest talents and reached their apogee in the sixteenth and seventeenth centuries. The court craftsmen attended to the demands of a grand aristocracy and created luxurious artifacts and utensils for the Church. The rulers of Moscow made splendid gifts to cathedrals and monasteries, thus multiplying the riches of the Church, which, after all, was the firm supporter of lay power.

The jeweler's art of the sixteenth century is represented in the exhibition by true masterpieces. The artifacts of the time are distinguished by the rich diversity of decorative techniques used, by the variety of surface treatment on the precious metals, and by the distinctive elegance of ornamentation and coloring. The jeweler's art of the time relied substantially on precise, graphic, stylized foliate ornament executed in niello, chasing, and filigree. One senses in some details the presence of Renaissance floral forms, inasmuch as the Russian craftsmen benefited from their creative contacts with the cultures of other countries. The craftsmen of the sixteenth and seventeenth centuries invariably used filigree and usually filled openwork patterns with multicolored enamel (19). One is particularly struck by the jewelers' devotion to niello, which had been known in Russia since ancient times and was used much more extensively than in other European countries. In the works of the Kremlin craftsmen niello is distinguished by a deep black tonality, which, when applied on the warm, gold ground, acquires a special velvety appearance.

The reliquary (22) presented by Czar Fedor Ivanovich (the son of Ivan the Terrible) to his wife, Irina, and the chalice (23) from a liturgical set presented by Czaritsa Irina to the Cathedral of the Archangel Michael in memory of her prematurely deceased husband are excellent examples of sixteenth-century niello work. The charm of these objects comes from the perfection of their artistic solutions and the harmony achieved in the combination of their materials—the careful use of subdued iridescent pearls and rounded, subtly polished jewels that brighten up their surfaces.

The best works of the silversmiths were much appreciated by their contemporaries and, like great paintings, often served as models for subsequent generations of artists. It is not by chance, therefore, that the magnificent golden censer (28) was designed in the form of a single-cupolaed square church of the time with its row of gables (*kokoshniki*) so typical of Moscow architecture. This piece was presented by Czar Mikhail Fedorovich (the first Romanov) to the Troitse-Sergiev Monastery near Moscow, and the craftsman obviously borrowed some design elements from this famous sixteenth-century architectural masterpiece.

Sometimes Russian jewelers of the sixteenth century also imitated older originals. For example, the cover of the Gospels given in 1568 by Ivan IV to the Cathedral of the Annunciation in the Kremlin (20) is very like the cover of the famous Gospels of 1392 commissioned by Fedor Andreevich Koshka, the Moscow boyar. The later piece, dating from the time of Ivan the Terrible, gives an impression of severe majesty, and the graceful figures of the saints, designed by a skillful master of miniature sculpture, have a certain archaic quality. The metallic surface below the images of the saints has been scored and, apparently, had been prepared for enameling, which often served as a ground for cast compositions.

In the Middle Ages books came to be regarded as works of art, the products of collaboration by artists of different disciplines. Russian manuscripts were richly decorated with miniatures, colorful vignettes, and initials. A small manuscript Gospels of the late sixteenth and early seventeenth century (26) is a fine example of artistic book design of ancient Russia. Book ornaments of this period are remarkably opulent and varied with a distinguishing elegance of style. In the second half of the sixteenth century a preference for floral forms developed; flowers, fruits, and leaves borrowed from nature were transformed into decorations for vignettes, initials, and frames. Gold was often added to the light color scheme of

white, blue, red, and green. The patterns of the vignettes in **26** recall the floral motifs used in the first Russian printed books of the sixteenth century.

If the applied art of the fifteenth and sixteenth centuries is best represented by ecclesiastical items that were safeguarded in the monasteries and church sacristies, the artifacts of the seventeenth century provide us with an insight into the distinctive artistic designs of secular Russia. A considerable number of gold and silver vessels from the 1600s have survived. Interesting specimens can be found in many Soviet museums, although the largest and most valuable collection is in the Armory of the Moscow Kremlin. The forms are simple, functional, and generally depend on prototypes found in peasant utensils. Various kinds of ancient Russian utensils are represented in the exhibition, but of particular importance are the traditional gold and silver *kovshi*, or dippers, which probably originated in the north of Russia. At their banquets the czars and princes drank mead, their favorite beverage, from these dippers or used a valuable dipper to reward outstanding service. The deep, oval dipper belonging to Fedor Nikitich Romanov (**24**) is closest in form to its wooden prototype. The gold dipper belonging to Czar Mikhail Fedorovich (**29**), with its low sides and wide, flat shape, is characteristic of the work of Moscow goldsmiths of the seventeenth century. This piece combines a noble severity of form with extraordinary splendor and beauty.

Another type of Russian vessel is the *brátina*, or toasting bowl, which was popular among the czars and boyars and an indispensable accessory at the banquet table. Although the basic form was simple, these bowls were of various types and were richly decorated with rhythmical floral patterns in relief, with engraved compositions, or with chased relief. Some bore triangular or rhomboid patterns with floral motifs (**30**). The *endová*, a globular vessel with a spout, was also evidently popular in old Russia. The Kremlin Museums possess the only surviving example from the seventeenth century (**37**). This large, rounded vessel, decorated with plain and repoussé gadroons, has a wide rim bearing an inscription with the name of the original owner, V. I. Streshnev, a relative of the czar and at various times head of the Kremlin workshops. The use of an inscription for decorative purposes was characteristic of ancient Russian applied art, and lettering was sometimes the only decoration on a vessel (**36**).

Stavtsy, or covered bowls, apparently used to serve desserts, were

popular in Russia up to the eighteenth century. The example exhibited here (41) belonged to Czarevna Sofia, sister of Peter I. To all intents and purposes she was the ruler of Russia, inasmuch as her brothers were minors. The vessel carries an interesting decoration: an engraved gilt pattern of flowers on thin, entwining stems scintillating on a niello ground.

During the second half of the seventeenth century the character of foliate ornament on metalwork began to change considerably and became freer, more pictorial, and closer to natural forms (35, 41, 49, 51, 52). This was not a fortuitous development; it related directly to the aesthetic of the time. In the seventeenth century Russian culture began to rely more strongly on secular interests and to concern itself with everyday life. The world of nature, therefore, became a source of inspiration for the artist. This new secular orientation gave art a heightened sense of decorativeness and intensity of color, and enameling, with its rich and vibrant colors, appealed to the taste of seventeenth-century jewelers. The Russian craftsmen were very well versed in the various techniques of enameling and superimposed enamel on chased and openwork patterns or on depictions in relief; they also painted on enamel. The resulting intensity and diversity of color prevailed not only on secular artifacts, but also on ecclesiastical objects (39, 43, 44, 46).

Items of ceremonial use occupied an important place in the production of the seventeenth-century Kremlin jewelers. These were part of the collection of ancient Russian state regalia and were constantly used at court—at coronations, at diplomatic receptions, and at the czar's official appearances. The crown exhibited (40) was made by Kremlin craftsmen on the occasion of the simultaneous enthronement of the two minor sons of Czar Alexei Mikhailovich—the fifteen-year-old Ivan, who was crowned with the Cap of Monomach, and the ten-year-old Peter I, who was crowned with the newly made cap of state. The latter work (40) repeats the form of the famous grand "Cap of Monomach," the ancient, hereditary crown of the Russian czars, which, according to legend, was sent to Rus' by the Byzantine emperor Constantine Monomachos and which, from the late fifteenth century onward, was an official symbol of the autocracy. Other objects of royal regalia are a chain of rings (32) and a pectoral cross with four arms (45). As early as the first half of the seventeenth century the chain is mentioned in the inventories of the Czar's Great Treasury—where objects for court ceremonies were stored. The chain is skillfully assembled

from gold rings bearing inscriptions of the full title of the Russian czar as established in the time of Ivan the Terrible.

Although works by Moscow craftsmen of the seventeenth century dominate the exhibition (inasmuch as the Kremlin collections relied on them), they represent only one part of the Russian artistic production of that time. In the seventeenth century Russia boasted many important artistic centers where the design and production of silverware were of a particularly high order. Works from the town of Solvychegodsk—the ancestral lands of the Stroganovs, the great family of Russian merchants and industrialists—are especially distinctive. The Solvychegodsk workshops produced the most diverse artifacts decorated with painted enamel and with motifs of tulips, daisies, and sunflowers woven into a single, multicolored bouquet. The painting was done in bright yellow, green, blue, and pink lilac tones on a pure white ground. Dark shading was also used to heighten the decorative force of the ornament. Sometimes the enamel pattern was outlined with twisted wires and the background was gilded to produce a distinctive artistic effect. Bowls, forks, knives, boxes, and caskets in which women kept their jewels and trinkets were decorated with enamel. But the Solvychegodsk craftsmen did not confine themselves to ornamental motifs and often used images of animals, birds, heroes from Russian fairy tales, or allegorical figures of the five senses or the seasons in their works **(47–51)**. These efforts prepared the way for great achievements in miniature enamel painting during the eighteenth century.

Indeed, the eighteenth century represented a new stage in the development of Russian culture. After having freed itself from the restrictions of the medieval world, Russian culture now acquired a pronounced secular orientation. The Petrine reforms prompted essential changes in Russian life and this, inevitably, affected the character of the applied arts. In the art of the silversmith, for example, this led to the modification or even eradication of certain traditional types of artifacts; these were replaced by new forms of decorative utensils and drinking vessels. During the eighteenth century Russian art developed along the general stylistic lines of European art while still retaining its essential national features. St. Petersburg became a major center for the silver industry, and an example of its craftsmen's work in the exhibition is the elegant, finely decorated soup tureen from the first half of the eighteenth century **(53)**. The art of filigree, which in the sixteenth and seventeenth centuries was used in conjunction

with enamel, acquired an independent value in the eighteenth century and was used in the creation of openwork boxes, caskets, salt cellars, and snuffboxes. During this period filigree was often applied to colored glass or to a smooth gilt surface. This kind of contrast—between the mat silver of the ornament and its brilliant gilding—is a characteristic of the baroque style.

The Moscow art of jewelry maintained its links with the traditions of ancient Russian art for a long time, but, from the mid-eighteenth century onward, it was dominated by fanciful rococo ornamentation. On the cover, of 1772, of a Gospels **(54)**, the raised pattern of shells, bouquets, and heads of cherubim frame cameos painted in enamel—a medium that achieved remarkable heights in the eighteenth century, especially in the miniature portrait. The influence of baroque painting on Russian religious art of the time can be felt in the agitated folds of the Evangelists' clothes, in the elaborate architectural backgrounds and splendid hangings, and in the rich colors of the enameling.

Although the aesthetics of the baroque and rococo styles gravitated toward volumetrical design—which prompted more extensive use of chasing in relief—the Russian craftsmen retained their love of niello. The works by the craftsmen in Velikii Ustiug **(59–61)** are especially interesting and distinctive in this context. The raised, dark design on the matted gilt ground is typical of this work. The niello here is distinguished not only by its lovely deep tone, but also by its extraordinary durability—it looks almost as if it could withstand hammerblows. The works made by the Tobolsk craftsmen **(56–58)** are of nearly the same quality as those made in Velikii Ustiug, for Tobolsk was the scene of a brief but brilliant flowering of the art of niello during the second half of the eighteenth century. Many of the Tobolsk pieces were made for D. I. Chicherin, governor of Siberia, and are stamped with his monogram. The subject matter of niello pieces of the second half of the eighteenth century is varied—courtly and domestic scenes, pastorales, and illustrations of literary works dominate. The Tobolsk objects often bear hunting scenes treated in a generalized and spontaneous way; at times these are rather naive and recall popular Russian cartoons. The rococo style persisted for a long time in the provinces, and the compositions on the Tobolsk pieces are often contained within simple rococo-like cartouches.

In the early nineteenth century Russian society began to focus more

attention on history and the fatherland; scenes of battle, landscapes, geographical maps, architectural monuments, and city views began to appear as niello decoration. This kind of depiction is typical of the art of Sakerdon Skripitsyn, a Vologda craftsman whose niello engraving is technically very different from the work of the silversmiths at Velikii Ustiug. His work on the covered serving dish of 1837 **(63)**, for example, is executed in thin lines with light shading on a smooth ground, which creates the effect of soft modulations of color. The restrained form of this piece is well defined, with elegant handles and chased palmettes, and it exemplifies the classic style that firmly established itself in Russian applied art from the late eighteenth century onward. A round platter **(62)** bears typical features of this style; the piece was presented by the citizens of Mikhailovsky Village to General Count M. I. Platov, hero of the patriotic war of 1812 and an ataman of the Don Cossack Host.

Russian silver of the second half of the nineteenth century reflects obvious moments of crisis, as does all European art of the time; one can see a loss of stylistic cohesion and evidence of eclecticism. However, the lower artistic standard observed in artifacts of precious metals did not completely halt progress in this area. Jewelry production was now concentrated in the hands of large firms. Works by the craftsmen of Fabergé and Company in St. Petersburg achieved universal recognition; Fabergé had branches not only in various cities within Russia, but also abroad. A Fabergé product of particular originality is the stylized model of the Moscow Kremlin **(64)**, which even contains a musical mechanism. The technical virtuosity manifested by this piece proves that skillful craftsmen were working in Russia at the beginning of the twentieth century.

<div align="center">M. V. Martynova</div>

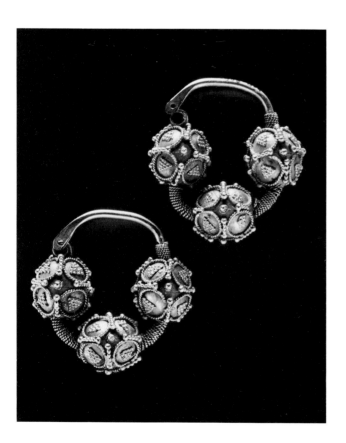

16. *Pair of rings worn on the temples*
(Colorplate, p. 51)

Three-beaded rings of the "Kiev" type. Decorated with filigree and granulation.

Found in excavations in Kiev near the Desiatina Church in 1846
Main collection of the Armory (Inv. no. 3702)
Kiev, 12th century
Gold; chasing, filigree, granulation
H. 1¹¹/₁₆ in. (4.3 cm.); W. 1⁹/₁₆ in. (4 cm.)

17. *Chalice*

(Colorplates, pp. 52, 53)

Silver, partly gilded, with a wide, hemispherical cup standing on a high base chased with convex "tongues." The rim bears a liturgical inscription; six roundels below it display images of the Savior, the Virgin, John the Baptist, the archangels Michael and Gabriel, and St. George the Martyr.

Presented by Prince Yurii Dolgorukii to the Cathedral
 of the Savior and the Transfiguration in the town of
 Pereslavl-Zalesski
Accessioned in the 1920s (Inv. no. 18173)
Vladimir-Suzdal, mid-12th century
Silver; chasing, engraving, matting, gilding
H. 10¼ in. (26 cm.); Diam. of cup 7¹¹/₁₆ in. (19.5 cm.)

Exhibited: *Ancient Russian Applied Art,* Japan, 1964

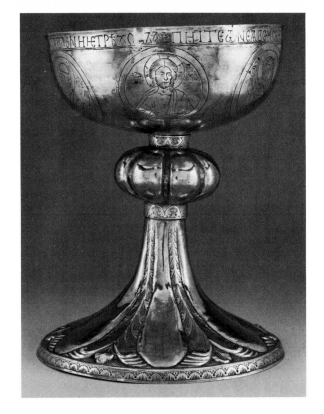

18. *Pectoral cross*

Silver; the reverse side is gold. The front bears an engraved cross with six arms, the reverse a heart-shaped, filigree pattern in opposed S-shaped scrolls with granulation.

Provenance: Cathedral of the Annunciation, Moscow Kremlin
Main collection of the Armory (Inv. no. 604)
Russia, 13th century
Silver, gold; casting, chasing, matting, engraving, filigree, gilding
H. 5⅛ in. (13 cm.); W. 3⁹/₁₆ in. (9 cm.)

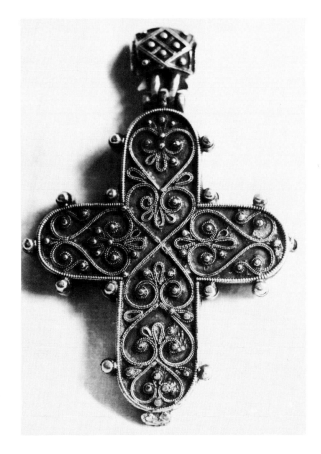

Russian Gold and Silver 155

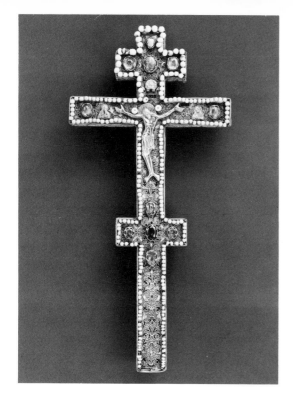

19. *Altar cross*
(Colorplate, p. 54)

Gold, with eight arms; with precious stones, pearls, and filigree floral pattern in enamels of different colors. The front center carries an applied, cast crucifix with half-length depictions of the Attendants; the reverse bears niello depictions of saints and the cross of Golgotha. An inscription tells us that the altar cross was a gift of Ivan the Terrible to the Solovetsky Monastery.

Accessioned from the Museum Fund in 1922 (Inv. no. 2566)
Moscow, Kremlin workshops, 1562
Gold, precious stones, pearls; casting, engraving, chasing, niello, filigree, enameling
H. 15¾ in. (40 cm.); W. 7½ in. (19 cm.)

Exhibited: *Ancient Russian Applied Art,* Japan, 1964

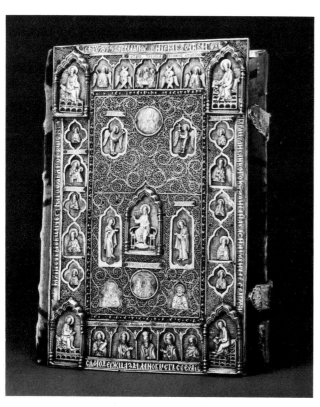

20. *Gospels*
(Colorplates, pp. 55, 56)

An altar Gospels in manuscript with painted illuminations and initials. The silver-gilt cover is decorated with filigree and applied cast, engraved figures. The front center carries a three-figure Deësis with the figures of the seated Evangelists in the corners. Saints are depicted around the Deësis against a filigree background and along the frame. An inscription is engraved along the edge of the front cover.

Presented by Ivan the Terrible to the Cathedral of the Annunciation in the Moscow Kremlin in 1568 (Inv. no. 711)
Provenance: Cathedral of the Annunciation, Moscow Kremlin
Text: Russia, 16th century; cover: Moscow, 1568
Silver, wood, paper, fabric; casting, engraving, filigree, granulation, gilding
L. 13³/₁₆ in. (33.5 cm.); W. 8¼ in. (21 cm.)

Exhibited: *L'URSS et la France: Les Grands Moments d'une tradition,* France, 1974–75

21. *Holy water basin*
(Colorplate, p. 57)

Silver, partly gilded, with two handles on a low copper base decorated with chased gadroons and open floral ornament. The rim of the bowl carries an incised inscription and the interior an enameled hemispherical medallion.

Donated by the boyar V.F. Skopin-Shuisky to the Solovetsky
 Monastery in 1586
Accessioned from the State Art Depository in 1922 (Inv. no. 2587)
Russia, 1586
Silver, copper; chasing, engraving, champlevé enameling, gilding
H. 9⅞ in. (25 cm.); Diam. 19⁵/₁₆ in. (49 cm.)

Exhibited: *The Culture and Art of Ancient Russia,* USSR, 1969;
From Ancient to Modern Times, Czechoslovakia, 1970

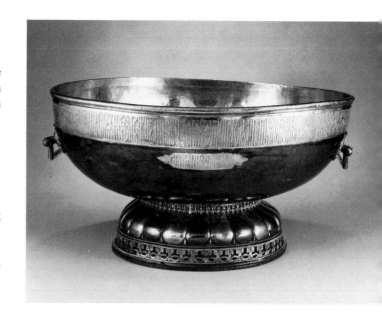

22. *Reliquary diptych*
(Colorplates, pp. 58, 59)

Gold, in the form of two rectangular sections decorated with niello, precious stones, and pearls. The front bears a chased depiction in high relief of the Virgin Enthroned with the Child. The reverse presents a niello, full-length depiction of Irina the Martyr carrying a scroll and a cross.

A gift from Czar Fedor Ivanovich to Czaritsa Irina
Accessioned from the Monastery of the Ascension, Moscow
 Kremlin, in 1918 (Inv. no. 15400)
Moscow, Kremlin workshops, 1589
Gold, precious stones, pearls; niello, engraving, chasing
Each wing H. 4⅝ in. (11.8 cm.); W. 2⁹/₁₆ in. (6.5 cm.)

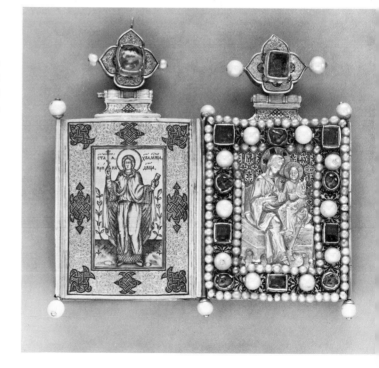

Russian Gold and Silver 157

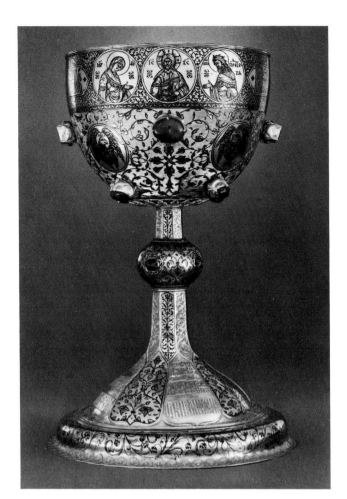

23. *Chalice*
(Colorplates, pp. 60, 61)

Gold, decorated in a niello pattern of floral scrolls with large precious stones in raised, chased mounts. The rim carries a liturgical inscription and niello depictions of a three-figure Deësis and the cross of Golgotha. Below this are round medallions with the symbols of the Evangelists. An incised inscription in the heart-shaped panels on the base states that the chalice was manufactured in memory of Czar Fedor Ivanovich.

Presented by Czaritsa Irina Fedorovna to the Cathedral
 of the Archangel Michael in 1598 (Inv. no. 12449)
Provenance: Cathedral of the Archangel Michael,
 Moscow Kremlin
Moscow, Kremlin workshops, 1598
Base: Moscow, late 18th century
Gold, precious stones; chasing, niello, engraving
H. 10⅝ in. (27 cm.); Diam. of bowl 5½ in. (14 cm.)

Exhibited: *Ancient Russian Applied Art,* Japan, 1964

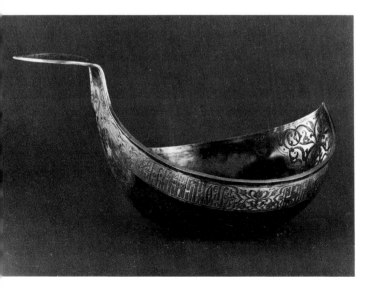

24. *Kovsh, or dipper*
(Colorplates, pp. 61, 62)

Silver, of deep, elongated form with a high handle and a high, sharp "prow." Decorated with gilding and engraved foliate pattern. Engraved medallions below the handle and the prow contain a lion and a griffin.

Formerly the property of Boyar Fedor Nikitich Romanov
Main collection of the Armory (Inv. no. 1388)
Moscow, Kremlin workshops, late 16th or early 17th century
Silver; engraving, gilding
H. 5⅛ in. (13 cm.); L. 9⅞ in. (25 cm.); W. 6¹¹/₁₆ in. (17 cm.)

25. *Panagiia, or pectoral icon*
(Colorplate, p. 63)

Silver, on a rectangular base and with a rounded top; the gilded frame is decorated with filigree. The front carries gilded cast figures representing the Crucifixion. On the reverse are the engraved images of the apostle Philip and Ipatii the Martyr.

Accessioned from the Kostroma State Museum in 1931
 (Inv. no. 18525)
Russia, late 16th or early 17th century
Silver, velvet; casting, engraving, filigree, gilding
H. 5⅝ in. (14.3 cm.); W. 3¹⁵/₁₆ in. (10 cm.)

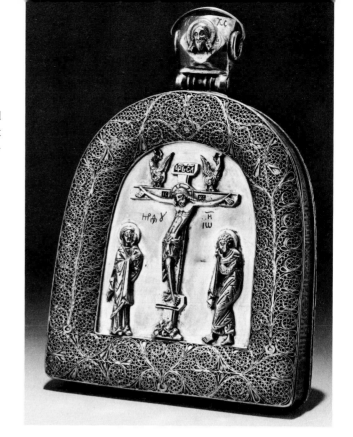

26. *Gospels*
(Colorplate, p. 65)

Painted illustrations and gilded illuminations embellish the manuscript. The wooden binding is covered in gold brocade with silver-gilt plaques depicting the Crucifixion and the Evangelists.

Accessioned from the Patriarch's Treasury in 1920
 (Inv. no. 13911)
Text: Russia, 16th century; cover: Russia, early 17th century
Silver, wood, paper, cloth; engraving, chasing, matting, gilding
H. 8¼ in. (21 cm.); W. 6⅛ in. (15.5 cm.)

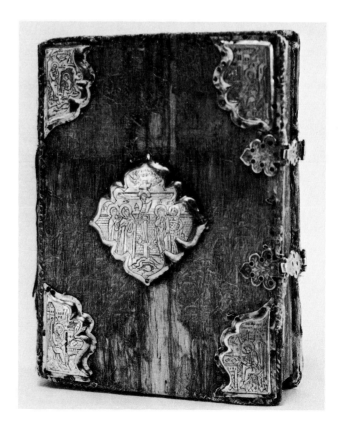

Russian Gold and Silver 159

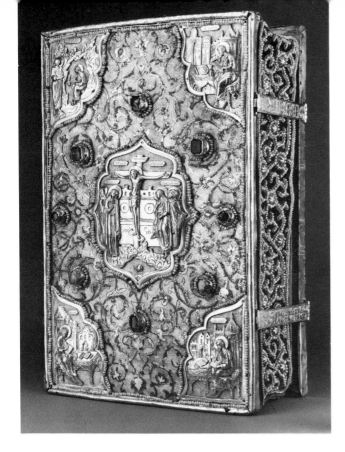

27. *Gospels*
(Colorplate, p. 64)

Altar Gospels; the manuscript decorated with illuminated vignettes and initials. The cover is silver gilt with niello floral ornament, precious stones, and chased representations of the Crucifixion and the four Evangelists.

Presented by the boyar prince Dmitrii Mikhailovich Pozharsky to the Solovetsky Monastery in 1613.
Accessioned from the State Art Depository in 1922 (Inv. no. 2834)
Text: Russia, 16th century
Cover: Russia, 17th century
Silver, precious stones, pearls, glass, wood, paper, cloth; niello, engraving, chasing, pearl embroidery, matting, gilding
H. 17¾ in. (45 cm.); W. 11¼ in. (28.5 cm.)

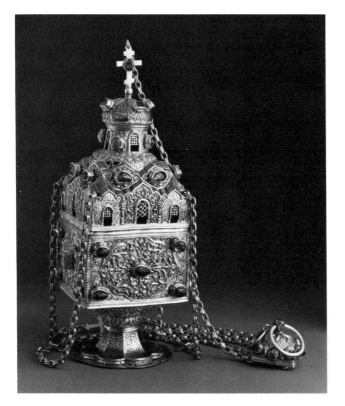

28. *Censer*
(Colorplates, p. 66)

Gold, in the form of a single-cupolaed church with bulbous dome. Cubic shape with two rows of gables *(kokoshniki)*. Decorated with chased and niello foliate ornament and precious stones. The inscription on the base tells us that the censer was presented by Czar Mikhail Fedorovich to the Troitse-Sergiev Monastery in 1616.

Accessioned from the Zagorsk State Historical and Art Museum in 1928 (Inv. no. 19773)
Moscow, Kremlin workshops, 1616
Masters: Tretiak Pestrikov and Daniil Osipov
Gold, precious stones; chasing, niello, engraving, matting
Total H. 12⅜ in. (31.5 cm.); W. 4⁵⁄₁₆ in. (11 cm.)

29. Kovsh, or dipper

(Colorplates, p. 67)

Gold, set with precious stones. Figures in a niello foliate pattern framed in pearl are inset into the handle and the prow. The bottom bears a double-headed eagle. The rim bears a nielloed inscription stating that the dipper was a gift to Czar Mikhail Fedorovich from his mother, Sister Marfa, in 1618.

Main collection of the Armory (Inv. no. 1123)
Moscow, Kremlin workshops, 1618
Gold, precious stones, pearls; chasing, niello
H. 5⅛ in. (13 cm.); L. 11¹³/₁₆ in. (30 cm.)

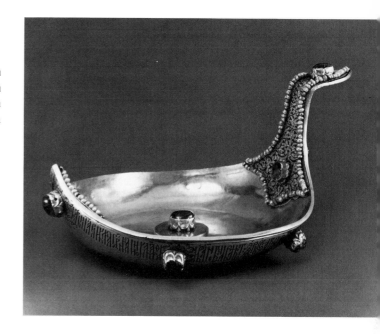

30. Brátina, or toasting bowl

Silver, partly gilded, with pointed plaques chased with foliate ornament. The rim carries embossed depictions of lions, griffins, and unicorns supporting a plaque stating that the brátina belonged to I. T. Gramotin.

Accessioned from the Patriarch's Treasury in 1920
 (Inv. no. 12168)
Moscow, Kremlin workshops, second quarter of 17th century
Silver; chasing, engraving, gilding
H. 4⁵/₁₆ in. (11 cm.); Diam. of neck 4⁷/₁₆ in. (11.3 cm.)

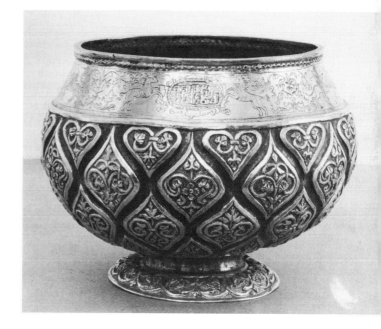

Russian Gold and Silver 161

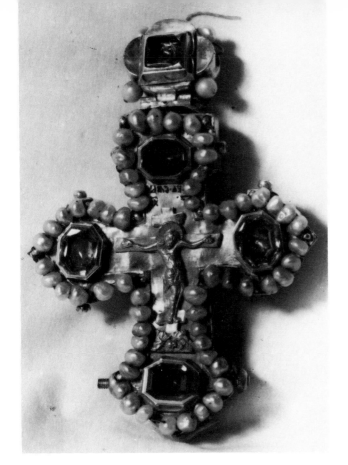

31. *Pectoral cross and reliquary*

Gold, with four arms with shaped ends; set with precious stones and pearls. On the front is a chased, applied figure of Christ crucified.

Formerly the property of Czar Mikhail Fedorovich
Accessioned from the State Art Depository in 1926
 (Inv. no. 16541)
Moscow, early 17th century
Gold, precious stones, pearls; chasing, engraving, niello
H. 4¹¹/₁₆ in. (12 cm.); W. 3⅛ in. (8 cm.)

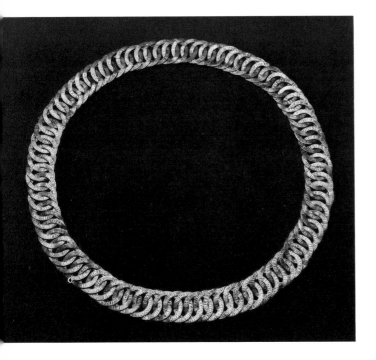

32. *Chain*
 (Colorplate, p. 68)

Gold, composed of eighty-eight rings. The rings are narrow, flat, and oval and bear engraved inscriptions—the full title of the czar—on a matted background.

Formerly the property of Czar Mikhail Fedorovich
Main collection of the Armory (Inv. no. 128)
Moscow, before 1642
Gold; chasing, engraving, matting, stamping
Diam. of each ring 1⁷/₁₆ in. (3.6 cm.)

33. *Brátina, or toasting bowl*
(Colorplate, p. 68)

Silver gilt with pointed lid; decorated with a chased foliate pattern. The rim carries an inscription: "True love is like a golden vessel. It never breaks, and if it bends, reason will set it to rights."

Formerly the property of Prince V. V. Golitsyn
Main collection of the Armory (Inv. no. 1274)
Moscow, Kremlin workshops, 1642
Master: Fedor Evstigneev
Silver; chasing, engraving, matting, gilding
H. 7 in. (17.7 cm.); Diam. of neck 1¾ in. (4.4 cm.)

Exhibited: *Ancient Russian Applied Art*, Japan, 1964; *L'Art russe des Scythes à nos jours*, France, 1967–68; *Soviet Union: Arts and Crafts in Ancient Times and Today*, USA, 1972

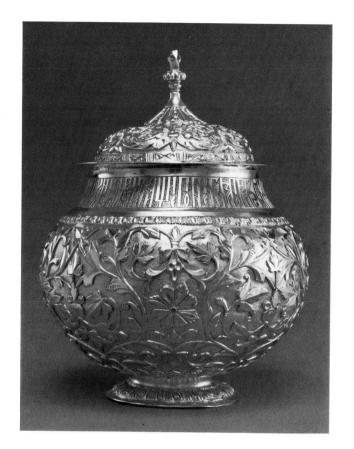

34. *Charka, or cup*
(Colorplate, p. 69)

Silver gilt; round, on three feet in the form of lions; decorated with chased, foliate ornament. The flat handle bears a chased scene of Samson forcing open the lion's jaws. The rim carries an engraved inscription: "Do not seek wisdom but meekness, for if you find meekness you will have wisdom."

Accessioned from the collection of L. K. Zubalov in 1924
(Inv. no. 16085)
Moscow, 17th century
Silver; casting, chasing, engraving, matting, gilding
H. 1⅝ in. (4.2 cm.); W. 3¾ in. (9.5 cm.)

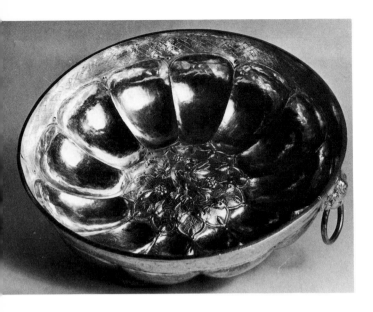

35. *Traveling charka, or cup*

Silver, partly gilded, and gadrooned, the bottom bearing a chased depiction of a bird. The handle is decorated with a mask in the form of a lion's head. The rim carries an inscription: "One drink is healthy, a second cheers the heart, a third clears the mind."

Accessioned from the State Art Depository in 1924
 (Inv. no. 15831)
Moscow, 17th century
Silver; casting, chasing, engraving, matting, gilding
H. 2¼ in. (5.8 cm.); Diam. 8¹¹/₁₆ in. (22 cm.)

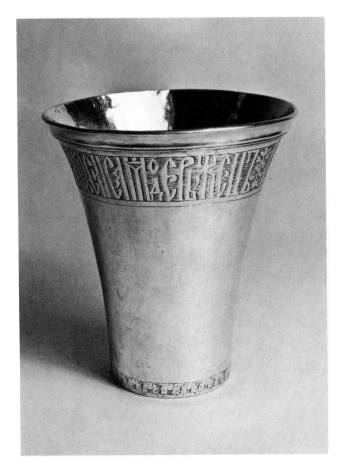

36. *Beaker*

Silver gilt, with flaring mouth. The inscription on the rim indicates that the beaker belonged to Czar Mikhail Fedorovich.

Main collection of the Armory (Inv. no. 2128)
Moscow, Kremlin workshops, first half of 17th century
Silver; chasing, engraving, gilding
H. 5⁷/₁₆ in. (13.8 cm.); Diam. 4¹¹/₁₆ in. (12 cm.)

164 Treasures from the Kremlin

37. *Endová, or drinking bowl with a spout*
 (Colorplate, p. 69)

Silver, partly gilded, in the form of a flattened, spherical vessel chased with gadroons and plain and repoussé foliate patterns. The inscription on the rim indicates that the endová belonged to the okolnichii V.I. Streshnev (an okolnichii occupied a social status second to that of a boyar during the Muscovite period).

Accessioned from the State Art Depository in 1924 (Inv. no. 15822)
Moscow, Kremlin workshops, 1644
Silver; chasing, engraving, matting, gilding
H. 6^{11}/$_{16}$ in. (17 cm.); Diam. at rim 9^{13}/$_{16}$ in. (25 cm.)

38. *Halo from an icon of the Mother of God*
 (Not illustrated)

Chased silver gilt with a figured top border depicting "cities" with winged cherubs between them. Decorated with applied precious stones in gold settings.

Provenance: Fund of Ecclesiastical Treasures, Severo-Dvinsk (Inv. no. 19149)
Russia, second half of 17th century
Gold, silver, precious stones, pearls; chasing, engraving, matting, gilding
H. 24 in. (61 cm.); W. 20^{7}/$_{8}$ in. (53 cm.)

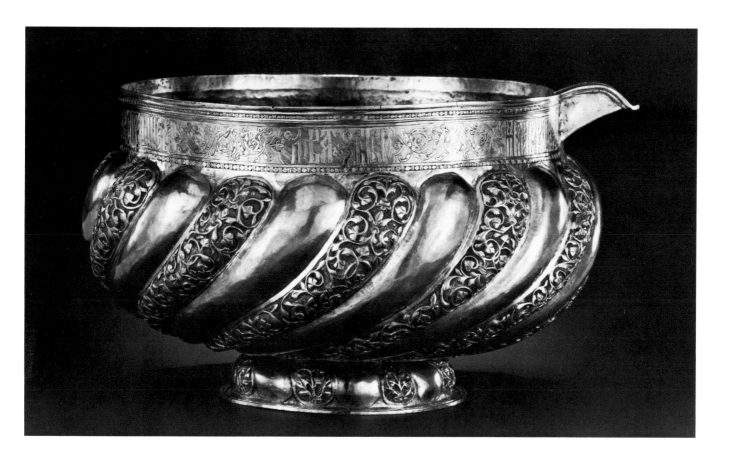

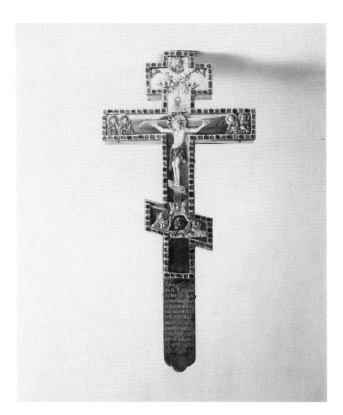

39. *Altar cross*
(Colorplate, p. 70)

Cross with eight arms; silver gilt with precious stones. The enameled plaques represent the Crucifixion and half-length figures of the Attendants. The inscription on the base tells us that Czar Fedor Alexeevich donated this cross to the Upper Savior Church in the Moscow Kremlin. Inscriptions on the reverse refer to relics.

Accessioned from the palace treasury in 1922 (Inv. no. 12544)
Moscow, Kremlin workshops, 1677
Silver, gold, precious stones; chasing, engraving, niello, enameling, gilding
H. 14 in. (35.5 cm.); W. 6¹¹/₁₆ in. (17 cm.)

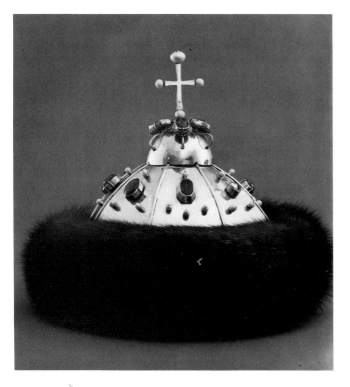

40. *"Cap of Monomach" from the minor robes of state*
(Colorplate, p. 71)

A gold hemisphere composed of eight plain panels with a cross at the apex. Decorated with precious stones and pearls. The edging is of sable.

Formerly the property of Peter the Great
Main collection of the Armory (Inv. no. 62)
Moscow, the Silver Chamber, 1682–84 (?)
Gold, precious stones, pearls; chasing, casting, engraving
H. 8 in. (20.3 cm.); Circum. 24 in. (61 cm.)

41. *Covered bowl*

(Colorplate, p. 72)

Silver gilt, of cylindrical and slightly tapering form, with a pointed lid. Decorated with engraved foliate ornament on a niello ground. The embossed inscription on the rim indicates that the beaker belonged to the regent Czarevna Sofia Alexeevna.

Main collection of the Armory (Inv. no. 2612)
Moscow, Kremlin workshops, 1685
Masters: Mikhail Mikhailov and Andrei Pavlov
Silver; chasing, niello, engraving, gilding
H. 4¹³/₁₆ in. (12.2 cm.); W. 4¹⁵/₁₆ in. (12.5 cm.)

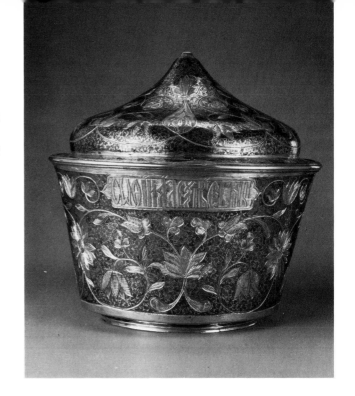

42. *Candlestick*

Silver gilt with indented foliate plaques on a round, chased base on three ball feet.

Accessioned from the Patriarch's Treasury in 1920 (Inv. no. 11650)
Moscow, 1692
Master: Semen Medvedev of the Patriarch's Palace
Silver; chasing, engraving, gilding
H. 29⅛ in. (74 cm.); Diam. of base 10¼ in. (26 cm.)

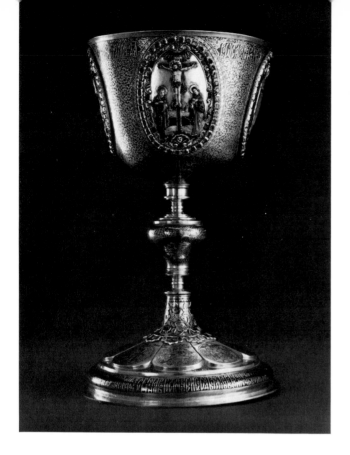

43. *Chalice*
(Colorplates, pp. 73, 74)

Gold, decorated with fine foliate patterns and oval medallions framed by precious stones. The medallions carry chased, multicolored enamel depictions of a three-figure Deësis and the cross of Golgotha. The foot of the cup carries niello depictions of seraphim. The base bears scenes from the Passion and an embossed inscription indicating that the metropolitan Ioasaf donated the cup to the Church of the Assumption in Rostov in 1695.

Accessioned from the State Yaroslavl Museum in 1926
 (Inv. no. 19818)
Moscow, Kremlin workshops, 1695
Gold, precious stones; chasing, niello, enameling, casting
H. 12¹³⁄₁₆ in. (32.5 cm.); Diam. of bowl 6⅞ in. (17.5 cm.)

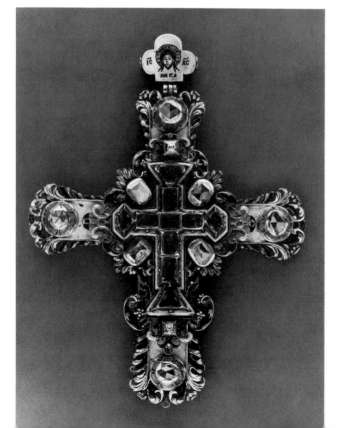

45. *Pectoral cross*
(Colorplates, pp. 76, 77)

Gold, with decorated outline and hinged trefoil attachment. Set with precious stones and multicolored enamel. At the center of the front is an inset emerald cross on which a Crucifixion is engraved. The reverse carries a depiction of the apostle Peter, and the attachment bears an enamel depiction of the Holy Face.

Formerly in the possession of Peter the Great
Main collection of the Armory (Inv. no. 90)
Moscow, last quarter of 17th century
Gold, precious stones; casting, chasing, carving, enameling
H. 6⅛ in. (15.6 cm.); W. 4³⁄₁₆ in. (10.7 cm.)

44. *Zvezditsa, or star-shaped frame to support the veil over communion bread*
(Colorplate, p. 75)

Gold, chased with fine foliate ornament and medallions bearing chased, enameled depictions of the four cherubim and God Sabaoth.

Accessioned from the State Rostov Museum in 1926
 (Inv. no. 19829)
Moscow, Kremlin workshops, 1695
Gold, precious stones; chasing, niello, enameling
L. of each arc 18⅛ in. (46 cm.)

46. *Paten*
(Colorplate, p. 75)

Silver, on a high, openwork, chased base. The bottom of the bowl is inset with an enamel depiction of the Eucharistic Lamb.

Provenance: Palace property (Inv. no. 11967)
Moscow, Kremlin workshops, late 17th century
Gold, silver, precious stones; chasing, engraving, enameling, matting
H. 4¹³⁄₁₆ in. (12.3 cm.); Diam. of bowl 10⁷⁄₁₆ in. (26.5 cm.)

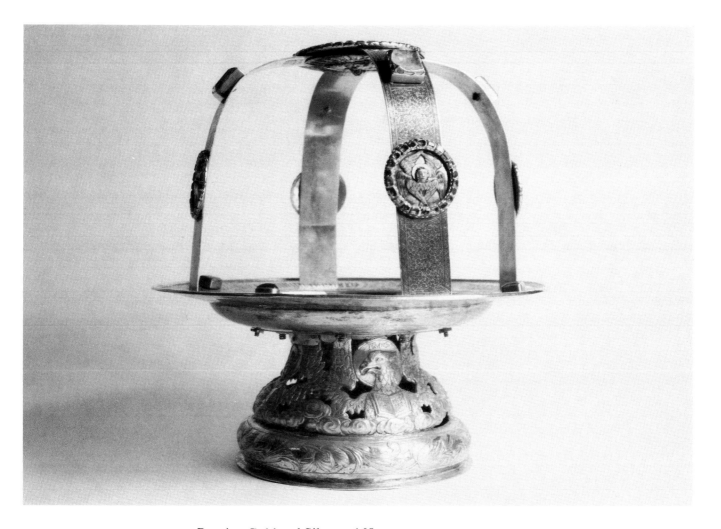

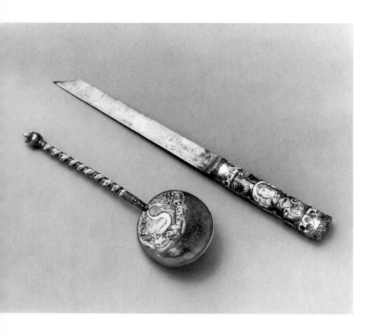

47. *Knife*
(Colorplate, p. 78)

A table knife of damask steel. The handle is silver gilt with foliate filigree ornament decorated with enamel. Two round medallions bear painted enamel depictions of male figures.

Accessioned from the Patriarch's Treasury in 1920
 (Inv. no. 12423)
Solvychegodsk, late 17th century
Silver, damask steel; painted enamel, filigree, gilding
L. 9¹⁵/₁₆ in. (25.2 cm.)

48. *Spoon*
(Colorplate, p. 78)

Silver, with multicolored enamel depictions, the front of the bowl showing a swan swimming, the back two birds.

Accessioned from the collection of L. K. Zubalov in 1924
 (Inv. no. 16100)
Solvychegodsk, late 17th century
Silver; painted enamel, filigree, chasing
L. 3⁵/₁₆ in. (8.4 cm.)

Exhibited: *Ancient Russian Applied Art,* Japan, 1964

49. *Bowl*
(Colorplates, pp. 78, 80)

Silver gilt; round, on a shallow base. Decorated on both sides with garlands of large flowers in painted enamel framed with filigree. The bottom of the bowl carries a painted enamel depiction of a lion; on the outside is a large, many-petaled flower.

Main collection of the Armory (Inv. no. 2783)
Solvychegodsk, late 17th century
Silver; painted enamel, filigree, gilding
Diam. 6⁷/₁₆ in. (16.3 cm.)

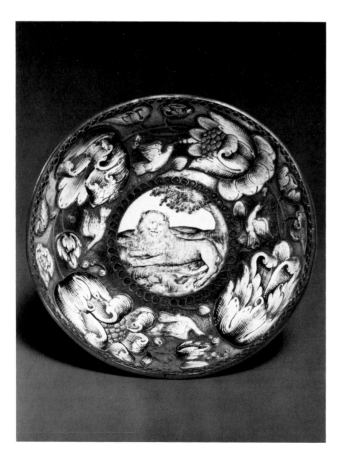

50. *Bowl*
(Colorplates, pp. 78, 79)

Silver; round, on a shallow base. Enamel flowers in filigree on a gilded ground decorate the outside. Allegorical depictions of the five senses (Taste, Sight, Smell, Hearing, Touch) are painted in medallions over white enamel on the inside of the bowl.

Main collection of the Armory (Inv. no. 1154)
Solvychegodsk, late 17th century
Silver; painted enamel, filigree, gilding
Diam. 6³/₁₆ in. (15.8 cm.)

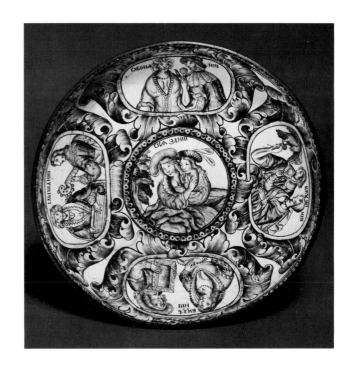

51. *Casket*
(Colorplate, p. 78)

Silver, in the form of a rectangular box with a hinged lid and canted sides. A filigree foliate pattern in painted enamel decorates a gold ground. The inside of the lid bears a hunting scene in enamel on a white enamel ground.

Accessioned from the collection of L.K. Zubalov in 1924
 (Inv. no. 16094)
Solvychegodsk, late 17th century
Silver; painted enamel, filigree, gilding
H. 4⁵/₁₆ in. (11 cm.); L. 7¹¹/₁₆ in. (19.5 cm.); W. 4⁵/₁₆ in. (11 cm.)

Exhibited: *L'URSS et la France: Les Grands Moments d'une tradition*, France, 1974–75

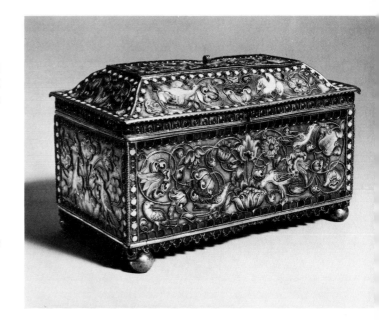

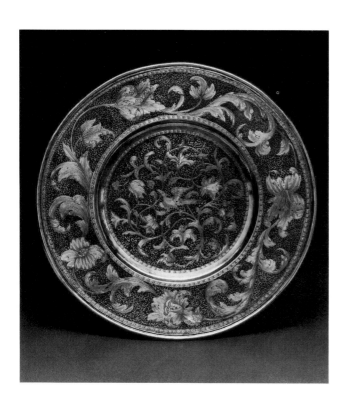

52. *Plate*
(Colorplate, p. 81)

Silver gilt, with niello ground showing an engraved foliate ornament and a bird sitting on a branch.

Main collection of the Armory (Inv. no. 2653)
Moscow, Kremlin workshops, late 17th century
Silver; chasing, niello, engraving, gilding
Diam. 8^{11}/$_{16}$ in. (22 cm.)

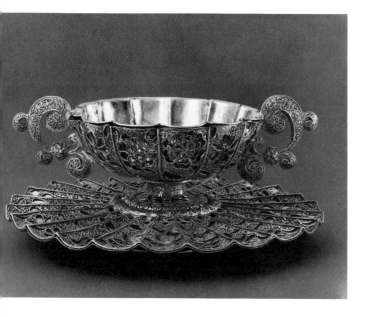

53. *Soup tureen*
(Colorplates, pp. 82, 83)

Silver, with two shaped handles and stand. Decorated with filigree and chased reliefs. Stylized foliate patterns appear as a silver filigree tracery.

Formerly the property of the Dolgorukii princes
 (Inv. nos. 12102, 12103)
Provenance: Palace property
St. Petersburg, 1737
Silver; chasing, filigree, gilding
H. without stand 2^{7}/$_{8}$ in. (7.4 cm.); Diam. 6 in. (15.2 cm.)
H. of stand 1^{3}/$_{16}$ in. (3 cm.); Diam. 9^{13}/$_{16}$ in. (25 cm.)

Exhibited: *L'Art russe des Scythes à nos jours*, France, 1967

54. *Gospels*
(Colorplates, pp. 84, 85)

Altar Gospels, printed with woodcuts and vignettes. Cover silver gilt, chased, with enamel medallions at the center and corners. The central medallion bears a depiction of the Descent into Hell, the corners the Evangelists with their symbols against architectural backgrounds.

Inv. no. 19594
Text: Moscow, 1681; cover: Moscow, 1772
Silver; chasing, painted enamel, gilding
Paper; woodcuts
H. 19¹¹/₁₆ in. (50 cm.); W. 12 in. (30.5 cm.); D. 3⁹/₁₆ in. (9 cm.)

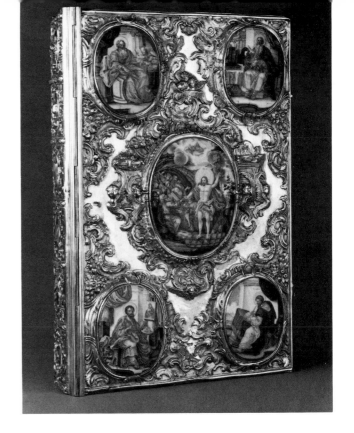

55. *Altar cross*
(Colorplates, pp. 86, 87)

Eight-armed. Silver, partly gilded, with niello depictions of the Crucifixion, God Sabaoth, the Virgin, St. John the Evangelist, and the pillar with the instruments of the Passion. The reverse bears chased rocaille medallions, one with an engraved inscription stating that the cross was made for the Church of Nicholas the Miracle Worker, Moscow, in 1774.

Inv. no. 19504
Moscow, 1774
Silver; chasing, matting, gilding, niello
H. 18⅛ in. (46 cm.); W. 12⅝ in. (32 cm.)

Exhibited: *Russian Decorative and Applied Art of the 18th–Early 20th Centuries*, USSR, 1973–76

Russian Gold and Silver 173

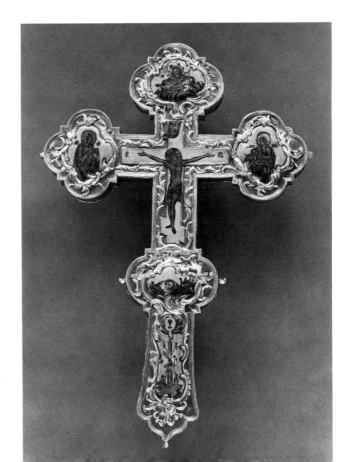

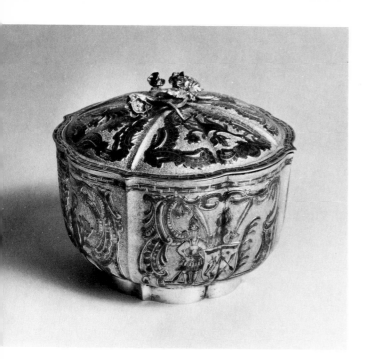

56. *Sugar bowl with lid*

Silver gilt, globular. Decorated with depictions of birds, the monogram "DCh" in Cyrillic, and the coat of arms of D. I. Chicherin in niello inset in rocaille medallions.

Provenance: From a tea service belonging to D. I. Chicherin
Accessioned from the State Art Depository in 1924
 (Inv. no. 15808)
Tobolsk, 1774
Marks: Tobolsk and the silversmith's monogram PMSh in Cyrillic
Silver; casting, niello, matting, gilding
H. 4³/₁₆ in. (10.7 cm.); Diam. at rim 5 in. (12.7 cm.); Diam. at base
 3⅜ in. (8.5 cm.)

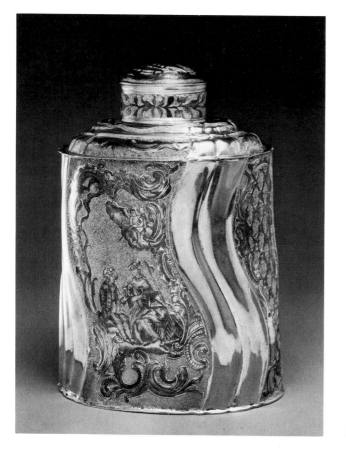

57. *Tea caddy*
 (Colorplates, pp. 88, 89)

Silver gilt, the body chased with oblique fluting. The niello panels depict pastoral scenes. There is a rounded slip-on cover.

Inv. no. 18210
Tobolsk, 1776
Silver; niello, matting, chasing, gilding
H. 7⁵/₁₆ in. (18.5 cm.); W. at base 4¹⁵/₁₆ in. (12.6 cm.)

58. *Coffeepot*
(Colorplate, p. 88)

Silver gilt, on three legs. Decorated in rocaille with hunting scenes in niello. The lid carries cast leafage and a silver flower. A niello inscription below the spout states the place and date of manufacture.

Inv. no. 15814
Provenance: Palace property
Tobolsk, 1779
Silver, wood; niello, matting, casting
H. 7⅞ in. (20 cm.)

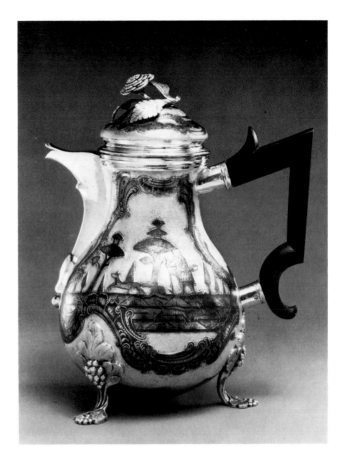

59. *Paten*
(Colorplate, p. 90)

Silver, partly gilded, with niello depictions of the Eucharistic Lamb, angels, and God Sabaoth on a matted ground.

Inv. no. 19035
Provenance: City of Viatka
Velikii Ustiug, 1770s
Silver; chasing, matting, gilding
H. 3¹⁵/₁₆ in. (10 cm.); Diam. of bowl 10¹³/₁₆ in. (27.5 cm.)

60. *Zvezditsa, or star-shaped frame to support the veil over communion bread*
(Colorplate, p. 90)

Silver, partly gilded, with niello depictions of the Evangelists, cherubim, and God Sabaoth on a matted ground.

Inv. no. 20143
Provenance: Fund of Ecclesiastical Treasures
Velikii Ustiug, 1770s
Silver; niello, matting, gilding
L. of each arc 16½ in. (42 cm.)

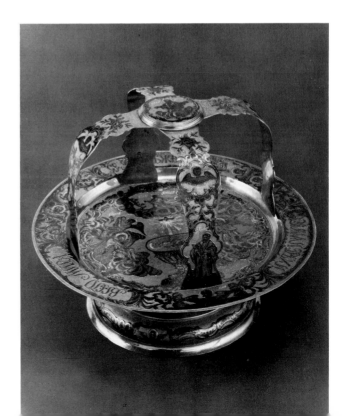

Russian Gold and Silver 175

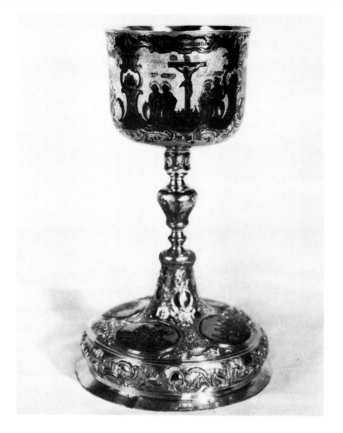

61. *Chalice*

Silver, partly gilded, with niello half-figure depictions of the Deësis, Nicholas the Miracle Worker, the Archangel Michael, and the archdeacon Lavrentii. The base is decorated with chased flowers, stylized shells, and four medallions with niello compositions on the theme of the Passion.

Inv. no. 19470
Velikii Ustiug, second half of 18th century
Silver; chasing, niello, matting, gilding
H. 13¼ in. (33.6 cm.); Diam. of base 7¹¹/₁₆ in. (19.6 cm.)

62. *Platter*

Round, silver gilt. A dedicatory inscription in the panels around the rim states that the platter is a gift from the citizens of Mikhailovsky Village to General Count M. I. Platov, hero of the war of 1812. His monogram is chased in the depression of the platter and framed with branches and military attributes.

Inv. no. 19540
Moscow, 1814
Silver; chasing, matting, niello, gilding
H. ¹¹/₁₆ in. (1.8 cm.); Diam. 18½ in. (47 cm.)

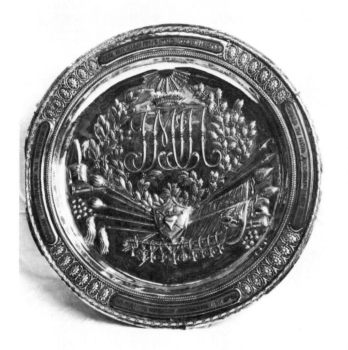

63. *Covered serving dish*
(Colorplates, pp. 91–93)

Silver, with gilded interior. Round, with two handles and a lid. The body bears a nielloed depiction of the embankment of the town of Vologda and Vologda Cathedral. The lid carries a niello depiction of the globe and the coats of arms of the ten districts of Vologda province.

Accessioned from palace property in 1923 (Inv. no. 15256)
Vologda, 1837
Master: Sakerdon Skripitsyn
Silver; niello, gilding
H. 3³⁄₁₆ in. (8.1 cm.); Diam. 8⁷⁄₁₆ in. (21.5 cm.)

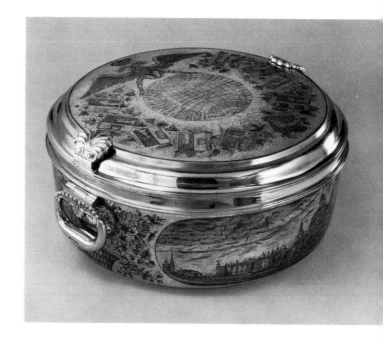

64. *Stylized model of the Moscow Kremlin*
(Colorplates, pp. 94, 95)

Gold, with silver, on a base of white schistose onyx. An enameled egg with the cupola of the Cathedral of the Assumption is in the center. Inside the egg a glass painting reproduces the interior of the cathedral. The model contains a musical mechanism.

Provenance: Gift of Emperor Nicholas II to Empress Alexandra
 Fedorovna at Easter
Accessioned from the Foreign Currency Fund in 1927
 (Inv. no. 17135)
St. Petersburg, 1904
Maker: House of Carl Fabergé
Gold, silver, glass, onyx; enameling, engraving, oil paint
H. 14³⁄₁₆ in. (36.1 cm.); Diam. of base 17⁵⁄₁₆ in. (18.5 cm.)

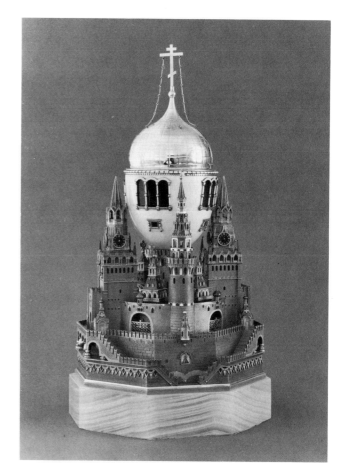

Russian Gold and Silver 177

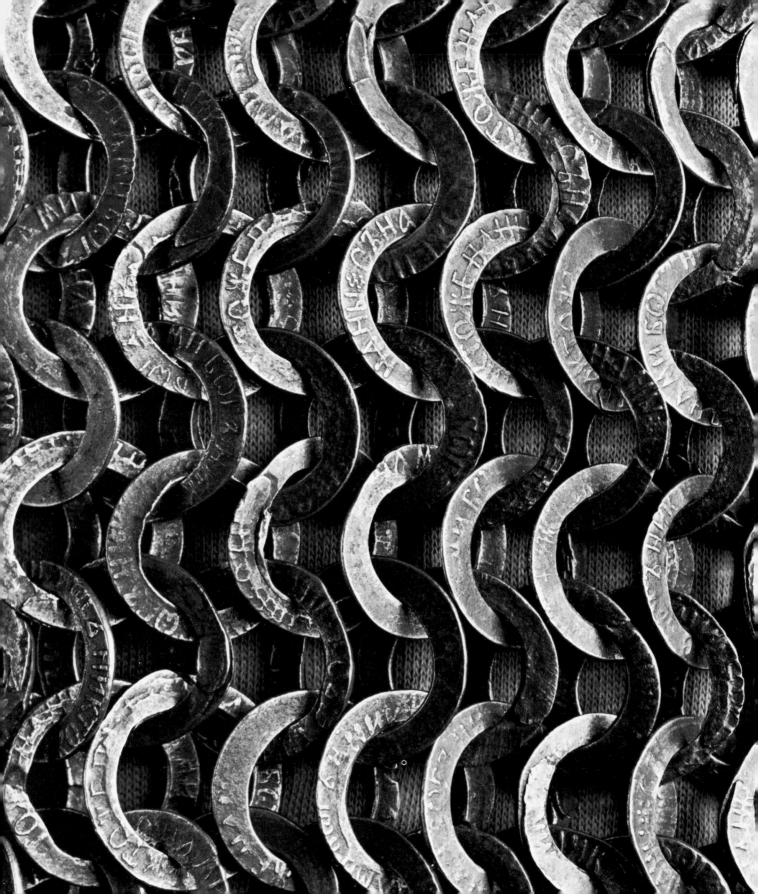

3. ARMS AND ARMOR

The Kremlin Museums contain a large and interesting collection of ceremonial and hunting weapons of Russian, European, and oriental manufacture. The collection, formed gradually over the years, is distinguished by the extraordinary technical accomplishment it demonstrates and the splendid decoration of its pieces. Relics of national interest are a major part of the collection, and many works are connected with the names of Russian statesmen and events crucial to the history of Russia.

The earliest written reference to the Armory is a chronicle of the early sixteenth century. At that time the collection was not only an arsenal, but also a main center for the manufacture of military and ceremonial armaments. Throughout the sixteenth and seventeenth centuries the collection continued to expand, and pieces were acquired from members of the czar's family, from state and military leaders, and from foreign monarchs, ambassadors, and merchants; other objects in the collection were manufactured by the craftsmen of the Armory itself. Later this treasure house was supplemented by weapons transferred from the Rüstkammer in St. Petersburg, by many items of historic interest from the Troitse-Sergiev Monastery, by unique archaeological finds, and by the most interesting pieces from the private collections of P. F. Korobanov and M. P. Pogodin. The most significant part of the Armory's holdings is the exceptional collection of Russian weaponry from the sixteenth and seventeenth centuries. In defending the frontiers of its land over the centuries, the Russian people developed a weaponry that was flexible, maneuverable, reliable, and sturdy enough to withstand attacks by light eastern cavalry or heavily armed knights from the west.

In the fourteenth through sixteenth centuries the armored headdress was popular among Russian warriors. It is represented here by the helmet (*shishak,* **65**) commissioned by Ivan the Terrible for his three-year-old son, Czarevich Ivan Ivanovich, in 1557. These helmets were of an elongated

etail of 66. *Coat of chain mail (baydàna)*
nce belonging to Boris Godunov (see p. 184)

cone shape, with a tall, thin "spire" on top to which bright pennants or colors were attached. Earflaps to protect the cheeks and ears were fastened to the bottom edge of the helmet. The surface of the shishak shone with polished steel and was sometimes chased with straight or curved lines to enhance its elegant form.

Chain mail was an important part of the armor of the Russian warrior. A coat of chain mail was woven from hundreds of tiny rings and was worn over a thick quilted garment. Although of steel, it was also flexible in order to protect the warrior's body without hindering his movements. There were various kinds of chain mail. The piece in the exhibition is Boris Godunov's *baydàna* (**66**), woven from large flat rings, each of which bears the inscription: "God is with us, no one can overcome us." Chain mail actually worn in battle was often supplemented with metal plates of various shapes and sizes—thus, such armor is known by many names: *bakhtertsy*, *yushmany*, and mirror armor. In the seventeenth century the surface of the plates on ceremonial armor was richly decorated with various scenes and with ornaments and inscriptions.

The broad chronological span of the pieces exhibited here allows the viewer to form an idea of the technical and practical accomplishments of Russian armorers over the centuries. For several centuries the Russian warrior carried side arms for stabbing and cutting: hatchets, battle hammers, maces, clubs, sabers, and falchions. All of these astonish us by their diversity of forms and attest the high level of craftsmanship among Russian armorers. During the seventeenth century many side arms became symbols of military authority, or ceremonial weapons. Such pieces combined the value of a strong combat weapon with an elegant artistic design, and often they were specially commissioned and made as a joint effort by armorers and jewelers from the Kremlin workshops.

One such piece is a saber of damask steel (**68**) made in 1618 by Ilia Prosvit, an outstanding master of the Armory. The scabbard and hilt are mounted in silver tracery over green velvet. The ornamentation of the blade bears a striking correspondence to its smooth curve and general form. Delicate scrolls, damascened in gold, constitute a precise, restrained pattern harmonizing perfectly with the design of the actual blade. The curve of the blade carries a wide band with an ajouré pattern of flower petals plated in gold and silver. The intricate design of the damascened sword demonstrates exceptional craftsmanship and great artistic taste.

On festive occasions and during official ceremonies in the seventeenth century the *saadak*, or bow case and quiver, was often used. The saadak was made of leather, covered with satin or velvet, and decorated with pearls and gold studs. The saadak in the exhibition (**71**) was made in 1673 in the Kremlin workshops for Czar Alexei Mikhailovich and is of stamped red leather embroidered with gold and silver threads. It is decorated with a traditional panorama of the Moscow Kremlin and the coats of arms of ancient Russian cities and provinces.

During the seventeenth century the Kremlin workshops were the most important center for the manufacture of combat and ceremonial arms, and they employed highly specialized craftsmen. Among those who helped in the manufacture of arms were armorers, cutlers, swordcutlers, craftsmen who mounted the hilts on sabers, barrel-, lock-, and stockmakers, and others. The most experienced craftsmen were known as masters of the gun *(pishchal)* and were responsible for the general design, construction, and assembly of the firearm and sometimes for the manufacture of the barrel and lock as well. The variety of media and methods used to make and decorate metal enabled the Moscow armorers of the seventeenth century to give free rein to their artistic fancies. During this time many ceremonial hunting guns were made by talented craftsmen who introduced elements of the folk arts and crafts into their firearm designs, combining popular ornamental motifs with official heraldic emblems. In this way a unique decorative system, which characterizes the products of the Kremlin workshops, was gradually developed. The Museum collection contains very interesting specimens of work by the outstanding craftsmen Ivan and Timofei Luchaninov, Pervusha Isaev, Dmitrii Konovalov, and Grigorii Viatkin. A hunting gun by Ivan Boltyrev (**72**) is included in the exhibition; its style and ornamentation are typical of the production of the Kremlin workshops in the 1670s–80s.

The pair of saddle pistols (**73**) was manufactured in the Armory workshops. Normally they were kept in two holsters attached to either side of the front arch of the saddle. These particular works are distinguished by their exceptionally sound construction and rich ornamentation.

An important place in the Armory collection of Russian arms is occupied by pieces manufactured by craftsmen from the leading armory centers in Russia during the eighteenth and nineteenth centuries—Tula, Olonets, St. Petersburg, and Zlatoust. The high technical and artistic level

identifiable with such works ensured their fame both in Russia and abroad. During the eighteenth century the general design of Russian firearms followed more and more closely the stylistic development of European applied arts. Nevertheless, within the confines of this or that style, the characteristics of a particular armory center or the individual preferences of a craftsman would always manifest themselves. This is evident from the application of favorite decorative motifs (often connected with the traditions of Russian art) and from some craftsmen's predilection for certain decorative techniques.

The armorers concerned themselves not only with creating arms that were technically perfect, but also with decorating them with engraving, gilding, bone carving, and inlays of both mother-of-pearl and wood. During the second half of the eighteenth century a distinctive decorative device, consisting of nodules of faceted steel, became popular. The cold luster of the steel provided the craftsman with opportunities to create interesting and unique decorative pieces. The scabbards and hilts of both combat and ceremonial side arms were decorated with diamond-cut polished steel; the shafts of pistols and the breech rings of rifles were also decorated in this manner. The saber manufactured in 1801 and bearing the monogram of Alexander I and the coat of arms of the city of Tula is one example of this technique (75). The hilt and scabbard bear nodules of faceted steel.

Besides St. Petersburg and Tula, another important center for the manufacture of side arms in the nineteenth century was Zlatoust. The Zlatoust factory was established in the 1810s on the site of an old metalworks. It was here that P. P. Anosov, the outstanding Russian engineer and metallurgist, invented a successful method of manufacturing Russian damask steel. Zlatoust also had art workshops that produced ceremonial side arms. A remarkable example of Zlatoust work, by Ivan Bushuev, one of its more famous craftsmen, is the saber produced in 1829 (76). The steel blade is decorated with scenes of the liberation of the city of Varna by the Russian army during the Russo-Turkish War of 1828–29. The scenes are executed by etching, gilding, and burnishing—a method popular among the Zlatoust craftsmen. The scabbard is faced with ivory mounted on gilded and burnished steel.

M. N. Larchenko

3. ARMS AND ARMOR

65. *Shishak, or helmet*
(Colorplate, p. 97)

The edge of the crown is decorated with double-headed eagles and lions and carries an inscription stating that the helmet belonged to Czarevich Ivan, son of Ivan the Terrible.

Main collection of the Armory (Inv. no. 4681 [4395])
Moscow, 1557
Steel; chasing, gold damascening
Diam. 7³/₁₆ in. (18.3 cm.)

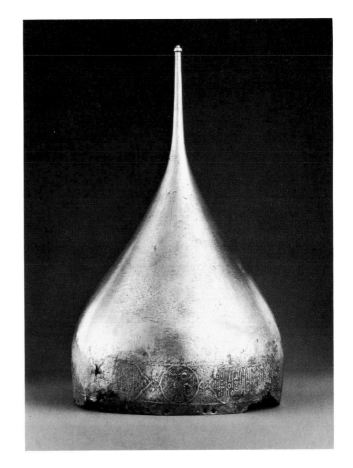

66. *Baydàna, or coat of chain mail*
(Colorplate, p. 98)

Made of large, flat, iron rings joined from behind. The rings carry the engraved inscription ''God is with us, no one can overcome us.''

Formerly in the possession of Boris Godunov
Main collection of the Armory (Inv. nos. 4560 [4835])
Moscow, late 16th century
Iron; engraving, interlinking
L. 31½ in. (80 cm.)

67. *Misiurka with barmitsa (an iron skullcap with chain mail attached)*
(Not illustrated)

The crown is of smooth steel. The barmitsa is of fine, round rings.

Main collection of the Armory (Inv. no. 4734 [4454])
Russia, 17th century
Steel
Diam. 5¹⁵/₁₆ in. (15 cm.)

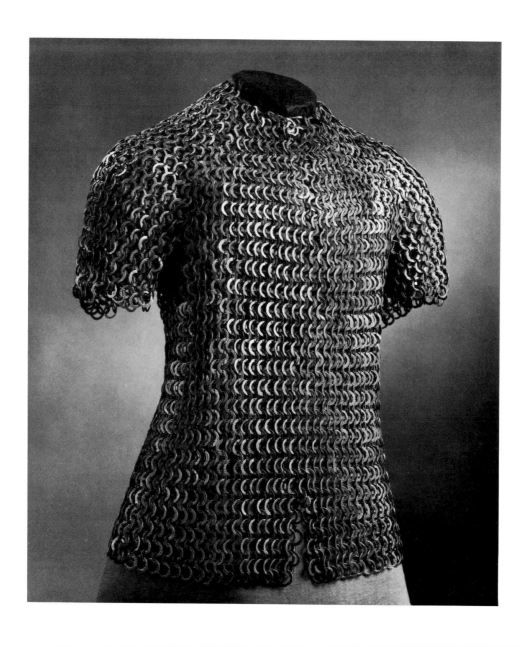

68. *Saber and scabbard*
(Colorplate, p. 99)

The blade of damask steel, engraved and damascened with gold, carries an inscription stating that the saber was made by the master I. Prosvit in 1618 for Czar Mikhail Fedorovich. The hilt and scabbard are covered in green velvet. The belt is in green braid with silver. The decorations are in silver tracery.

Main collection of the Armory (Inv. no. 6210 [5902])
Moscow, the Armory, 1618
Master: Ilia Prosvit
Damask steel, wood, velvet, silver; engraving, gilding, gold and
 silver damascening
Total L. 41¹³/₁₆ in. (106.2 cm.); L. of blade 36¹¹/₁₆ in. (93.2 cm.);
 L. of sheath 37⅜ in. (95 cm.)

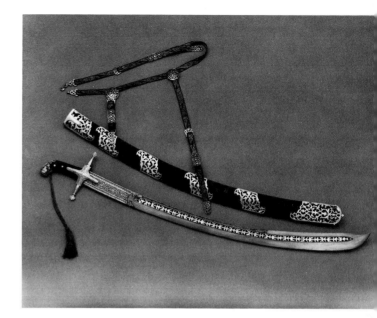

69. *Chekan, or battle hammer*
(Colorplate, p. 99)

Iron, with gold damascened foliate ornament. An inscription states that the battle hammer belonged to Prince Fedor Andreevich Teliatevsky. The handle is of wood covered in leather. The silver hammer bears a laced, foliate pattern, engraved and partly gilded.

Formerly in the possession of Prince F. A. Teliatevsky
Main collection of the Armory (Inv. no. 5506 [5246])
Moscow, second half of 17th century
Iron, silver, wood, leather; engraving, gilding, gold damascening
L. 29⁵/₁₆ in. (74.5 cm.)

Exhibited: *The Culture and Art of Ancient Russia,* USSR, 1969

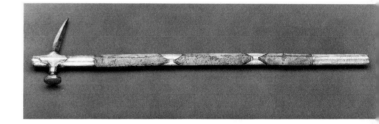

70. *Shestoper, or parade mace*
(Colorplates, pp. 100, 101)

Iron, with a wooden shaft. Decorated with stylized, foliate ornament in gold damascening.

Main collection of the Armory (Inv. no. 5494 [5233])
Moscow, the Armory, 1660s
Iron, wood; gold damascening
L. 23⅝ in. (60 cm.)

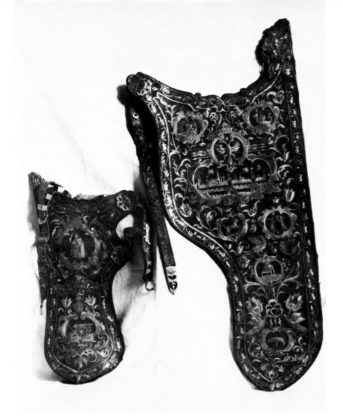

71. *Saadak, or bow case and quiver*

The covers for the bow and arrows are made of red leather, embroidered with silver and gold threads. In the center of the bow case is a depiction of the Moscow Kremlin as seen from Red Square. Above this is the Russian double-headed eagle, and to the sides are the coats of arms of Novgorod, Pskov, Tver, Kazan, Siberia, and Perm. The quiver carries the Russian double-headed eagle and the coats of arms of Riazan and Smolensk on the sides. The fittings are silver gilt with niello ornamentation.

Formerly in the possession of Czar Alexei Mikhailovich
Main collection of the Armory (Inv. no. 6696 [6342])
Moscow, the Armory, 1673
Master: the embroiderer Prokofii Andreev
Leather, silver, silver and gold thread; embroidery, embossing, engraving, niello, gilding
L. of bow case 28$^{5}/_{16}$ in. (72 cm.); L. of quiver 16$^{5}/_{16}$ in. (41.5 cm.)

Exhibited: *The Craft of Russian Armorers,* USSR, 1976–77

72. *Pishchal, or gun*

A double-barreled hunting gun with revolving mechanism. The barrels are decorated with foliate ornament and with depictions of animals, birds, and a heraldic double-headed eagle, damascened and embossed. One bore is smooth, the other is threaded. The embossed, gilded bolt is of the French flintlock type. The stock is inset with bone depictions of a reclining deer and a heraldic double-headed eagle.

Main collection of the Armory (Inv. no. 8075 [7594])
Moscow, the Armory, 1670s–80s
Master: Ivan Boltyrev; stock by Evtikhii Kuzovlev
Steel, wood, bone; engraving, gold inlay, gilding
Total L. 50 in. (127 cm.); L. of barrels 35$^{1}/_{16}$ in. (89 cm.);
 caliber: 9 mm.; 10 mm.

73. *Pair of saddle pistols*

The barrels are decorated with engraved foliate ornament on a gilded, matted ground. The bolt is engraved in an openwork pattern, and the silver-gilt fittings are decorated with enamel. The action is of the flintlock type.

Main collection of the Armory (Inv. nos. 9177, 9178 [8281])
Moscow, the Armory, second half of 17th century
Iron, steel, silver, wood; embossing, matting, gilding, enameling, wood carving
Total L. 23⅝ in. (60 cm.), 23¾ in. (60.3 cm.); L. of barrels 15⅞ in. (40.3 cm.); caliber: 13 mm.

74. *Saddle pistol*

The barrel is decorated with engraved foliate ornament on a gilded, matted ground. The bolt is engraved with an openwork pattern, and the silver-gilt fittings are decorated with multicolored enamel. The bolt panel carries the master's stamp. The action is of the flintlock type.

Main collection of the Armory (Inv. no. 9163 [8274])
Moscow, the Armory, second half of 17th century
Master: Osip Alferiev. Master's stamp: "OSIP" in Cyrillic in a shield with a figured edge
Iron, steel, silver, wood; engraving, matting, gilding, enameling, wood carving
Total L. 18¹³⁄₁₆ in. (47.7 cm.); L. of barrel 12³⁄₁₆ in. (31 cm.); caliber: 8.5 mm.

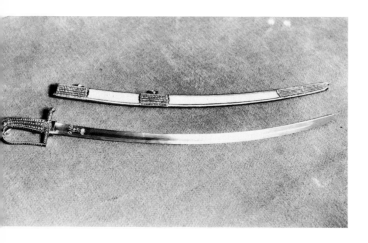

75. *Saber and scabbard*

The blade is of damask steel with the monogram of Emperor Alexander I and with gold damascening depicting the coat of arms of the city of Tula. The scabbard is covered in white fish skin and decorated with nodules of faceted steel.

Main collection of the Armory (Inv. no. 6265 [5961])
Russia, Tula Arms Factory, 1801
Steel, wood, fish skin, fabric; damascening, engraving, faceting
Total L. 37¹¹/₁₆ in. (95.8 cm.); L. of blade 31⅞ in. (81 cm.);
 L. of scabbard 38¼ in. (97.1 cm.)

Exhibited: *Russian Decorative and Applied Art of the 18th–Early 20th Centuries,* USSR, 1973–76

76. *Saber and scabbard*
 (Colorplates, pp. 102–105)

The steel blade is decorated on both sides with depictions of the siege and storming of the fortress of Varna by the Russian armies on September 28, 1828. It also carries the double-headed eagle and the monogram of Emperor Nicholas I. The inscription on the blade states that the saber was made by the master Ivan Bushuev in 1829. The guard is gilt bronze. The hilt is topped by the figure of Victory bearing a wreath in the center of which is the monogram of Emperor Nicholas I. The scabbard is set with bone and steel panels.

Inv. no. 23858
Zlatoust, 1829
Master: Ivan Bushuev
Steel, wood, bronze, bone; engraving, etching, burnishing, gilding
Total L. 39⅜ in. (100 cm.); L. of blade 33¹/₁₆ in. (84 cm.);
 L. of scabbard 34¼ in. (87 cm.)

Exhibited: *The 90th Anniversary of the Russo-Turkish War of 1877–78 and the Liberation of Bulgaria from the Turkish Yoke,* Bulgaria, 1968

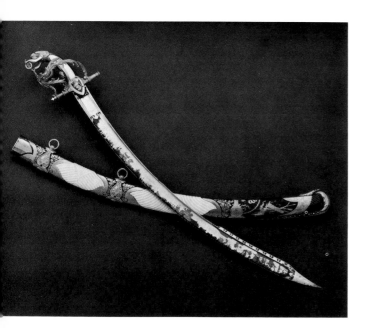

*Detail of 77. Silver-gilt noseband (reshma),
with double-headed eagle (see p. 192)*

4. CEREMONIAL EQUESTRIAN ACCESSORIES

The collection of equestrian accessories in the Armory is unique in its richness and diversity and includes magnificent items created by the finest Russian and foreign craftsmen of the sixteenth and seventeenth centuries. Many works in this great collection were gifts from foreign ambassadors or commercial representatives of Iran, Turkey, China, Bukhara, Germany, Poland, and other countries with which Muscovy had developed strong commercial and diplomatic ties.

In the past the main collection of ceremonial equestrian accessories constituted the czar's treasury, which was under the auspices of the Stable Office, part of the Kremlin since the late fifteenth century. Much harness work was done in the Kremlin workshops by the outstanding craftsmen I. Popov, Semen Fedotov, Larion Afanasiev, Luka Mymrin, and others. Their saddles, bridles, horse cloths, tassels, jingle chains, and stirrups—chased, engraved, nielloed, and enameled on gold and silver—are distinguished by high technical standards, by the richness of artistic imagination they demonstrate, and by the diversity of the ornament they carry. Works by Russian craftsmen were renowned far beyond Russia, and tales and legends made the beauty and splendor of Russian saddles known the world over. These saddles were sturdily built, allowing the rider mobility and flexibility as he rode.

From the sixteenth century until the second half of the seventeenth the form of the Russian saddle remained fairly constant except in a few details, but, during the second half of the seventeenth century, a new form of saddle, the so-called *archak*, was developed. This was a small saddle with a cushion fastened to the seat. Archaki were often made by a group of craftsmen, and they astonish us with their rich designs, precious fabrics,

and gold and silver mounts. The archak in the exhibition (80) was made by the outstanding craftsmen Afanasiev, Mymrin, and Fedotov for Czar Fedor Alexeevich in 1682. The silver-gilt saddle bows are covered in a colorful filigree and enamel pattern of luxurious stylized flowers and leaves on curved stems.

The Stable Office was in charge of staging the ceremonial processions that accompanied the czar's great exits and receptions of foreign ambassadors. Great importance was attached to these events, and the ceremonial equestrian accessories were distinguished by particular richness and splendor. The secretary of the British ambassador Carlisle wrote in 1664: ''Most [riders] were on fine horses with rich harnesses and reins of silver. . . . Some of the horses bore saddle-cloths covered in jewels whose brilliance, it seemed, added light to the light of day.''

Silver chains of broad, thinly hammered links were used extensively on equestrian accessories; when the horse moved, the chains chimed majestically. The exhibition includes two silver bridle chains (78) produced in the seventeenth century by special craftsmen from the workshops of the Stable Office and the Silver Chamber in the Kremlin. Such bridle chains were hung along the bridle as far as the front saddle bow. This particular pair is joined by a cast silver-gilt buckle in the form of a crowned double-headed eagle, a decorative element characteristic of Russian ceremonial artifacts. A similar motif is present on the *reshma*, or ornamental noseband (77).

L. P. Kirillova

4. CEREMONIAL EQUESTRIAN ACCESSORIES

77. *Reshma, or noseband*

Silver gilt with a chased stylized foliate pattern. The center bears a relief design of a double-headed eagle.

Main collection of the Armory (Inv. no. 10439)
Moscow, Kremlin workshops, 17th century
Silver; chasing, gilding
L. 6^{11}/$_{16}$ in. (17 cm.); W. 4^{5}/$_{16}$ in. (11 cm.)

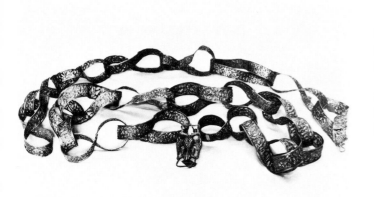

78. *Pair of bridle chains*

Silver, with chased foliate pattern and twisted wire along the edges of the links. The silver-gilt buckle fastened to one of the chains is in the form of a double-headed crowned eagle.

Inv. no. 10463
Moscow, Kremlin workshops, 17th century
Silver; casting, chasing, gilding

79. *Pair of stirrups*
(Colorplate, p. 107)

In the form of arches on oval bases. The mounts are in silver, partly gilded, with double-headed eagles in relief and chased foliate patterns.

Formerly in the possession of Czar Alexei Mikhailovich
Main collection of the Armory (Inv. no. 9953)
Moscow, Kremlin workshops, second half of 17th century
Iron, silver; chasing, engraving, gilding
H. 6^{11}/$_{16}$ in. (17 cm.); base 4^{1}/$_{8}$ x 4^{1}/$_{2}$ in. (10.5 x 11.5 cm.)

Exhibited: *Soviet Union: Arts and Crafts in Ancient Times and Today,* USA, 1972

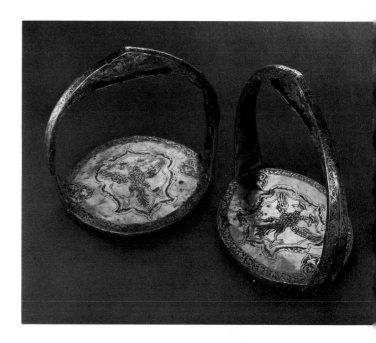

80. *Archak, or saddle*
(Colorplates, pp. 108, 109)

Covered in velvet and mounted in silver gilt. Decoration of multicolored enamel with a filigree pattern in the form of stylized flowers and leaves with curving stems.

Formerly in the possession of Czar Fedor Alexeevich
Main collection of the Armory (Inv. no. 9477)
Moscow, Kremlin workshops, 1682
Masters: Larion Afanasiev, Luka Mymrin, Semen Fedotov
Silver, wood, velvet; filigree, enamel, gilding
L. 18^{1}/$_{8}$ in. (46 cm.); H. of front pommel 9^{1}/$_{16}$ in. (23 cm.); of rear pommel 6^{11}/$_{16}$ in. (17 cm.)

81. *Saddle cloth*
(Not illustrated)

Made of double-pile gold velvet with large flowers and green leaves on a pink ground. The center and lining are of red cotton. The edges of the cloth are decorated with plaited gold lace.

Main collection of the Armory (Inv. no. 10366)
Moscow, Kremlin workshops, 17th century
Velvet: Italy, 17th century; lace: Russia, 17th century; cotton fabric: the Orient, 17th century
Silk and gold thread; braiding
53^{9}/$_{16}$ x 30^{5}/$_{16}$ in. (136 x 77 cm.)

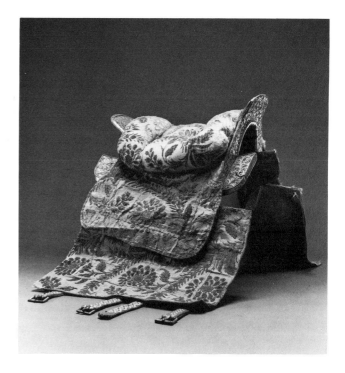

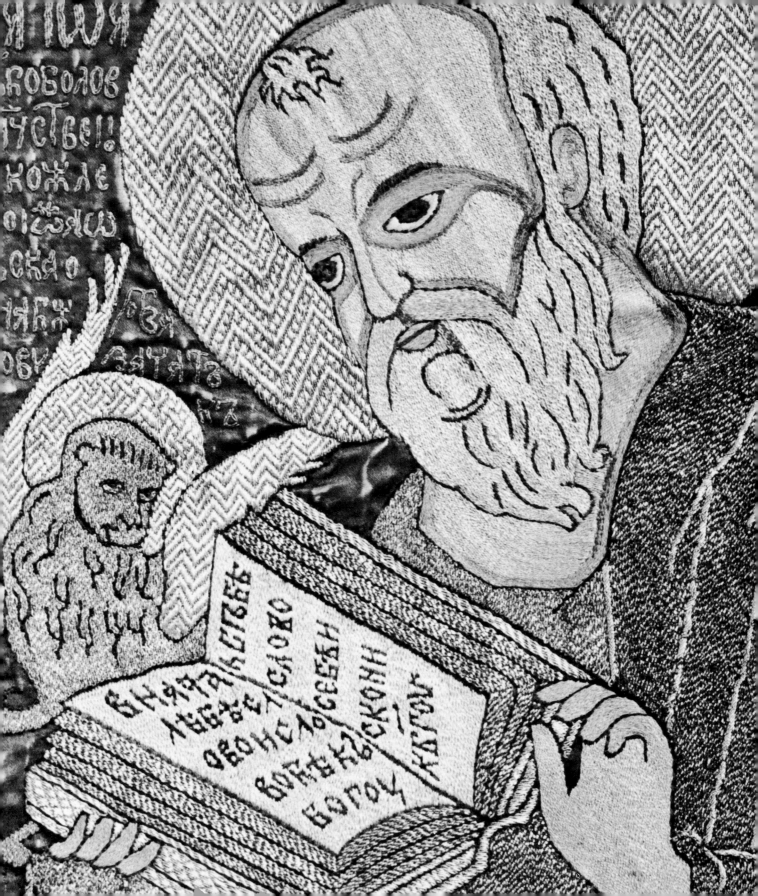

5. TEXTILES AND NEEDLEWORK

Russia's extensive international connections ensured a constant influx of expensive silk and gold textiles from the East and West into the country. The Moscow Kremlin collection has examples of ecclesiastical and secular clothing from the fourteenth through nineteenth centuries made of Byzantine, Italian, Spanish, French, Iranian, Turkish, and Chinese textiles. A distinguishing feature of the collection is an absence of remnants and incomplete parts, both of which are often encountered in public and private collections. In the hands of Russian craftswomen foreign textiles were transformed into ceremonial dress, into objects for enhancing a palace festivity or a church interior, or into items for domestic use. From the specimens of weaving preserved in the Kremlin Museums it is possible to judge the width of an original panel of cloth or the size of an entire pattern. A second distinguishing feature of the collection is the presence of embroidered dedications on most pieces and the fact that many of them are mentioned in historical documents, so the dates of manufacture of these unique textiles can be determined.

Imported fabrics were highly prized and were used as gifts or awards. Clothes made from them were often recut and used again, and pure silk (damask, taffeta) was used to make banners, ecclesiastical veils, undergarments, and linings for all manner of articles. Brocades (in gold, on pile weaves, or on moiré plain weaves) were used for ceremonial dress and for liturgical use. During the sixteenth and seventeenth centuries Italian textiles were very popular in Russia, and the Moscow Kremlin has examples from the major Italian centers of silk weaving—Venice, Florence, and Genoa. The exhibition includes one of the most attractive specimens of Italian weaving from the seventeenth century, the *sakkos*, or bishop's vestment, made of golden stitched velvet for the patriarch Adrian (**88**). The

Detail of 83. *Embroidered satin veil (pelená) with St. John the Evangelist* (see p. 199)

large, luxurious foliate pattern and the combination of colored silk threads with gold and silver ones are characteristics of Italian work of the mid-seventeenth century, which is when the material was brought to Russia and made into a garment for Czar Alexei Mikhailovich. When it was later converted to a sakkos the Russian craftswomen decorated the textile with strips of red velvet embroidered in pearls with double-headed eagles, unicorns, lions, and (in imitation of Italian textiles) cornucopias and flowers with crowns.

Ottoman velvets were valued less highly, inasmuch as they had a cotton warp, not a silk one. Still they carried large and vibrant patterns and were popular in Russia. The seventeenth-century *phelonion,* or cope, of cut velvet (**89**), with its pattern of large, pointed oval medallions enclosing bouquets of carnations and sweetbriar buds, is a typical Turkish product. The shoulders of the phelonion are decorated with pearl-embroidered foliate flourishes and an inscription stating that the embroidery was made in the workshop of Princess Romodanovskaia. The Kremlin Museums collection also contains other garments sewn from imported textiles and decorated with pearls (**84, 86–88**).

The ornamental and pictorial embroidery of ancient Rus' has achieved wide recognition. It is one of those few spheres of culture in which the women of ancient Rus' could manifest their creative talent, their artistic taste, and fine craftsmanship. The art of embroidery was known in Rus' from earliest times, but it developed in earnest with the spread of Christianity at the end of the tenth century. Like the icon and the fresco, embroidery was used to depict the Christian saints and scenes from the Bible. Elements of pagan symbolism were reinterpreted and turned into ornamental patterns. Embroidery became an integral part of everyday Russian life and was used to decorate clothes, towels, tablecloths, and equestrian and military accessories. Embroidered icons, ensigns, and banners appeared in military campaigns and in social, political, and religious ceremonies. Hangings, drapes, funeral palls, and veils, together with paintings, were the principal decorations of the interiors of churches.

In ancient Rus' all strata of society used embroidery. However, pictorial embroidery required the skill of a professional artist who could trace the design on the silk fabric for the craftswomen to fill in with silk and gold threads and pearls. Consequently ornamental embroideries made with cheap materials (canvas with linen thread) were available to the public at

large, but pictorial embroidery was supported primarily by the upper classes of feudal society. Embroidery workshops, or so-called *svetlitsy*, were to be found in every princely and boyar household, in the homes of the merchant and military classes, and in convents; the Czaritsa's Workshop Chamber was particularly large. The embroidery craftswomen received special instruction and were highly regarded. But, although most of the finest embroideries bear inscribed dedications, rarely are the craftswomen who made them identified. Still the dates and patrons' names enable us not only to attribute works accurately, but also to sense the palpable human interests, ideas, and feelings of the individuals who designed them.

The collection of ancient Russian needlework in the Kremlin Museums is one of the richest in the country. It incorporates treasures from the Patriarch's Treasury, the Kremlin cathedrals and palaces, and from many monasteries and churches. It includes ecclesiastical hangings and vestments, royal regalia, military banners, equestrian accessories, women's clothing, and items of everyday domestic use. For the most part these artifacts date from the seventeenth century, although there are earlier examples, which represent the products of various artistic centers such as Novgorod, Moscow, and Solvychegodsk. The Kremlin workshops were responsible for most of the pieces.

The exhibition contains works that reveal the essential traits of ancient Russian needlework—subtle nuances of color, emotional expressivity of image, and decorative force—and they enable the viewer to trace the basic course of development of this art. The slender, elongated figures in the veil with the Appearance of the Virgin to St. Sergius (**82**), with their graceful movements enhanced by multicolored silks, are typical of Moscow embroidery of the late fifteenth century and recall the Dionysius school of icon painting. But the veil with St. John the Evangelist (**83**), which dates from the second half of the sixteenth century, is quite different. Here attention is focused on the psychological impact of the image, a characteristic that corresponds to the general trends in Russian painting during the reign of Ivan the Terrible. The face of St. John expresses the intensity of the ascetic, while his face and hands and the head of the lion are inclined toward the text of the Bible, the axis of the composition. The abundant use of gold and silver threads, the underscoring of volume by stitching the outline of each form, and the compactness of the figure are typical qualities of the needlework of the period.

The *pokrovéts,* or embroidered eucharist cover, with the Agnus Dei produced at the Czaritsa's Workshop Chamber in 1598 (**84**) demonstrates one of the main characteristics of the art of the late sixteenth and seventeenth centuries. The entire design and all the inscriptions are outlined with strings of pearls and decorated with precious stones, so that the embroidery resembles an expensive piece of jewelry.

The *plashchanitsa,* or Good Friday shroud (**87**), with its traditional composition, was sewn in the house of Ivan Guriev, a rich Moscow merchant, in 1678. The high quality of gold embroidery in this piece and the stylization and schematic treatment of the decorative elements are typical of such artifacts of the seventeenth century.

<div align="right">

I. I. Vishnevskaia
N. A. Maiasova

</div>

5. TEXTILES AND NEEDLEWORK

82. *Pelená, or veil, with the Appearance of the Virgin to St. Sergius*
(Colorplates, pp. 111, 112)

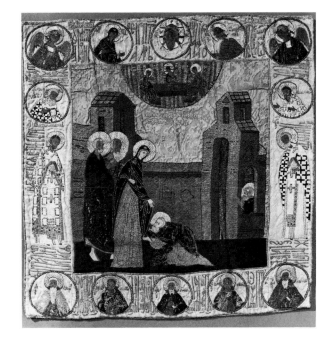

The Appearance of the Virgin to St. Sergius, with the Old Testament Trinity above, is embroidered in the central panel on yellow damask with silk and gold threads. Full-length figures of St. John of Zlatoust and St. Nicholas of Myra, in Lycia, are embroidered on a ground of crimson damask on the border at left and right, with half-length figures of the Deësis and the saints in medallions. A liturgical inscription fills the spaces between the figures.

Accessioned from the Museum Fund in 1922 (Inv. no. 13693)
Needlework: Moscow, second half of 15th century; fabric:
 Italy, second half of 15th century
Damask, gold and silk threads; weaving, embroidery
19⅞ x 19⁵/₁₆ in. (50.5 x 49 cm.)

Exhibited: *The Culture and Art of Ancient Russia,* USSR, 1969

83. *Pelená, or veil, with St. John the Evangelist*
(Colorplate, p. 113)

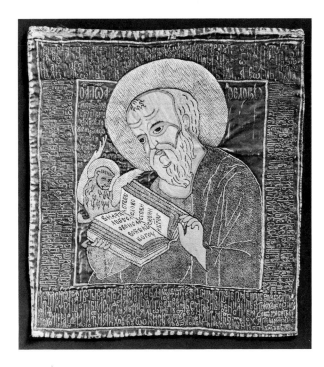

St. John the Evangelist reading the Gospels is depicted in gold and silk thread on red satin. His symbol, the winged lion, is beside him. There is a liturgical inscription along the border and in the background of the central panel.

Inv. no. 13509
Provenance: Monastery of the Miracle, Moscow Kremlin
Needlework: Moscow, second half of 16th century; satin:
 Italy, mid-16th century
Satin, gold and silk threads; embroidery
14³/₁₆ x 12⁹/₁₆ in. (36 x 32 cm.)

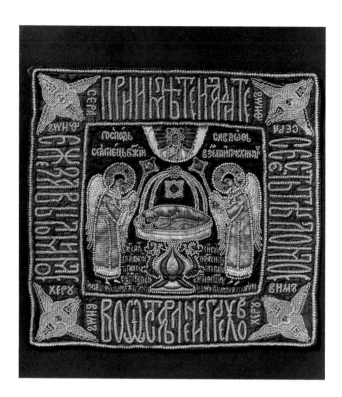

84. *Pokrovéts, or embroidered eucharist cover, with the Agnus Dei*
(Colorplate, p. 114)

The central panel depicts the Christ Child as the Lamb of God on a paten. God Sabaoth, the Holy Ghost, and two angels with flabella are embroidered in gold and silk threads on red damask. The images are decorated with pearls and precious stones and are accompanied by embroidered inscriptions. The blue damask border carries a liturgical inscription and seraphim and cherubim at the corners.

Presented by Czaritsa Irina Fedorovna to the Cathedral of the
 Archangel Michael in 1598
Accessioned from the Patriarch's Vestry in 1920 (Inv. no. 13286)
Needlework: Moscow, Czaritsa's Workshop Chamber, 1598;
 fabric: Italy, second half of 16th century
Damask, gold and silk threads, gold, precious stones, pearls;
 embroidery
20½ x 21¼ in. (52 x 54 cm.)

85. *Towel*
(Colorplate, p. 115)

Made of fine white linen embroidered with gold and silk threads. Patterns of carnations and double-headed eagles appear at the corners; sprigs of flowers and foliate scrolls decorate the edges.

Main collection of the Armory (Inv. no. 4043)
Moscow, Czaritsa's Workshop Chamber, mid-17th century
Linen, gold and silk threads; weaving, embroidery
93 x 24⁷/₁₆ in. (236 x 62 cm.)

Exhibited: *L'Art russe des Scythes à nos jours,* Paris, 1967–68; *The Culture and Art of Ancient Russia,* USSR, 1969; *50 Years of the USSR,* Czechoslovakia, 1972; *Ancient Russian Art,* Bulgaria, 1973

86. *Pair of ecclesiastical armlets or cuffs*
(Colorplate, p. 116)

Made of black velvet decorated with a foliate pattern and embroidered with pearls and spirally twisted gold thread. Buttons are of silver gilt.

Formerly in the possession of Patriarch Pitirim
Accessioned from the Patriarch's Treasury in 1920
 (Inv. no. 13115)
Needlework: Moscow, Kremlin workshops, 1670s; fabric: imported
Velvet, gold thread, silver, pearls; weaving, embroidery
8¹¹⁄₁₆ x 7⅞ in. extended (22 x 20 cm.)

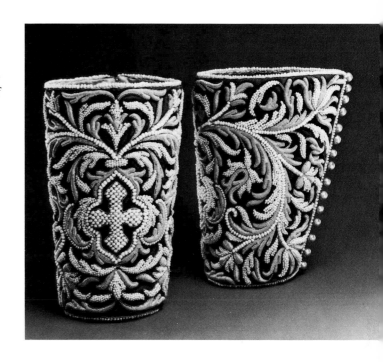

87. *Plashchanitsa, or Good Friday shroud*
(Colorplates, pp. 117–119)

The Entombment is embroidered in the central panel in gold and silk threads on dark blue satin. The symbols of the Evangelists appear at the corners, and a dedicatory inscription is inset on the right. Half-length figures of saints are embroidered on the light green satin border, and the Evangelists are seated in the corners. The body and halo of Christ and the head and halo of the Virgin are outlined with strings of pearls.

Presented by the merchant Ivan Guriev to the Monastery of the
 Miracle, Moscow Kremlin, in 1678
Accessioned from there in 1919 (Inv. no. 13469)
Needlework: Moscow, 1678; fabrics: Italy, mid-17th century
Satin, damask, gold and silk threads, precious stones, pearls;
 embroidery
53⅛ x 74⁷⁄₁₆ in. (135 x 189 cm.)

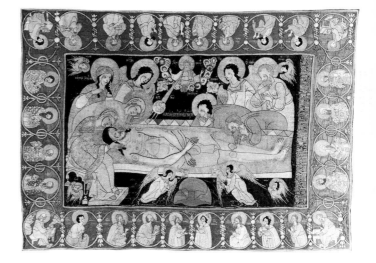

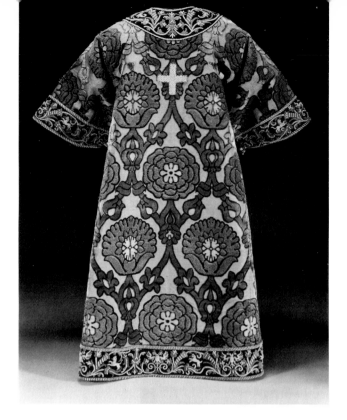

88. *Sakkos, or bishop's vestment*
(Colorplate, p. 120)

Made of gold velvet decorated with pomegranate flowers and a Gothic rose. The flowers are contained within pointed, oval medallions formed by foliate flourishes. The neckline, sleeves, and hem of red velvet are embroidered in pearls with a pattern of double-headed eagles, unicorns, and cornucopias. Some of the silver buttons and "jingle bells" are decorated with pearls.

Made from a vestment of Czar Alexei Mikhailovich
Formerly in the possession of Patriarch Adrian
Accessioned from the Patriarch's Treasury in 1920
 (Inv. no. 13063)
Needlework: Moscow, Czaritsa's Workshop Chamber, second half of 17th century; fabric: Italy, 17th century
Gold velvet, taffeta, satin, pearls; weaving, embroidery
L. 53⅛ in. (135 cm.)

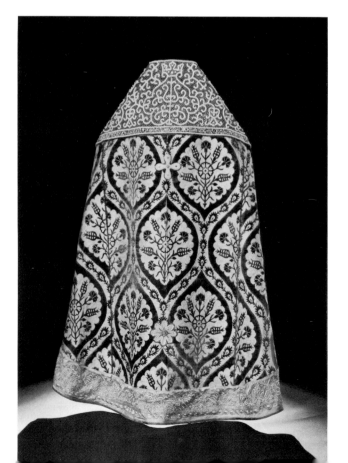

89. *Phelonion, or cope*
(Colorplates, pp. 120, 121)

Made of gold cut velvet decorated with bouquets of carnations and sweetbriar buds in large, pointed oval medallions. The light silk background is brocaded in silver with a red and green pattern. The shoulders are decorated with pearls and spangles with foliate flourishes and a dedicatory inscription. The hem of yellow satin is decorated with a border of braided gold and silver lace.

Presented by Boyarynia P. A. Romodanovskaia to the Monastery of the Raising of the Holy Cross, Moscow, in 1680
Accessioned from there in 1922 (Inv. no. 16303)
Needlework: Russia, 1680; velvet: Turkey, mid-17th century
Gold velvet, satin, lace, gold thread, spangles, precious stones, pearls; weaving, embroidery, braiding
L. 57¹/₁₆ in. (145 cm.)

90. *Sakkos, or bishop's vestment*
(Colorplate, p. 122)

Made of silver brocade decorated with bouquets of flowers between vertical, spiraling bands of floral garlands. The garlands are embroidered in gold thread, spangles, and blue chenille and are decorated with foil and glass. The buttons and jingle bells are of silver.

Accessioned from the Monastery of the Miracle, Moscow Kremlin, in 1919 (Inv. no. 13385)
Russia, 1780s
Brocade, gold braid, gold thread, chenille, foil, spangles, glass, silver; embroidery
L. 46⅞ in. (119 cm.)

Exhibited: *Russian Decorative and Applied Art of the 18th–Early 20th Centuries,* USSR, 1973–76

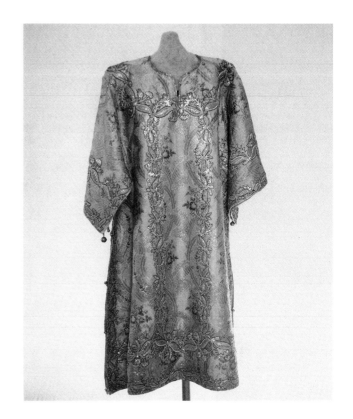

91. *Miter*
(Colorplate, p. 123)

Made of gold brocade decorated with medallions of painted multicolored enamel and with a foliate pattern embroidered in relief in pearls. The medallions carry depictions of God Sabaoth, Christ, John the Baptist, Our Lady of Tikhvin, and a cross.

Accessioned from the Monastery of St. Simon, Moscow, in 1918 (Inv. no. 13673)
Russia, early 19th century
Brocade, silver, pearls; embroidery, enameling
H. 9¼ in. (23.5 cm.); Diam. 7¹¹/₁₆ in. (19.5 cm.)

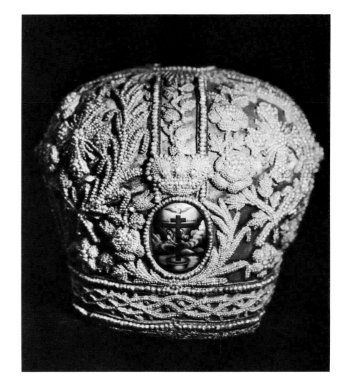

Textiles and Needlework 203

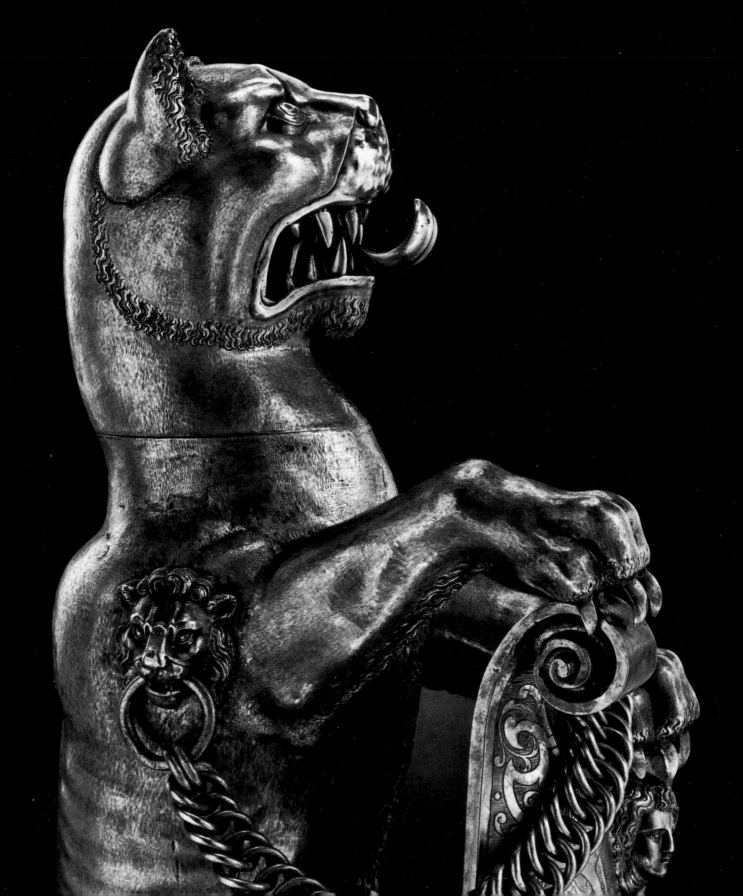

6. WESTERN EUROPEAN SILVER

The collection of western European silver of the fourteenth through nineteenth centuries is one of the key components of the original museum of the Armory. These treasures, which over the centuries were amassed in the Kremlin storehouses, now constitute an astonishing collection—the largest in the world—of exceptional aesthetic and educational value. The collection is distinguished by its breadth and diversity. It includes works from every period in the last six centuries and from every major art center in Europe. Each piece represents the national character of the country in which it was made and the highest level of artistry.

The notable features of this collection have been determined by its unique "biography." Diplomatic gifts from foreign powers and delegations brought to Moscow in the sixteenth and seventeenth centuries make up the main part of the collection. Thus it contains a wealth of material that can be used to delineate Russia's various political and commercial contacts. The collection also serves as an indirect source of information on important episodes in European diplomacy. At the same time the collection provides a rare opportunity to study the development of gold and silver making and of the art of jewelry as practiced in many European countries during the Renaissance and the baroque period; moreover, the works presented are of the highest quality. The character of the collection of silver from England, Holland, Denmark, Sweden, Poland, Germany, and Austria in the Armory indicates that the artifacts intended for Russia were selected consciously and carefully. Obviously attention was paid to the material value of the objects and to the mastery of their execution, and, moreover, the objects were clearly chosen to represent the decorative fashions of Europe. The prestige and authority of the rulers of Muscovy

205

Detail of 93. *Silver leopard-shaped vessel* (see p. 209)

occasioned this concern, and, in any case, Muscovy officials made sure that the czar's honor was not slighted by an unfortunate choice, by an oversight, or by the gift of a second-rate artifact. The gifts were presented in an elaborate and well-defined ceremony that took place amid the splendor of the czar's court. The works in the exhibition by silversmiths from London, Augsburg, Stockholm, and Danzig are among the most important ambassadorial gifts in the Armory.

The Kremlin collection of English silver is outstanding. It is the largest collection in the world of works by London goldsmiths of the period 1557–1663. Historical circumstances dictate that some periods and stylistic trends receive uneven representation in the collection, but the works dating from the 1580s–90s, from the turn of the sixteenth and seventeenth centuries, and from the first third of the seventeenth century are of the greatest interest and quality. The three English pieces included here are from these periods and are exceptionally rare: there are only a few items to compare with the flask (**92**); the leopard (**93**) and water jug (**94**) are unique. Nevertheless, the distinctive qualities of each work are integral parts of the characteristically English art produced between 1580 and 1635. The three pieces reflect the style of the late Renaissance of the last Tudors and the first Stuarts. A simplicity, lucidity, and serenity of design are combined with a firmness of form and a rational, but noble, elegance. In their workmanship cast details do not compete with chased and engraved ones. On the surfaces the combinations of realistic and stylized foliate and geometrical motifs are applied with a feeling of great harmony. Even the fantastic, fairy-tale images—the winged dragon and snake on the water jug—do not disturb the measured lines and good taste identifiable with the best works of the English craftsmen.

The collection of German silver in the Kremlin Museums is of extraordinary richness. Huge purchases were made for what used to be the czar's treasury, and many countries on the Continent made extravagant gifts of works by German goldsmiths. Germany was the richest source of silver ore and boasted the most centers for the production of silver wares; its numerous craftsmen worked with great technical virtuosity and creative imagination. German silversmiths produced a remarkable diversity of silver vessels and decorative utensils whose novelty, unusual style, ornamentation, and luxurious design won them renown. These silver wares were eagerly sought by collectors and became valued palace property. The

works on display are typical of the baroque style in which most of the German pieces in the Armory collection are executed. They are characterized by their great size, intricate shapes, sinuous lines, intense, dynamic forms, and rich decorative elements.

The sculptural piece from Augsburg (**97**) and the platter (**98**) are typical examples of the products of this great center, which flourished in the late seventeenth century. Biller, the designer of both pieces, belongs to a brilliant dynasty of goldsmiths. The subject of the chased composition in the center of the platter is the captured Turks at the feet of Emperor Leopold; the motifs applied on the sides also reflect the victory of the European armies over the Turks at Vienna in 1683. Inasmuch as this platter was part of an ambassadorial gift from Austria in 1684, meant to bring Russia into a coalition against the Turks, it can be regarded as a specific example of visual propaganda benefiting the donor.

The impressive array of diplomatic gifts made by the Poles and Lithuanians during the seventeenth century and housed in the Armory is represented here by only one item, the large Danzig pitcher made by Paulsen (**96**). This work was selected for the exhibition because of its original design and because it was made by such a prominent silversmith. The work compels the viewer with its massive body, twisted into a spiral as if by some invisible force, by its large, heavy, chased reliefs, by its smooth gilt and white surfaces, by the handsome astragal molding on the body, by the beaded motif along the handle, and, finally, by the unexpectedly elaborate design of the mask on the spout.

The Armory contains over thirty examples of Swedish silver from the seventeenth century, one of the major collections of its kind among European museums. These works were amassed during the period of close diplomatic relations between Russia and Sweden between 1647 and 1699. The candlestick (**100**) and the beaker (**99**) exhibited are characteristic of the development of silvermaking in Stockholm and clearly demonstrate the Swedish preference for classical severity and elegant simplicity.

G. A. Markova

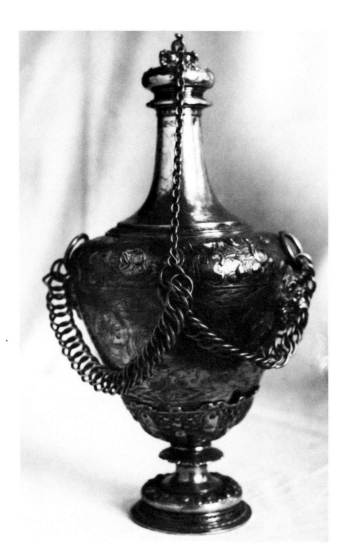

92. *Flask*

Silver gilt, conical, with a high neck and a screw top attached by chains. Birds, trophies, bunches of fruit, and draperies are engraved on the neck. A frieze of fruit and medallions with dolphins is embossed along the top of the body, and below this a foliate ornament and the coat of arms of King James I of England framed with laurels are engraved.

Presented by the English ambassador Sir Thomas Smith to Czar
 Boris Godunov on behalf of King James I in 1604
Main collection of the Armory (Inv. no. 2090)
Hallmarks: London, 1580–81
Maker's mark: "F"
Silver; chasing, casting, gilding
H. 17⁵/₁₆ in. (44 cm.)

Exhibited: *From the History of Anglo-Russian Relations,*
England-USSR, 1967

93. *Leopard*
(Colorplate, p. 125)

The vessel—cast, chased, and gilded—takes the form of a leopard sitting on his hind legs. The lid is in the form of a detachable head with teeth bared. The leopard's front paws rest on an ornamental shield with chains. The square base is chased with a motif of gadroons.

Purchased in Archangel from the English agent Fabian Ulianov in
 1629 for the Kremlin treasury of Czar Mikhail Fedorovich
Main collection of the Armory (Inv. no. 2451)
Hallmarks: London, 1600–01
Maker's mark: a triangle intersected
Silver; casting, chasing, gilding
H. 38⁹⁄₁₆ in. (98 cm.)

Exhibited: *From the History of Anglo-Russian Relations,* England-USSR, 1967

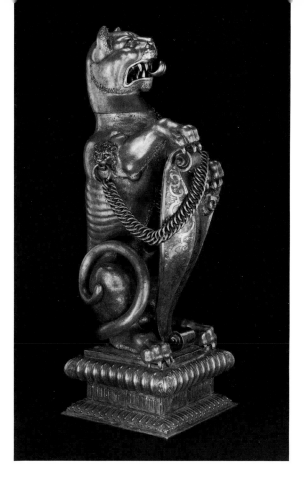

94. *Water jug*
(Colorplates, pp. 126, 127)

Silver gilt, with swelling, tapering body, tall, cylindrical neck, and hinged lid. Decorated with engraved foliate ornament and chased undulating reliefs. The cast spout is in the form of a dragon, his wings spread against the body of the pitcher. The handle is in the form of a coiled snake.

Purchased in Archangel from the English agent Fabian Ulianov in
 1629 for the Kremlin treasury of Czar Mikhail Fedorovich
Main collection of the Armory (Inv. no. 1744)
Hallmarks: London, 1604–05
Maker's mark: "WI"
Silver; casting, chasing, engraving, gilding
H. 24 in. (61 cm.)

Exhibited: *From the History of Anglo-Russian Relations,* England-USSR, 1967

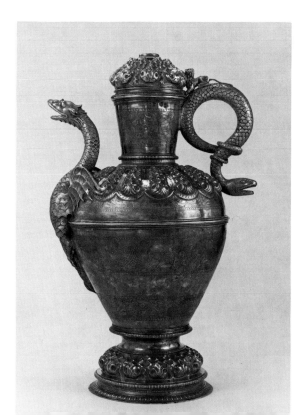

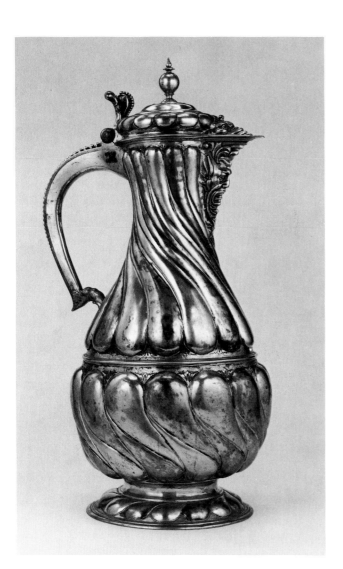

95. *Cup*
(Not illustrated)

A tall, covered vessel. Silver gilt, with a chased diaper of large double ogee bosses. The foot displays the cast figure of a winged cupid with arms raised wearing a quiver.

Presented to Czar Alexei Mikhailovich by the boyar B. I. Morozov
 on January 19, 1648
Main collection of the Armory (Inv. no. 1470)
Hamburg, 1628–40
Maker: Johann Yanes
Hallmark: Hamburg
Silver; chasing, casting, gilding
H. 39⅜ in. (100 cm.)

96. *Pitcher*
(Colorplate, p. 128)

Large, silver, partly gilded, with a pear-shaped lid, tall neck, and arched handle with large spiraling ornaments. The triangular spout is decorated with a male mask. Every second spiral ornament is gilded, and the lid carries a cast baluster in the center.

Brought to Moscow by the Lithuanian ambassador
 on October 22, 1667
Formerly in the possession of the princes Golitsyn; returned
 to the czar's treasury in 1690 after the Golitsyns had
 fallen from grace
Main collection of the Armory (Inv. no. 1751)
Danzig, 1630–50
Maker: Christian Paulsen I
Hallmark: Danzig
Silver; chasing, casting, gilding
H. 29⅛ in. (74 cm.)

97. *Horseman*

A silver vessel in the form of a mounted warrior wearing classical Roman armor and carrying a sword. Cast, chased, and partly gilded. The lower part of the tall base is decorated with chased bunches of fruit and foliage. The opening for pouring is in the horse's head, hidden by the forelock.

Brought as a gift from Emperor Leopold I to the czars
 Ivan and Peter the Great in 1684
Main collection of the Armory (Inv. no. 2443)
Augsburg, 1678–84
Maker: Lorenz Biller II
Hallmark: Augsburg
Silver; casting, chasing, gilding
H. 17^{7}/$_{16}$ in. (44.4 cm.)

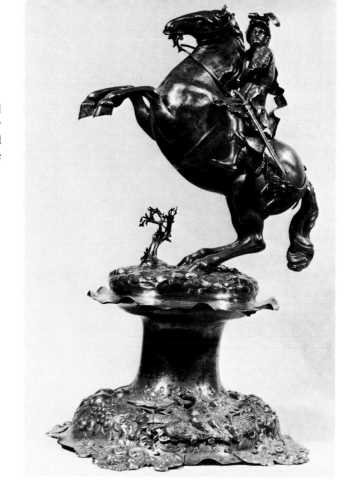

98. *Platter*

Chased silver, partly gilded. In the center the captured Turks at the feet of Emperor Leopold are depicted. The sides are decorated with bunches of fruit and trophies. The piece commemorates the defeat of the Turks by the European allies at Vienna in 1683.

Brought as a gift from Emperor Leopold I to the czars Ivan and
 Peter the Great in 1684
Main collection of the Armory (Inv. no. 1771)
Augsburg, 1683–84
Maker: Lorenz Biller II
Hallmark: Augsburg
Silver; chasing, gilding
L. 36^{5}/$_{8}$ in. (93 cm.); W. 30¾ in. (78 cm.)

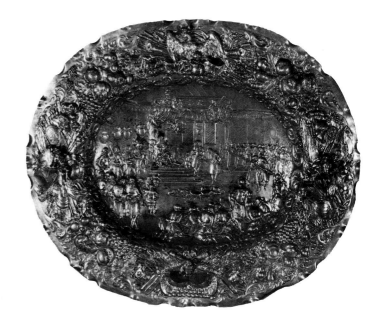

99. *Beaker*

Silver gilt, conical, with a lid. Undecorated. Brought as a gift from King Charles XII of Sweden in 1699

Main collection of the Armory (Inv. no. 2117)
Stockholm, 1698
Maker: Johann Nishzel
Hallmark: Stockholm
Silver; chasing, casting, gilding
H. 12³/₁₆ in. (31 cm.)

100. *Candlestick*

Silver, partly gilded. A table candlestick in the form of a square, fluted pillar on a square, stepped base. Gilded moldings in relief decorate the top and center of the pillar.

Brought as a gift from King Charles XII of Sweden in 1699
Main collection of the Armory (Inv. no. 2562)
Stockholm, 1698
Maker: Andreas Bengston Starin
Hallmark: Stockholm
Silver; chasing, gilding
H. 9¼ in. (23.5 cm.)

SELECTED BIBLIOGRAPHY

RUSSIAN SOURCES

Denisova, M. M. *Khudozhestvennoe oruzhie XIX veka Zlatoustovskoi oruzheinoi fabriki*. Trudy Gosudarstvennogo istoricheskogo muzeia, no. 18. Moscow, 1947.

Donova, K. V. *Russkoe shitie zhemchugom XVI–XVII vekov*. Moscow, 1962.

Drevnosti Rossiiskogo gosudarstva. Sec. 3. Moscow, 1853.

Felkerzam, A. E. *Opisi serebra dvora Ego Imperatorskogo Velichestva*. Vols. 1, 2. St. Petersburg, 1907.

Goldberg, T. G. *Chernevoe serebro Velikogo Ustiuga*. Moscow, 1952.

Goldberg, T. G., et al. *Russkoe zolotoe i serebrianoe delo XV–XX vekov*. Moscow, 1967.

Gosudarstvennaia Oruzheinaia palata Moskovskogo Kremlia: Sbornik nauchnykh trudov. Moscow, 1954.

Grabar, I. E., et al., eds. *Istoriia russkogo iskusstva*. Vol. 3. Moscow, 1955.

Ilin, M. A. *Iskusstvo Moskovskoi Rusi epokhi Feofana Greka i Andreia Rubleva*. Moscow, 1976.

Khudozhestvennye pamiatniki Moskovskogo Kremlia. Moscow, 1956.

Larchenko, M. N. *Russkoe oruzhie XVII veka*. Moscow, 1971.

Lazarev, V. N. "Etiudy po ikonografii Bogomateri." In *Vizantiiskaia zhivopis*. Moscow, 1971.

Lazarev, V. N. *Moskovskaia shkola zhivopisi*. Moscow, 1971.

Maiasova, N. A. *Pamiatnik s Solovetskikh ostrovov: Ikona "Bogomater Bogoliubskaia s zhitiiami Zosimy i Savvatia," 1545 g*. Leningrad, 1969.

Maiasova, N. A. *Drevnerusskoe shitie*. Moscow, 1971.

Markova, G. A. *Nemetskoe khudozhestvennoe serebro XVI–XVIII vekov*. Moscow, 1975.

Markova, V. I. *Dragotsennye tkani*. Moscow, 1971.

Martynova, M. V. *Dragotsennyi kamen v russkom iuvelirnom iskusstve XII–XVIII vekov*. Moscow, 1973.

Materialy i issledovaniia Gosudarstvennykh muzeev Moskovskogo Kremlia. Vols. 1, 2. Moscow, 1973, 1976.

Nenarokomova, I. S. *Gosudarstvennye muzei Moskovskogo Kremlia*. Moscow, 1977.

Nikolaeva, T. V. *Prikladnoe iskusstvo Moskovskoi Rusi*. Moscow, 1976

Opis Moskovskoi Oruzheinoi palaty. Moscow, 1884–93.

Oruzheinaia palata. Moscow, 1964.

Pisarskaia, L., et al. *Russkie emali XI–XIX vv.* Moscow, 1974.

Popova, O. S. "Ikona 'Spas Yaroe oko' iz Uspenskogo sobora Moskovskogo Kremlia." In *Drevnerusskoe iskusstvo: Problemy i atributsii.* Moscow, 1977.

Postnikova-Lebedeva, M. M. *Russkie serebrianye i zolotye kovshi.* Moscow, 1953.

Postnikova-Loseva, M. M. *Russkoe iuvelirnoe iskusstvo, ego tsentry i mastera XIV–XIX vekov.* Moscow, 1974.

Russkoe dekorativnoe iskusstvo. Vols. 1–3. Moscow, 1962–65.

Rybakov, B. A. *Remeslo drevnei Rusi.* Moscow, 1948.

Sbornik Oruzheinoi palaty. Moscow, 1925.

Sizov, E. S. *"Voobrazheny podobiia kniazei": Stenopis Arkhangelskogo sobora Moskovskogo Kremlia.* Moscow, 1969.

Svirin, A. N. *Drevnerusskoe shitie.* Moscow, 1963.

Tikhomirov. N. Ya., and Ivanov, V.N. *Moskovskii Kreml.* Moscow, 1967.

Troitsky, V. I. *Slovar moskovskikh masterov zolotogo, serebrianogo i almaznogo dela XVII veka.* Moscow and Leningrad, 1930.

Vasilenko, V. M. *Russkoe prikladnoe iskusstvo.* Moscow, 1977.

Yakunina, L. I. *Russkoe shitie zhemchugom.* Moscow, 1955.

Zabelin, I. E. *Domashny byt russkikh tzarits v XVI i XVII stoletyach.* Moscow, 1901, 1915.

Zhelesnov, V. F. *Ukasatel masterov, russkikh i inozemzev, rabotavshikh v Rossiy do XVIII veka.* St. Petersburg, 1907.

Zonova, O. B. *Khudozhestvennye pamiatniki Moskovskogo Kremlia.* Moscow, 1963.

Zonova, O. B. "Bogomater umilenye XII veka is Uspenskogo gobora Moskovskoga Kremlia." In *Drevnerusskoe iskusstvo Khudozhestvennaia Kultura domogolskei Rusi.* Moscow, 1972.

NON-RUSSIAN SOURCES

Ainalov, D. *Geschichte der russischen Monumentalkunst der Zeit des Grossfürstentums Moskau.* Berlin and Leipzig, 1933.

Alpatow, M. V., Danilowa, I. J., and Sarabjanow, D. W. *Geschichte der russischen Kunst.* Dresden, 1975.

Conway, M. *Art Treasures in Soviet Russia.* London, 1925.

Duncan, D. *Great Treasures of the Kremlin.* New York, 1968.

Felicetti-Liebenfels, W. *Geschichte der byzantinischen Ikonenmalerei.* Lausanne, 1956.

Froncek, T., ed. *The Horizon Book of the Arts of Russia.* New York, 1970.

Hamilton, G. *The Art and Architecture of Russia.* Baltimore, 1975.

Hare, R. *Tausend Jahre russische Kunst.* Recklinghausen, 1964. *(The Art and Artists of Russia.* London, 1965.)

Kaganovich, A. *Arts of Russia, 17th and 18th Centuries.* Cleveland and New York, 1968.

Kornilovich, K. *Arts of Russia, from the Origins to the End of the 16th Century.* Cleveland and New York, 1967.

Loukomski, G. *Le Kremlin de Moscou.* Paris, n.d.

Martin, F. *Schwedische königliche Geschenke an russische Zaren.* Stockholm, 1900.

Maskell, A. *Russian Art and Art Objects in Russia.* London, 1884.

Meares, B., trans. *Around the Kremlin.* Moscow, 1967.

Nemitz, F. *Die Kunst Russlands: Baukunst, Malerei, Plastik. Vom 11 bis 19 Jahrhundert.* Berlin, 1940.

Oman, C. *English Silver in the Kremlin 1557–1663.* London, 1958.

Polovtsoff, A. *Les Trésors d'art en Russie sous le régime bolcheviste.* Paris, 1919.

Rice, T. *A Concise History of Russian Art.* New York, 1967.

Viollet-le-Duc, E. *L'Art russe.* Paris, 1877.

Voyce, A. *The Moscow Kremlin.* Berkeley, 1954.

Note: In addition to the above, the reader may wish to consult the catalogues of the exhibitions cited in the entries.

INDEX OF NAMES

DOLGORUKII: A family of princely rank; many were state functionaries, p. 172.

EVSTIGNEEV, Fedor: Silversmith in the workshops of the Moscow Kremlin, seventeenth century, p. 163.

FEDOR ALEXEEVICH (1661–82): Czar of Russia from 1676; son of Czar Alexei Mikhailovich, pp. 143, 166, 193.

FEDOR IVANOVICH (1557–98): Czar of Russia from 1584; second son of Ivan the Terrible, p. 157.

FEDOTOV, Semen: Master in filigree at the Silver Chamber of the Moscow Kremlin, 1676–87, p. 193.

GODUNOV, Boris Fedorovich (about 1552–1605): Czar of Russia from 1598, pp. 184, 208.

GODUNOVA, Irina Fedorovna (1563–1604): Czaritsa from 1580; wife of Czar Fedor Ivanovich (son of Ivan the Terrible); sister of Czar Boris Godunov, pp. 157, 158, 200.

GOLITSYN: A family of princely rank; many were state functionaries, p. 210.

GOLITSYN, Vasilii Vasilievich (1643–1714): Prince, boyar, diplomat; commander-in-chief of the army during the regency of Czarevna Sofia Alexeevna, p. 163.

GRAMOTIN, Ivan Tarasovich (Ivan Kurbatov; d. 1638): Prominent member of the ambassadorial office; diplomat; director of the Gold Chamber of the Moscow Kremlin from 1634, p. 161.

GURIEV, Ivan: Merchant; a member of the famous Guriev merchant family; active in seventeenth century, p. 201.

IOASAF (Skripitsyn): Metropolitan of Moscow and All Russia, 1539–42, p. 168.

IVAN ALEXEEVICH (Ivan V; 1666–96): Czar from 1682, son of Czar Alexei Mikhailovich; elder brother of Peter the Great, pp. 183, 211.

IVAN IVANOVICH (1554–84): Czarevich; elder son of Czar Ivan the Terrible, p. 183.

IVAN VASILIEVICH (Ivan IV; Ivan the Terrible; 1530–84): Grand Prince from 1533; the first Russian czar (from 1547); son of Grand Prince Vasilii III, p. 156.

JAMES I (1566–1625): King of England from 1603, p. 208

KUZOVLEV, Evtikhii: Gunsmith and gunstock maker at the Armory of the Moscow Kremlin; active second half of seventeenth century, p. 186.

LEOPOLD I (1640–1705): Emperor of Austria from 1658; member of the Hapsburg dynasty, p. 211.

MEDVEDEV, Semen Anikeevich: Silversmith at the Patriarch's Palace of the Moscow Kremlin, end of seventeenth century, p. 167.

MIKHAIL FEDOROVICH (1596–1645): Czar of Russia from 1613; son of the boyar Fedor Nikitich Romanov, pp. 160, 161, 162, 164, 209.

MIKHAILOV, Mikhail: Master in niello at the Gold and Silver chambers of the Moscow Kremlin, 1664–85, p. 167.

MOROZOV, Boris Ivanovich (1590–1662): Boyar, state functionary, tutor of Czarevich Alexei Mikhailovich; headed the Russian government in the mid-seventeenth century, p. 210.

MYMRIN (or Murmin), Luka Semenovich: Master in filigree and enamelist at the Silver Chamber of the Moscow Kremlin, 1682–1700, p. 193.

NIKOLAI PAVLOVICH (Nicholas I; 1796–1855): Emperor of Russia from 1825; son of Emperor Paul I, p. 188.

NISHZEL, Johann: Silversmith active in Stockholm, 1676–1715, p. 212.

OSIPOV, Daniil: Master in niello and chasing at the Gold and Silver chambers of the Moscow Kremlin from 1617, p. 160.

PAULSEN I, Christian: One of the Paulsen dynasty of silversmiths in Danzig; active 1630–50, p. 210.

PAVLOV, Andrei: Master in niello at the Gold and Silver chambers of the Moscow Kremlin, 1663–85, p. 167.

PESTRIKOV, Tretiak: Master at the Silver Chamber of the Moscow Kremlin from 1616, p. 160.

PETR ALEXEEVICH (Peter the Great; 1672–1725): Czar from 1682; first emperor of Russia from 1721; son of Czar Alexei Mikhailovich, pp. 166, 168, 211.

PITIRIM (d. 1673): Metropolitan, 1652–67; Patriarch of Moscow and All Russia from 1673, p. 201.

PLATOV, Matvei Ivanovich (1751–1818): General in the cavalry; hero of the war of 1812; comrade-in-arms of commanders Suvorov and Kutuzov, p. 176.

POZHARSKY, Dmitrii Mikhailovich (1578–1642): Prince, boyar, state and military functionary; headed the struggle of the Russian people against the Polish and Swedish intervention, beginning of seventeenth century, p. 160.

PROSVIT, Ilia: Master of side arms at the Armory of the Moscow Kremlin, first half of seventeenth century, p. 185.

ROMANOV, Fedor Nikitich (known as Filaret; 1555–1633): Boyar; Patriarch of Moscow and All Russia from 1619, p. 158.

ROMODANOVSKAIA, P. A.: Boyarynia; lived second half of seventeenth century, p. 202.

SKOPIN-SHUISKY, Vasilii Fedorovich (d. 1595): Boyar from 1577; state functionary; governor of Pskov from 1579 to 1582; governor-general of Novgorod and Vladimir, 1591–93, p. 157.

SKRIPITSYN, Sakerdon: Master in niello and silversmith in Vologda from 1837, p. 177.

SMITH, Sir Thomas: English merchant who often functioned as ambassador of King James I to Russia, p. 208.

SOFIA ALEXEEVNA (1657–1704): Daughter of Czar Alexei Mikhailovich; regent of Russia, 1682–89 on behalf of her brothers the minor czars Peter and Ivan Alexeevich, p. 167.

STARIN, Andreas Bengston: Silversmith; active in Stockholm, end of seventeenth century, p. 212.

STRESHNEV, Vasilii Ivanovich (d. 1661): Okolnichii from 1630; headed the workshops of the Moscow Kremlin (the Armory and the Gold, Silver, and Icon chambers), p. 165.

TELIATEVSKY, Fedor Alexandrovich (d. 1645): Member of an old princely family; governor of Astrakhan, p. 185.

ULIANOV, Fabian: English tradesman of the seventeenth century, p. 209.

USHAKOV, Simon Fedorovich (1626–86): Important seventeenth-century artist; painter at the workshops of the Moscow Kremlin; supervised the mural painting in the cathedrals of the Archangel Michael and the Assumption and the Palace of Facets in the Moscow Kremlin; headed the icon workshop there from 1664, p. 143.

YANES, Johann: Silversmith active in Hamburg, 1617–58, p. 210.

YURII DOLGORUKII (about 1090–1157): Prince of Rostov and Suzdal; Grand Prince of Kiev from 1155; according to tradition, founded Moscow in about 1147, p. 155.

ZUBALOV, L. K.: Russian collector, active in nineteenth century, pp. 163, 170, 171.

Composition by Zimmering and Zinn, Inc., New York

Printed by Lebanon Valley Offset Company, Annville, Pennsylvania

Bound by Mueller Trade Bindery Corp., Middletown, Connecticut, and
Publishers Book Bindery, Inc., Long Island City, New York

Color photography, with the following exceptions, by Sheldan Collins,
 Photo Studio, The Metropolitan Museum of Art (**4, 5, 8, 12, 13, 14, 39,
 44, 46, 90, 91**). Coordinator of photography: J. Kenneth Moore, Photograph
 and Slide Library, The Metropolitan Museum of Art